the *Joy of* BIRD Photography

Gulf Publishing Company
Houston, Texas

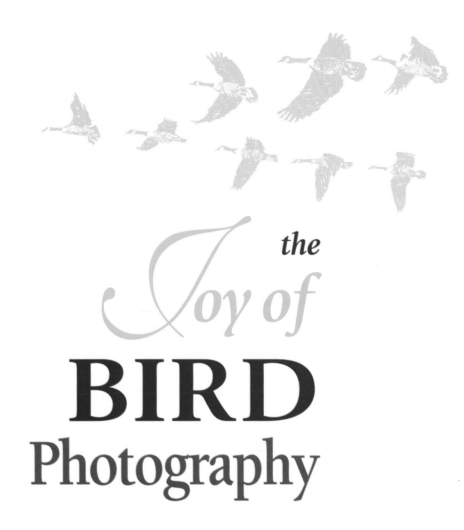

the *Joy of* BIRD Photography

*From your backyard
to exotic locations,
learn the secrets
and techniques for
taking great bird photos*

Vernon Eugene Grove, Jr., M.D.

The Joy of Bird Photography

Copyright ©1998 by Gulf Publishing Company, Houston, Texas. All rights reserved. Printed in the United States of America. This book, or parts thereof, may not be reproduced in any form without permission of the publisher.

Gulf Publishing Company
Book Division
P.O. Box 2608 ☐ Houston, Texas 77252-2608

10 9 8 7 6 5 4 3 2 1

Library of Congress Cataloging-in-Publication Data

Grove, Vernon Eugene.
 The joy of bird photography : from your backyard to exotic locations, learn the secrets and techniques for taking great bird photos / Vernon Eugene Grove, Jr.
 p. cm.
 Includes bibliographical references and index.
 ISBN 0-88415-238-3 (alk. paper)
 1. Photography of birds. I. Title.
TR729.B5G76 1998
778.9′328—DC21 97-39472
 CIP

Photographs © by Vernon Eugene Grove, Jr.

Dedication

For my father, the sportsman,

who showed me that wildlife

can be appreciated without a gun,

who lowered his rifle to simply watch

the magnificent bull elk

because it was

"too beautiful to shoot."

Contents

INTRODUCTION . 1

EQUIPMENT . 27

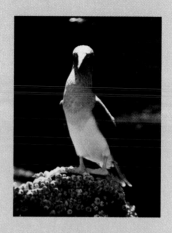

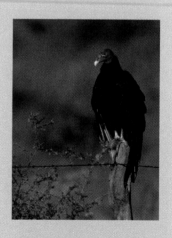

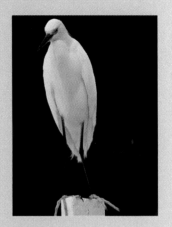
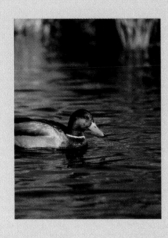
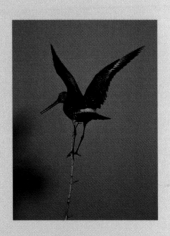

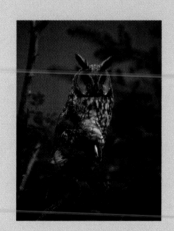

Acknowledgments

With special appreciation to those who opened my eyes to the world of birds: my mother, who has encouraged and directed my attention to the beauty of nature, from mountains to sunsets. To countless courteous ladies and gentlemen, many unnamed but remembered, who were willing to show and share their birds in off-the-beaten pathways of the world. And especially to Ed Kutac, outstanding naturalist of Texas, to whom no Texas bird or plant is a stranger, whose knowledge is exceeded only by his ability to teach and share. And, best of all, to my wife Barbara, the gentle, pretty lady who can tame wild beasts, who coaxed softly the trumpeter swan. She typed, organized, and encouraged this book. Her eye for composition is remarkable, and some of her photographs enhance this book. I hope to share the wonders of nature with her always.

Foreword

I first met Gene Grove in July 1980 in Austin, Texas, when he enrolled in a bird identification class I was teaching. Usually, a number of people from such association remain a part of your life in various ways, a few become birding companions, and a handful become very good friends. Gene Grove fits the latter category.

Of course, nearly all laymen who become interested in birds play the bird game in different ways. Gene's way was through serious bird photography. This turned out to be of good fortune to me because for years he supplied me with some of his "extra" slides, which I still use in my classes and when giving programs. I am most grateful to him for this. He once told me jokingly there were other pursuits I could have started him on that were less expensive.

For many years I participated in BIRDATHON, a fund-raising event for Travis Audubon Society (and others), and for at least seven of those years Gene helped me in this endeavor. He furnished his vehicle, did the driving, and helped find birds. Barbara, his wife, also supplied a chest full of sandwiches and drinks even though I and others along always brought our own food. When trying to find all the birds in a given area in one day, time cannot be spent in a restaurant. We would meet before dawn, usually in late April or early May, bird all day until after sunset, when we would try for owls and nightjars. His contribution helped make possible whatever success was achieved. We continued this association until he moved from Austin to pursue other opportunities in his medical practice. It was a lot of fun doing BIRDATHON together while raising money for a good cause.

The Joy of Bird Photography has all the information needed for anyone interested in photographing birds, from cameras, film, composition, and filters to merchandising photographs and presenting programs. Also included are references for further reading, organizations that use bird photographs, and so forth.

For non-photographers the book offers a wealth of marvelous bird pictures taken from all over the continent, which alone is well worth having on one's coffee table or wherever. As will be apparent, Gene takes great scenery shots as well as being a superlative bird photographer.

Edward A. Kutac
Amarillo, Texas

Black-legged kittiwake nest, bird islands near
Homer, AK. 300mm f2.8 lens, Fujichrome 100
film, 1/2000 of a second. The modified
monopod attachment tucked into belt was
used from a boat.

Introduction

The Joy of Bird Photography shares with you the tricks of the trade—methods the pros use to take photographs of birds that seem to fly from book and magazine covers. This book will show you surprisingly easy techniques using camera equipment you may already own; ways you can custom design your equipment; and how composition, exposure, lighting, and arranging your vantage point can work for you as a participating observer in the delightful and fascinating world of birds. This book will also explain how you can turn a good photographic opportunity into a spectacular experience, as well as how to show and share your bird photographs.

"First do no harm," a principle in medicine, guides this book, in which the lovely, challenging lords of the air will be neither harmed nor bothered by the use of the techniques discussed in this book. Rather, you will see how to use the observation skills of an artist, the lore of a naturalist, and the stealthy vigilance of a hunter to "shoot" a bird so that you and others can enjoy the thrill of the chase, yet know that your trophy is still out there somewhere, flying free.

Your goal should be to photograph birds so they never know that they are going home in your camera. Disturbing a bird that is nesting can cause desertion and death of the eggs and/or nestlings. Do not remove foliage that protects a nest

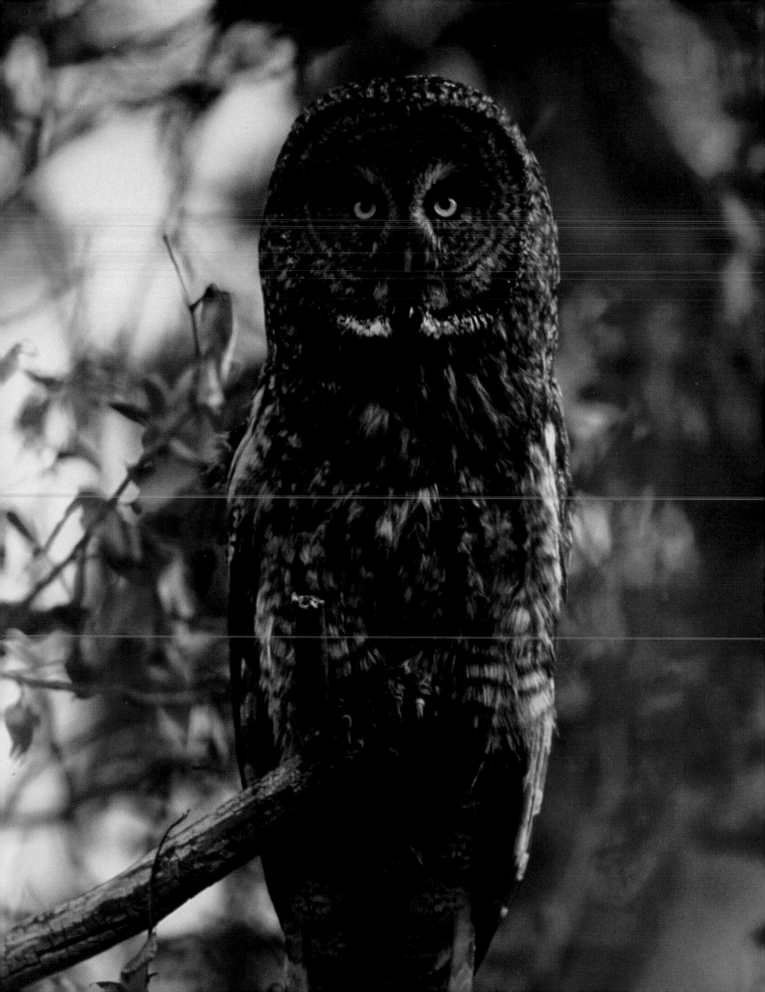

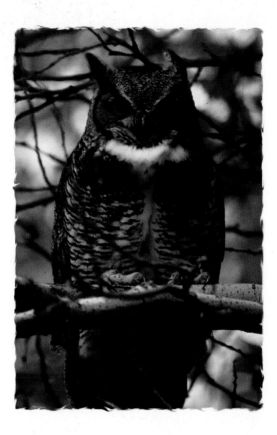

GREAT HORNED OWL HOOTING, PUFFING OUT THROAT. THESE DEEP HOOTS ON A STILL NIGHT SEEM TO FLOAT OUT OF A LONELY PLACE FROM SOMEWHERE BEYOND THE SHADOWS. IT IS EASY TO IMITATE THEIR CALL, BUT DO SO CAUTIOUSLY, AS THESE POWERFUL BIRDS HAVE ATTACKED PHOTOGRAPHERS.

from the sun or predators. If a branch obstructs a view, tie it back briefly and then replace it. Hawks, eagles, and owls can be vicious and have been known to attack and blind photographers when they felt their nesting was threatened. Do not get too close to a bird, and watch for signs that the bird is harassed in terms of behavioral change or the "broken-wing display." If there is any question, pass up the shot. Use telephoto lenses and blinds so that birds will not be aware that you have photographed them. We will all get more and better bird photographs if we are unnoticed and inconspicuous. This and more forms the essence of *The Joy of Bird Photography.*

◁

GREAT GRAY OWL POSES FOR A LATE AFTERNOON PORTRAIT, GRAND TETON NATIONAL PARK, WY. THIS ELUSIVE "GHOST OF THE NORTH WOODS" ALLOWS REMARKABLY CLOSE APPROACHES. KODACHROME 64 FILM, TRIPOD, NIKON 600MM F4 LENS.

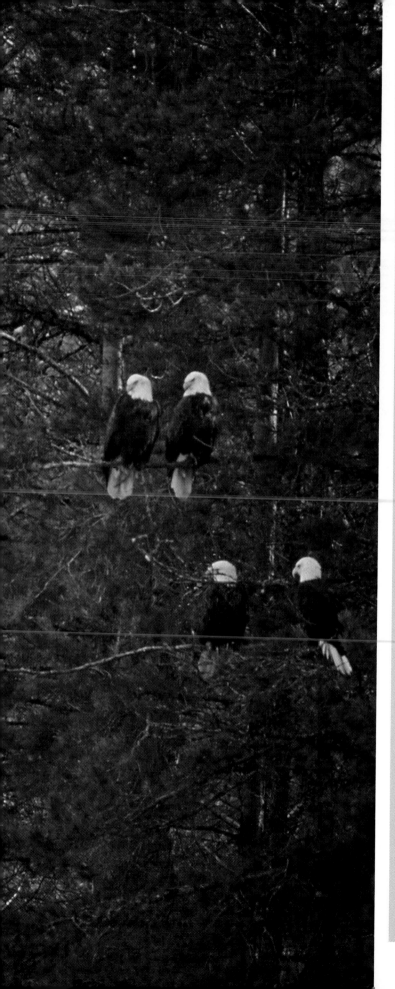

Why Photograph Birds?

A photograph lets us share birds' remarkable world, such as the Arctic Tern's incredible migratory journey between the poles of the earth; and to participate, by observing, as they reveal skills that we can only envy.

We photograph birds perhaps to share their power. Or to sense the elemental hunting instincts we may still share—the near impossible challenge of photographing the blazing flight of the world's fleetest predators. In a screaming stoop toward their prey, some falcons zoom beyond the cruising speed of many small aircraft. Their sensory abilities challenge us to photograph them in action. Only through our binoculars can we equal the telescopic vision of many birds of prey, and perhaps most of our raptor photographs are taken with their knowledge and forbearance. They certainly hear us coming: the great gray owl ("Ghost of the North Woods") can soar silently to the sound of a scurrying vole, deep under distant snow.

The feathers of eagles and tropical birds have crowned noble heads since ancient times, and some species were almost lost forever so humans could wear their lovely plumage. We thrill to the challenge of photographing the wild turkey with its colorful display, and we marvel at the breeding plumage of many tropical birds, costumed to stagger the imagination of human designers.

There is a joy in recording delightful courtship displays such as the frenetic dancing of the whooping and sandhill cranes, and the marvelous drumming of the grouse. We smile at the least tern's anticipation as he offers his beloved the prize—a tiny minnow.

We try to catch a moment with the camera.

A photograph cannot capture a song, but it can freeze forever the moment of singing, and be ours to share with others.

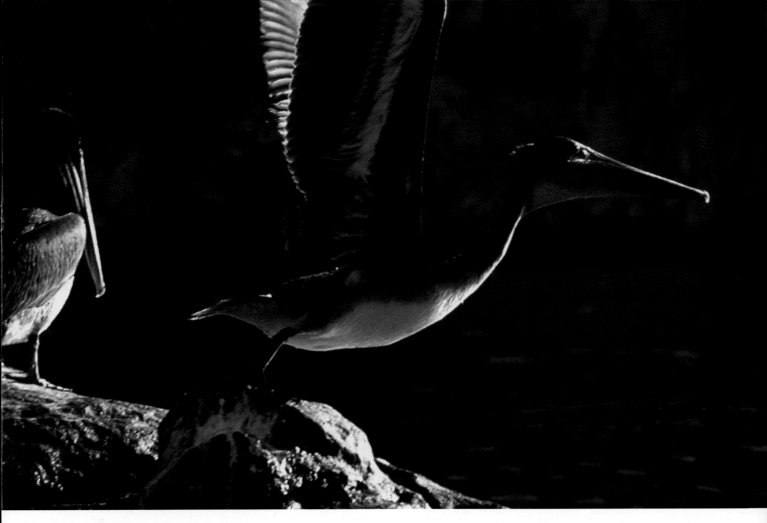

Brown pelican, Baja, Mexico. Our
grandchildren think this bird
may be stuck to the rocks!
Kodachrome 64 film, 300mm f2.8
lens, 1/1000 second.

◁

"Eagle Spectacular," fall, Glacier
National Park, MT. Hundreds of
eagles once gathered to feast at
a salmon-choked stream. Sadly, the
salmon spawning run has decreased
in recent years, so there are
fewer eagles. Kodachrome 64 film,
600mm lens.

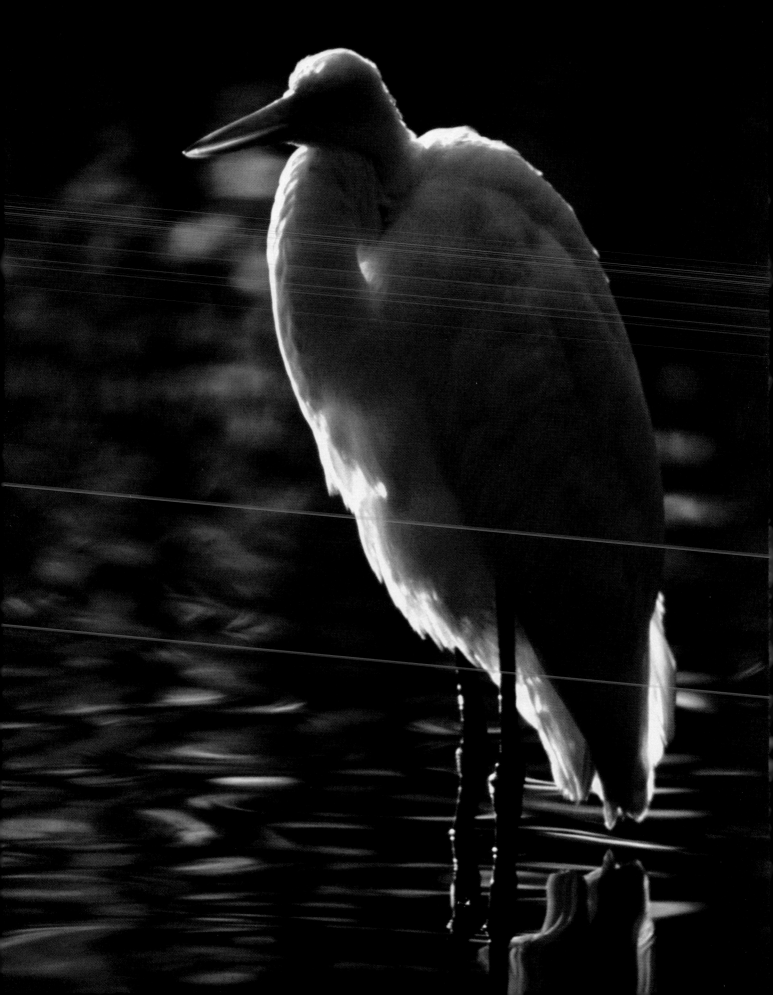

ATTRACTING AND FINDING BIRDS

For some serious birders, finding and attracting birds is their reason for being, and brings unbelievable satisfaction to the bird photographer. This section includes fun and easy ways to get birds to come to your camera by supplying feed, water, shelter, or by simply going to beautiful "birdy" places. Captions accompany most photographs presented in this book, which include where I was when I took the photo. You will notice that the areas range from wildlife reserves and zoos, to roadside shots, parks, coastal areas, my own backyard, and even municipal wastewater ponds. Birds usually live in beautiful, scenic surroundings, with the possible exception of the Tamaulipas crow, which resides at the famous Brownsville, Texas, dump. Beautiful bird photographs can, of course, be taken anywhere. The following locations are but a few of the many wonderful spots to photograph birds. Wherever you go, take your camera along, and you may be rewarded with photographs of beautiful birds in their natural habitats.

Alaska

You can view and photograph bald eagles in Haines where these beautiful birds gather from October through February. The best opportunity is said to be around mid-November.

◁

EGRET REFLECTED IN WATER, EVERGLADES NATIONAL PARK, FL. A LIGHT BREEZE CAUSED RIPPLES AND ADDED A SENSE OF MOVEMENT AND INTEREST TO THE PHOTO. NOTICE HOW THE SUNLIGHT BEHIND THE BIRD CAUSED THE TRANS-ILLUMINATED BILL AND THE FEATHERS TO GLOW IN THE RIM-LIGHTING. ADD A STOP OR TWO OF LIGHT TO BRING OUT DETAIL IN THE FOREGROUND.

Arizona

The state's flowers are spectacular in March and April, and they provide beautiful backgrounds for native bird specialties. In the spring and summer, southeast Arizona is outstanding for flowers and bird observation and photography, and many tours specialize in this area at that time. The Ramsey Canyon area is legendary for spring and summer swarms of hummingbirds and is an enjoyable place to both see and photograph these beautifully feathered jewels.

Florida

Bird photography in the Everglades starts to peak in late fall and continues through early spring (November–March). You may find some birds in their spectacular plumage during late February and March. Ding Darling Wildlife Sanctuary provides a photo drive where you can see many of the state's bird specialties in their breeding plumage (winter–early spring).

Nebraska

In early March through April, the gathering of sandhill cranes in the Platte River is a world-famous photographic event. A half-million cranes flock to this area, where the Platte River is "an inch deep and a mile wide."

Texas

In the spring, the Gulf Coast offers an incredible display of migrating birds that drop out of thundershowers when driving rainstorms force down northbound birds, exhausted and starving, after many hours of nonstop flying over the Gulf of Mexico. High Island, Texas, a small community just north

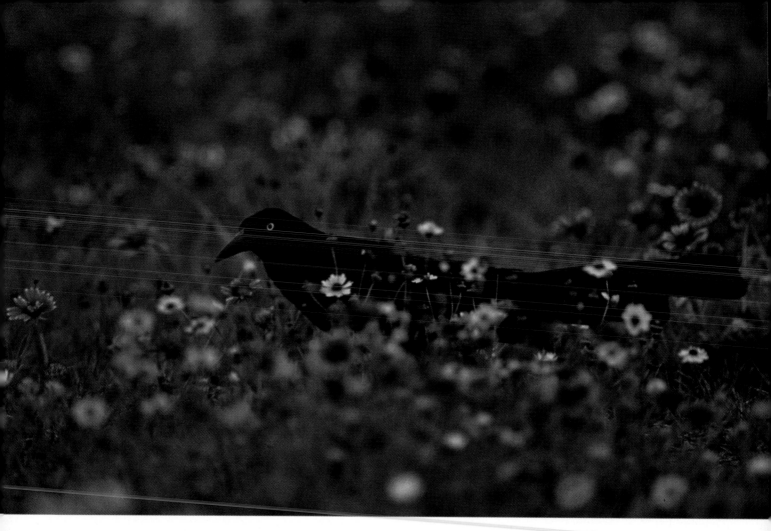

GRACKLE SURROUNDED BY SPRING FLOWERS, TEXAS COAST NEAR ROCKPORT/FULTON.

of Galveston, is the first landfall for these weary travelers after crossing the Gulf. This town is a few miles up the beach from Bolivar Flats, which is famous for shorebirds. The birds collapse into trees on this slightly elevated stretch of land and literally allow handshaking distance approaches by eager birders, who are also soaked by the downpour. While photographing the birds, don't forget to include the spellbound, happily soggy human spectators.

Rookery Island tours (April 1–July 1) allow you to take incredible close-up photos of nesting shorebirds. Special tours (November 1–April 1) in the Aransas/Rockport/Fulton communities guarantee looks at the rare and beautiful whooping crane; and Rockport hosts a hummingbird festival each fall, with exhibits, lectures, and tours, offering many opportunities to photograph hummingbirds.

CLOTHESPIN-OVER-YOUR-NOSE PHOTOGRAPHY—THE UNEXPECTED BONANZA OF SEWAGE TREATMENT PONDS. BIRDS AND BIRDERS FLOCK TO THIS NUTRIENT-RICH HABITAT. ALMOST EVERY TOWN HAS ONE, AND USUALLY THERE ARE DRIVING TRAILS AROUND POND PERIMETERS SO THAT YOU CAN USE YOUR AUTO AS A PHOTO BLIND. HERE THE CHALLENGE IS TO FIND GOOD LIGHTING TO CAPTURE A BIRD'S REFLECTION AND AN UPWIND VANTAGE-POINT. 600MM F4 LENS.

Municipal Wastewater Ponds

Your local wastewater treatment pond can be a birding bonanza. These ponds make up one of bird photography's best-kept secrets. This nutrient-rich habitat supports the growth of insects, plants, and other food for all sorts of birds. You can expect to find in abundance shorebirds and migratory pond-dwellers, as they are attracted to small organisms on which many birds feed.

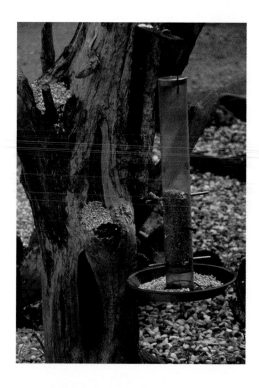

◁

BACK VIEW OF CYPRESS STUMP SHOWS
BACKYARD FEEDING SETUPS. GRAIN, SUET,
AND OTHER GOODIES CAN BE PLACED IN THE
NOOKS AND CRANNIES OUT OF SIGHT OF THE
CAMERA, BUT EASILY LOCATED BY THE BIRDS.

A BEMUSED HOUSE FINCH CONTEMPLATES
FEEDING FROM THIS BACKYARD SETUP,
WHICH I DESIGNED FOR PHOTOGRAPHIC USE.
THE TELEPHOTO LENS ALLOWS CLOSE-UP
PORTRAITS AS THE BIRD PERCHES ON THE
RAILING. NOTICE THE USE OF CONFIDENCE
DECOYS (ARTIFICIAL BIRDS), WHICH ARE
AVAILABLE AT RETAIL STORES.

Backyard Setups

It is wonderful having your yard as a haven for birds, even when you are not photographing them. A backyard feeder and bird bath are excellent places to start photographing birds. It is easy to start attracting all sorts of friendly and fearless birds once they realize that they have a place near shelter where they can eat and drink in safety, away from predators, where they are not disturbed. In addition to food, water, and shelter, certain plants will attract birds almost year-round.

Use an assortment of feeders, including hummingbird feeders, homemade platform feeders, feeders that dispense suet, or feeding logs or "snags" (a dead tree or stump). Drill or chisel holes in the feeding platforms that will contain the seeds (suet, sunflower, thistle) and hide them behind photo props of sticks or natural-appearing limbs.

Place water, feed, and props in an "edge," which is an area where two habitats come together, such as the area joining the yard and a hedge. This area should give birds access to hiding places, so they can venture out just a short distance for food and water and feel relatively safe and secure. It helps to have dripping water in the area. Hang a bucket of water over a pan to catch the drip with a small hole releasing a drop at a time. Birds will hear the water splashing and be attracted to this area. In addition to a source of dripping water, a more elaborate waterfall setup, perhaps connected to a re-circulating pump or water-supply source, or a mister arrangement, which sprays out a very fine mist and is available in hardware garden stores, can attract various birds.

Put out bait in a scenic area, such as around cacti, flowers, or places where there will be a pretty foreground or background. Use artificial and natural memorabilia or objects associated with certain vintages and habitats. For instance, a steer skull placed in a cactus garden with concealed birdseed can make an interesting and attention-getting photo. Plant an assortment of flowering plants that produce seed and nectar year-round. When putting out the feed or seed, place in areas where birds can find it and have places to perch, but make sure that the food and the perches are concealed and will not be visible in the photograph.

Hide a hummingbird nectar feeder for sugar water inside the petals of real or artificial flowers. You might also use a hummingbird decoy to attract these little birds. You can purchase or make your own hummingbird decoys out of various handcrafted materials. Hang the decoys near a feeder. Such a setup can look very real and allow for beautiful portraits of these flying gems. Use artificial birds with special identifying field marks painted on them to represent

BIRD FEEDERS ALSO ATTRACT SQUIRRELS, WHICH ARE LOTS OF FUN TO WATCH AND PHOTOGRAPH. 600MM F4 LENS.

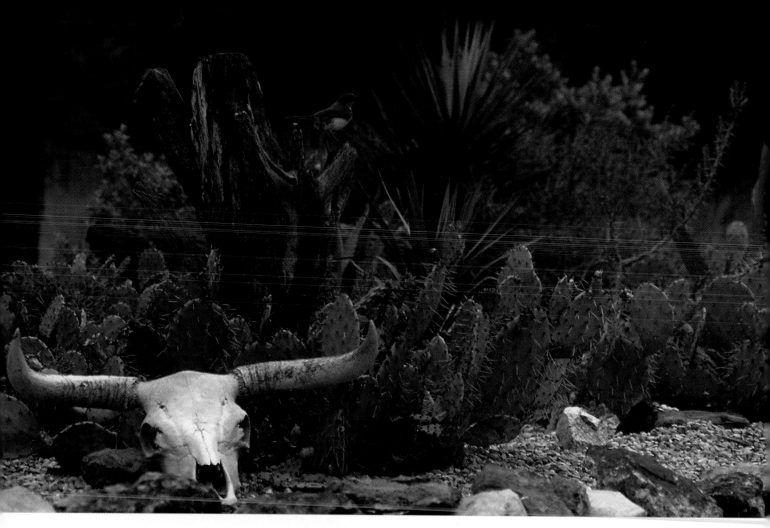

SCRUB JAY PERCHES ON A CYPRESS STUMP IN A SPECIALLY DESIGNED PHOTOGENIC CACTUS GARDEN. I FOUND THE STUMP WASHED UP IN A LAKE. THE STEER SKULL IS A PROP, OF COURSE, AND THE CACTUS GARDEN AND ROCKS CONCEAL A NUMBER OF FEEDERS. A SOURCE OF DRIPPING WATER IS NEARBY.

the bird being attracted. This may bring about some very interesting territorial display behavior, which is interesting to photograph.

You can also use a painted background with colors of your choice on a piece of cardboard placed several feet behind the photographic setup. When a large aperture is used on a telephoto lens, you can take advantage of the shallow depth of field so that the colors seen behind the background become very diffuse and have a very pretty effect. These backgrounds—lighted artificially with colored lights on extension cords—are limited only by your imagination.

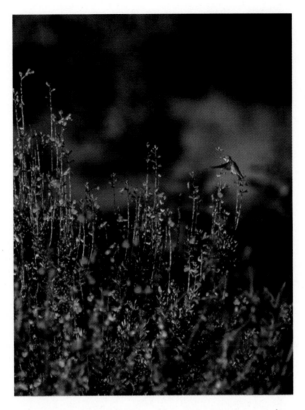

Hummingbird in sunlit field of scarlet sage, home photo garden. Composed using "Rule of Thirds," Fujichrome 100 film, as metered, 300mm f2.8 lens.

▷ ▷

Horned screamer, San Antonio Zoo, Texas. This South American bird posed for a portrait. Note the sharp focus on eyeball. Fujichrome 100 film exposed as metered, tripod, 300mm f2.8 lens and extension tube, which allow close focus.

▷ ▷ ▷

Snowy owl, Calgary Zoo, Calgary Canada. I focused out the interfering bars by using a long 300mm telephoto lens at f4, wide-open aperture. The distracting foreground and background were blurred by the shallow depth of field.

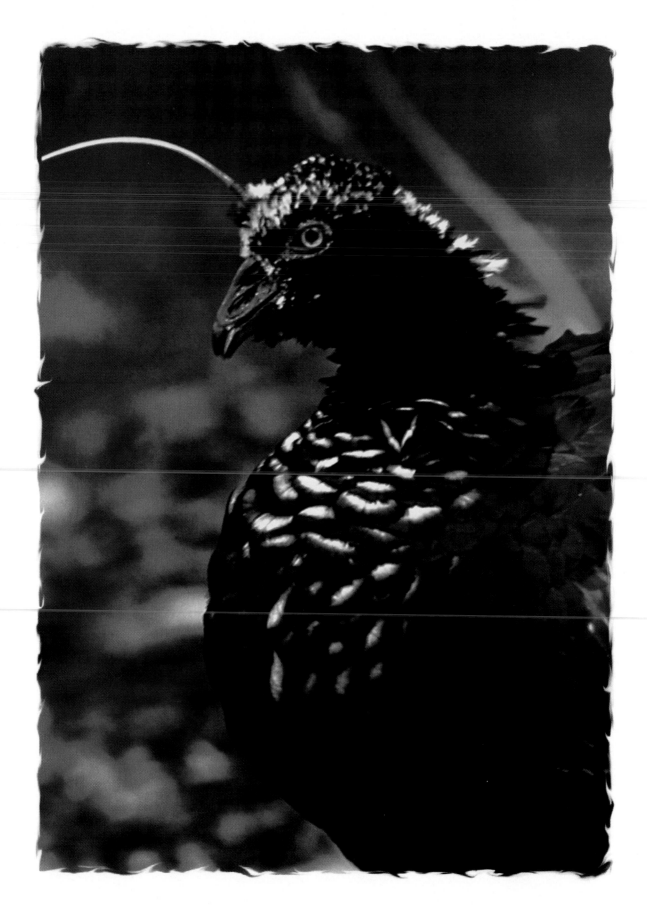

THE JOY OF BIRD PHOTOGRAPHY

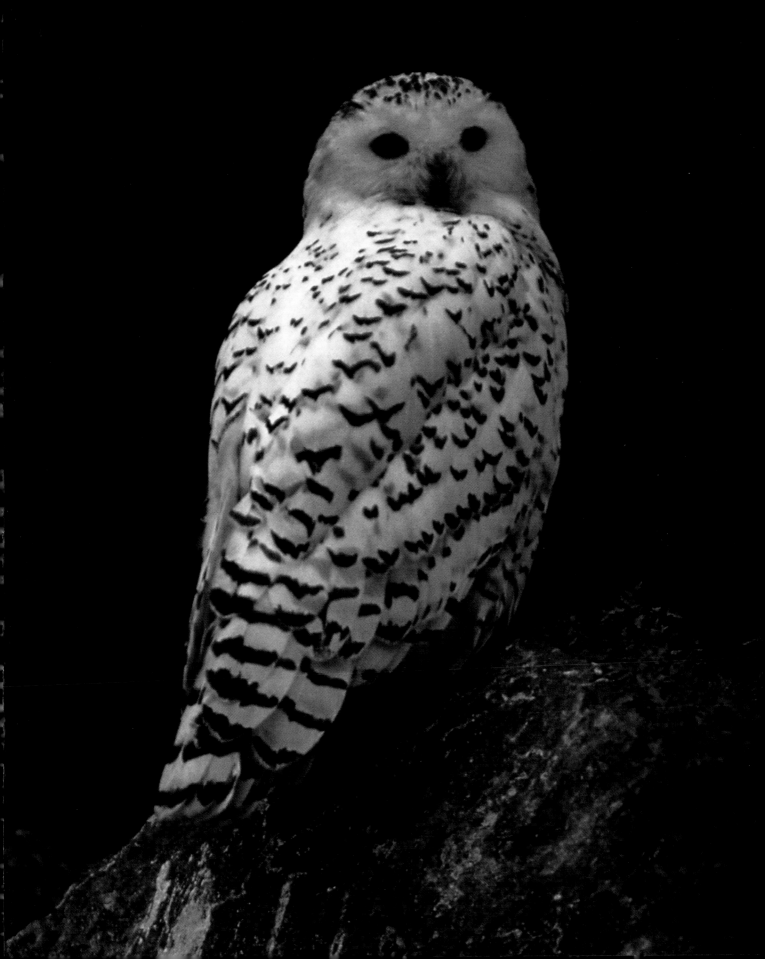

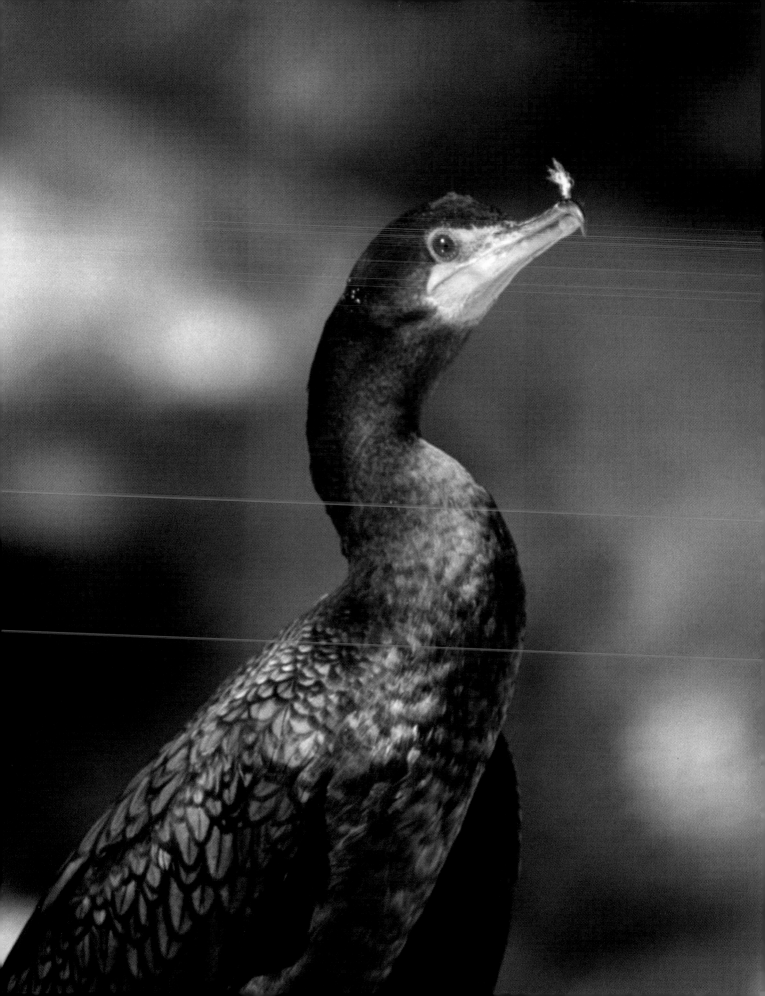

Controlled Locations

You may also photograph birds in controlled situations—zoos, wildlife model workshops, local falconers, and wildlife rescue organizations. There are several "rent-a-bird" services where birds have been accustomed to photographers and their behavior can be controlled and even predicted. Falconers may allow their raptors to be used for photographic purposes. Local wildlife rescue facilities may be good sources for injured, and thereby flightless birds. Although photographs taken under controlled conditions such as at zoos or wildlife parks, are certainly legitimate for publications, you should inform the editor of the circumstances. It is neither ethical nor honest to misrepresent a captive bird as a wild one.

It is best to get to the zoo when traffic will be light—early in the day when the zoo opens. Visit your local zoo at different times of the day and different days of the week looking for periods of low visitor concentration and times of best lighting situations. There may be excellent lighting at some particular time of the day in a particular cage area. As in photographing any bird, try to maneuver your photographic viewpoint to look for an appealing background situation. Look for times of increased or decreased bird activity, including feeding times.

If you want to photograph birds that are behind glass, first make certain that the aviary curators are comfortable with flash photography, and that the flash will not disturb the subjects. Use a flash unit with a remote cord. Place the flash unit and the lens (preferably with a soft rubber lens hood) against the glass to eliminate reflections. A polarizer might be useful for glass reflections, if taken from a distance. Focus through the bars with a telephoto lens at the widest aperture, perhaps using an extension tube to allow close-up focusing with slight subject enlargement. Just the bird will be in focus, and the bars or wires of the cage may be rendered invisible by this technique.

Use a beanbag or tripod to stabilize the camera/lens setup, or a shoulder or monopod setup. When using a tripod be careful not to get in the way of the other zoo guests. When using a flash, remember that automatic flash may not accurately register a small bird. Use the flash unit's instruction manual, perhaps with a dedicated flash setup, which interfaces with the camera for good fill-in flash exposures. Manual calculation of exposure using the guide number may work better. Fill-in flash supplements natural lighting, at perhaps one-half of the setting for daylight exposure, to fill in shadows and illuminate hidden details.

Rent a stroller to haul camera bags, tripods, and heavy lenses, or make your own rolling carrying device. Always take more film than you think you will need. It is nice to have a small zoom lens plus a large long-focus lens with teleconverters and perhaps even a spot meter. Spot meters are especially useful for the uneven illumination often found in zoos.

◁

DOUBLE-CRESTED CORMORANT PAYS CLOSE ATTENTION TO FEATHER ON NOSE. IT LOOKS AS THOUGH HE IS BALANCING THIS FEATHER OUT OF BOREDOM. THIS INJURED BIRD IS BEING REHABILITATED, TEXAS ZOO, VICTORIA, TX. 600MM F4 LENS AND AN EXTENSION TUBE ALLOW CLOSE-UP PORTRAIT.

△

TENDER MOMENT BETWEEN TWO GALAPAGOS PENGUINS, GALAPAGOS ISLANDS. THE COLD HUMBOLDT CURRENT CHILLS THE WATER FOR THIS SMALL PENGUIN COLONY.

▷

ELF OWL PEERS FROM HOLE IN TREE, BIG BEND NATIONAL PARK, TEXAS. TRIPOD, 600MM F4 LENS WITH 1.4X TELECONVERTER.

▷ ▷

CAPTIVE, RARE ALBINO BARRED OWL, "ANIMAL RESCUE," AUSTIN, TX. "ALBIE" POSES IN FRONT OF A DARK BACKGROUND. EXPOSED BY TWO STOPS LESS THAN CAMERA'S METER SETTING, 300MM F2.8 LENS.

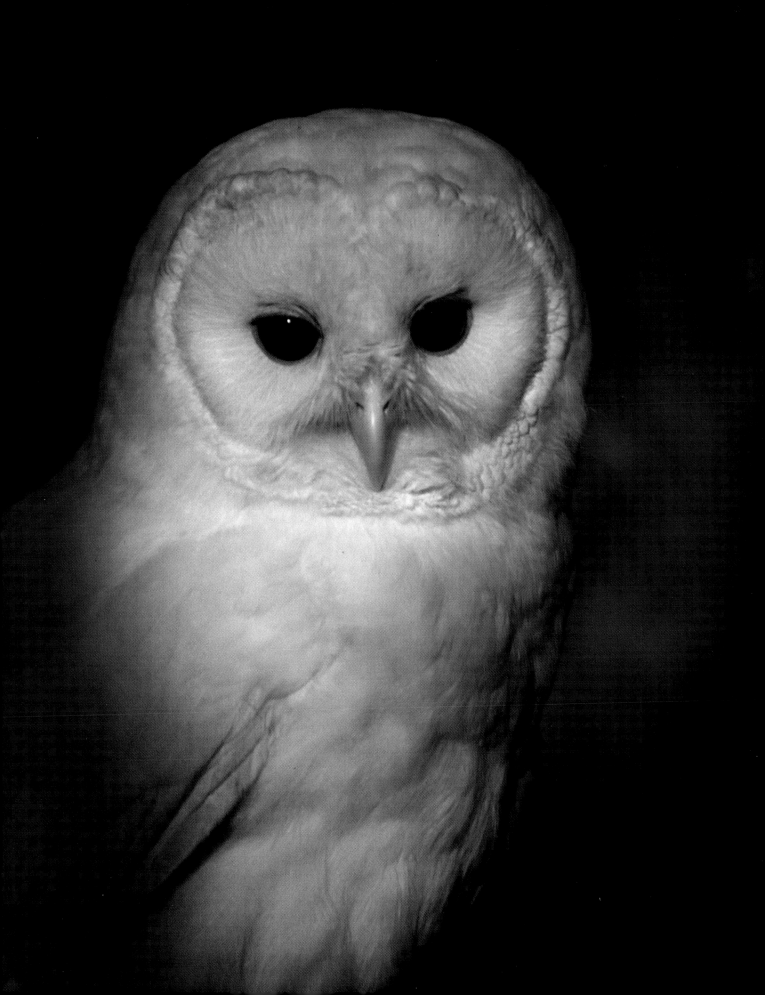

There are zoos with walk-in hummingbird aviaries, such as the Sonoran Desert Museum in Tucson, Arizona, and the San Diego Zoo in California. Some not-to-be-missed zoos that offer photographic opportunities include the following.

Calgary Zoo, Calgary, Canada. A wonderful zoo with a wide variety of exotic birds, especially large raptors. Gyrfalcons, snowy owls, long-eared owls, and many others are here, but often in cages. Here the focus-through technique, previously described, works well.

Monterey Aquarium, Monterey, CA. This world-famous attraction has a walk-in, simulated beach and tidal flat area with beautiful shorebirds and waterfowl. Close-up photographs without obstructions are easily taken here. If a bird is banded, as is often the case in zoos, photograph the bird when the band is concealed, or take a close-up of the bird excluding the distraction. Some wading birds may rest on one leg, and about half of the time, these birds will tuck the banded leg under their body.

San Antonio Zoo, San Antonio, TX. This zoo has a walk-in Australian bird enclosure. A small zoom lens with fill-in flash works well here. Beautiful parrots perch and fly within inches of the photographer. You can photograph African crowned cranes, with their gold-wire topknots burning like fire in the sunlight, without interfering cages. South American horned screamers with their large horny-appearing spikes atop their heads are another must.

San Diego Zoo, San Diego, CA. This elegant setting in one of the world's loveliest parks has many caged birds, including mighty eagles. Their star attraction is their world-famous walk-in hummingbird house.

Sonoran Desert Museum, Tucson, AZ. This is the gold standard by which all others are to be compared, in my opinion. Placed in a lovely setting surrounded by saguaro cacti, this magic place has walk-in cages allowing natural-appearing, close-up images.

The Gladys Porter Zoo, Brownsville, TX. This is a small, but elegantly designed treasure in deep South Texas. The zoo allows unrestricted photographs of various exotic cranes and other birds.

The Miami Zoo, Miami, FL. Said to be a photographer's paradise with tropical birds and flowers in abundance.

Check around and perhaps a zoo near you offers surprising bird photograph opportunities.

Other Areas

Field birds, such as scissortail flycatchers, kingbirds, meadowlarks, dickcissels, horned larks, and plovers, can be photographed from your car on the highway or in rural areas. They are frequently seen on fence posts or by flowers. Watch their behavior and try to catch them near wildflowers, with insects in their mouths, and/or feeding their young. As you watch their behavior, try not to stare at a bird with direct full-face/eye contact, or let your body language show that you are giving constant attention to a bird: This is the behavior of a predator just before an attack. Try to look elsewhere, watching the bird out of the corner of your eye, until the bird is accustomed to your presence. This would be true even for certain owls, such as the great gray owl and others, which allow a surprisingly close approach.

▷

KINGBIRD IN DAVIS MOUNTAINS OF WEST TEXAS. AUTO POSITIONED TO PLACE OUT-OF-FOCUS BACKGROUND COLORS BEHIND BIRD BY ROADSIDE. 600MM F4 LENS ON BEANBAG.

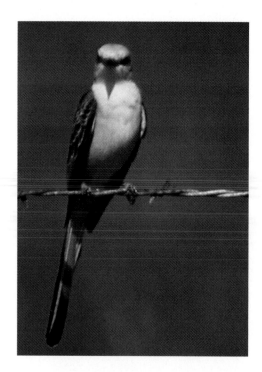

Scissortail flycatcher near Victoria, TX. 600mm lens with 1.4 teleconverter, beanbag stabilization.

"Ghost of the North Woods"—will allow remarkably close approaches. The book by Nero, *The Great Gray Owl,* describes where to find these owls and certain behavioral aspects that will help you photograph them.

Elf owls often live in holes in trees and cacti, such as the giant saguaro of Arizona. Owls occupying holes in a tree or cactus will sometimes stick their heads out of the hole if you scratch or lightly tap on the cactus or tree. This should not be done excessively, as it could cause the owl to desert the nest.

Warblers seem to be fragments of rainbows, flitting bright gems of almost constant motion. A good book to consult is Dr. Eliot Porter's *Birds of North America: A Personal Collection.* This book outlines very patient, time-consuming techniques, which lead to beautiful photographic results. Some of these flashy birds are so brilliant they appear to glow from inside.

Hummingbirds, lovely little jewels, seemingly dipped in the colors of the rainbow, are easy to photograph. Leaves and flowers attract these beautiful little characters, providing an excellent background for photographs.

Bird Calls

To call birds, it is helpful to learn how to pish! Making a sound resembling a "pish" attracts birds. Consider taking a birding course to learn bird calls—both the techniques and the cautions.

Crow and owl fight decoys and calls, which you can purchase from sporting goods stores, can be fascinating to use. Place decoys either on poles or around trees, and then play at a high volume a crow and owl fight

You can locate owls by listening for their call, or simply by calling them with the very careful use of tape recordings of their calls. Be very careful when calling owls. The owl may think that another owl is trying to take over its turf and may fly in, silent, unseen, talons flashing and extended, ready for a scrap. A photographer was blinded by a great horned owl in this exact circumstance.

You can find burrowing owls, which are active during the day, around prairie-dog towns. Long telephoto lenses are usually necessary for the occasional photo-shy burrowing owl. Use your car as a photo blind in these circumstances.

Some of the more exotic and seldom seen owls can be surprisingly tame and allow close approaches if the photographer moves slowly and does not make any sudden movements. The magnificent gray owl—the

Well camouflaged barred owl responds to a very brief call, Texas coast, riparian habitat. Auto photo blind, Kodachrome 64 film, 600mm f4 lens. ▷

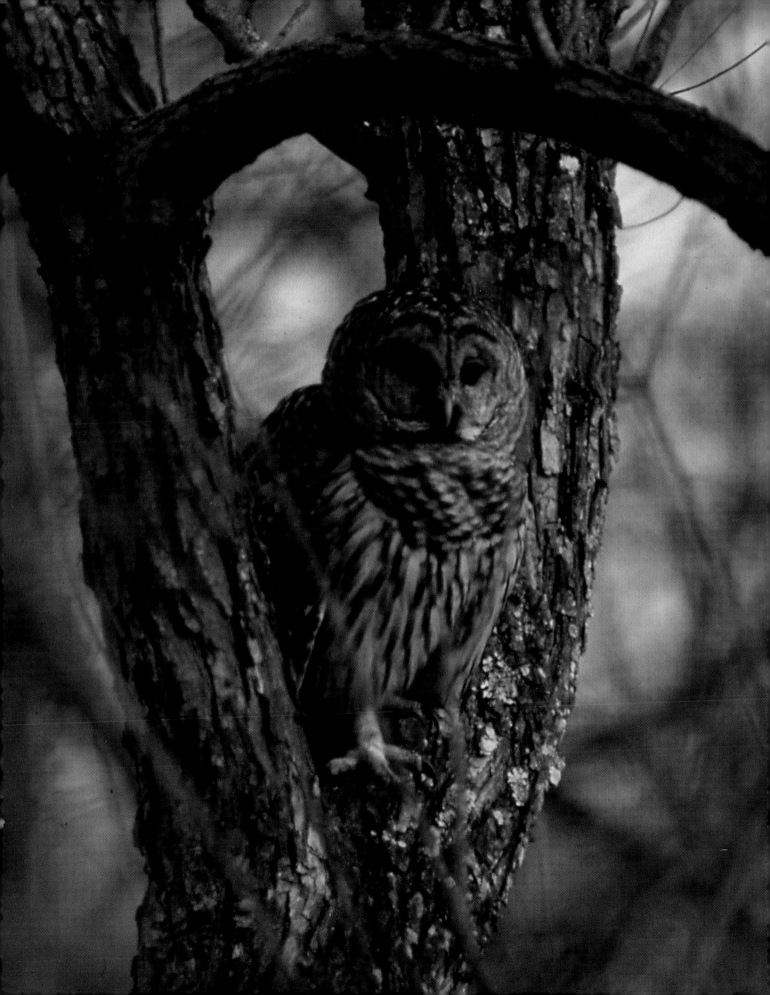

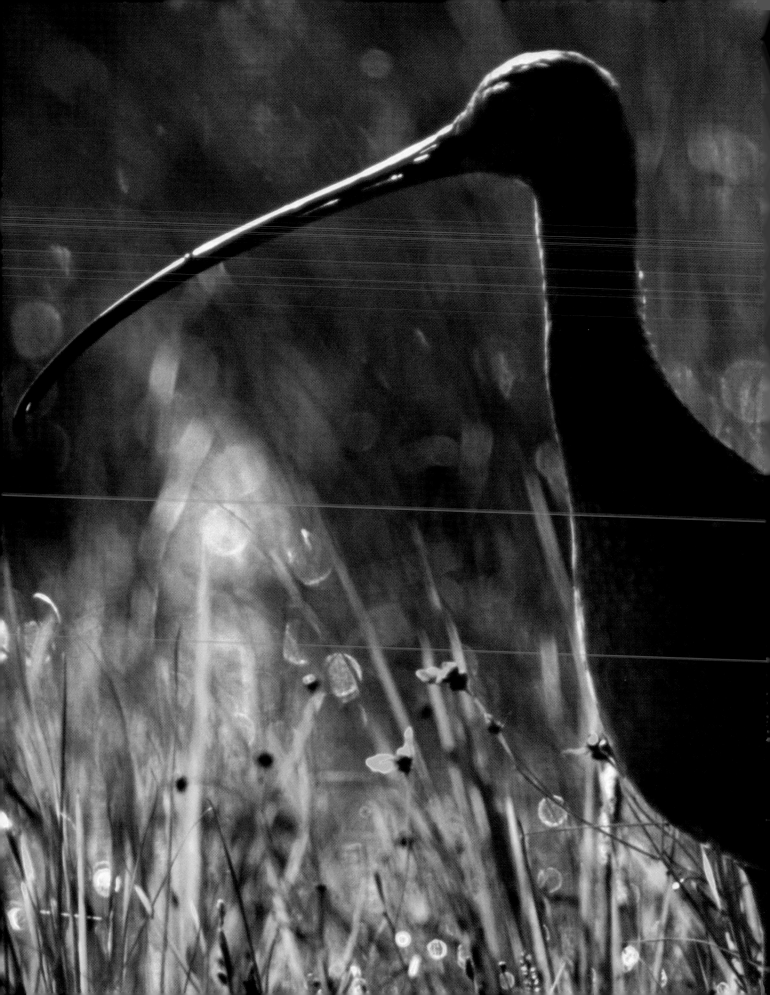

tape. I have seen the air fill with crows spoiling for a scrap with owls, and I once saw a great horned owl respond to the commotion and then get into an actual rumble with the crows. That was one wild and unforgettable melee.

When you call birds and use decoys, place a remote speaker near the decoys. This allows you to play and replay the tape-recording of the bird calls while being at a distance from the actual bird(s). You can sit on a blind or use camouflage netting draped over yourself while calling, making sure there is no silhouette to betray your presence. Sit quietly in the shadows and move slowly, if at all. Have cameras set up on a tripod before you start calling. Consider putting a "mouse" or "twitcher" near the speaker for birds to see when they respond to the call. You can make an artificial mouse or use an owl decoy and place nearby to attract the interest of the responding birds. You can use a nylon leader line and drape it over a limb, to allow you to twitch the object. Interesting photographs result from birds interacting with decoys.

Remember to use plenty of bait to attract birds. Position setups so the birds will fly and land exactly where you want them. You may want the light from the side, in front of, or even behind the birds, for interesting silhouettes or the beautiful "rim" lighting effect of a backlighted bird. Make sure the places where the birds will perch are about the same distance from your camera so you can pre-focus and have several feeding and perching sites that you can cover from one stop. This could be from a window of your home, a chair on your patio, or other convenient spot.

◁

LONG BILLED CURLEW SURROUNDED
BY FLOWERS, TEXAS COASTAL PLAINS. I
ADDED ONE-HALF STOP OF LIGHT TO
CAMERA'S METERING, AUTO BLIND,
BEANBAG STABILIZATION, BACKLIGHTED,
600MM LENS.

AUTHOR SURROUNDED BY "ROCK DOVES" (PIGEONS)
CALIFORNIA COAST, PHOTOGRAPHED BY
BARBARA P. GROVE. 50–300MM ZOOM LENS.

Equipment

Please do not feel that any possibly unfamiliar equipment or techniques are necessary for great bird photographs. No prior experience is needed, just interest and enthusiasm. The following sections include simplified tips and techniques that will help you use remarkably effective, yet simple equipment, even without a specialized photography background.

You can use any camera, lens, flash, and either slide film or print film to produce wonderful and exciting bird photographs. Most professional photographers have devised their own winning system, and most would agree that it is not what you have, but how you use it. Even point-and-shoot cameras (units with one lens and often with automatic focus and exposure capabilities) can have excellent optics, and take calendar-quality photographs. I prefer Nikon cameras, which interchange with a wide system of lenses. This section explains how to use simple manual focus lenses and cameras to take sharp photographs in all settings.

When photographing birds, you want to be as inconspicuous as possible. Therefore, select black camera bodies, along with photographic equipment that is dull in color.

THE CAMERA

The *35mm camera system,* which uses a film size of 35mm, is the most popular system in photography. The 35mm single lens reflex (SLR) camera system uses only one lens to focus and expose a photographic film, which is made possible by a mirror device that rapidly flips at the instant of exposure, allowing light to reach the film. You can attach a variety of lenses to this SLR system. This type of camera, along with ISO (International Standards Organization) 100 speed slide film, and a fairly wide-angle lens of 24mm to 35mm focal length, will be good beginning equipment for park and backyard bird photography.

An *auto-focus camera* includes a lens system that automatically focuses an image. These cameras are very effective, but expensive.

The new *advanced photo systems (APS),* which many of the major camera companies are beginning to produce, have a slightly smaller image size than 35mm format. This camera is ideal for bird photography as it is compact, has interchangeable lenses, and has numerous advantages in terms of cataloging and producing images.

Photo-electric imaging (digital) is a photographic system that does not use film, but relies on electronic technology to capture and process images. This is a rapidly growing technology and may make film as we know it a thing of the past, and in time, replace the use of conventional film cameras.

Camera Features

The following explains the different camera features that you should be familiar with before purchasing a camera or accessory. A glossary on page 185 will explain any terms that are unfamiliar to you.

A *motor winder (motor drive, power winder)* is an electro-mechanical device in some cameras that rapidly advances the film. Cameras with this feature have several drawbacks, including running out of film in seconds, just when the action is really getting going. In very cold climates, motor winders, or automatic power winders, can break cold and brittle film. They can also generate sparks, which may show up as light objects on the film.

Combination of aperture priority camera settings versus shutter priority settings automatically sets the exposure based on the aperture (lens opening, f-stop) or the shutter (part of a camera that moves very rapidly to open and close, allowing light to reach the film) speed. Photographers using telephoto lenses may want to use the aperture priority set to the widest opening, which usually has a shallow depth of field. This produces bird portraits by blurring objects on the near and far sides of the bird, and at the same time, has the fastest available shutter speed to stop motion.

▷

MOCKINGBIRD ON SPANISH DAGGER PLANT NEAR UVALDE, TX. VERTICAL FORMAT, FUJI PROVIA ISO 100 FILM, 600MM F4 LENS WITH 1.4X TELECONVERTER. NOTE CATCHLIGHT IN EYE.

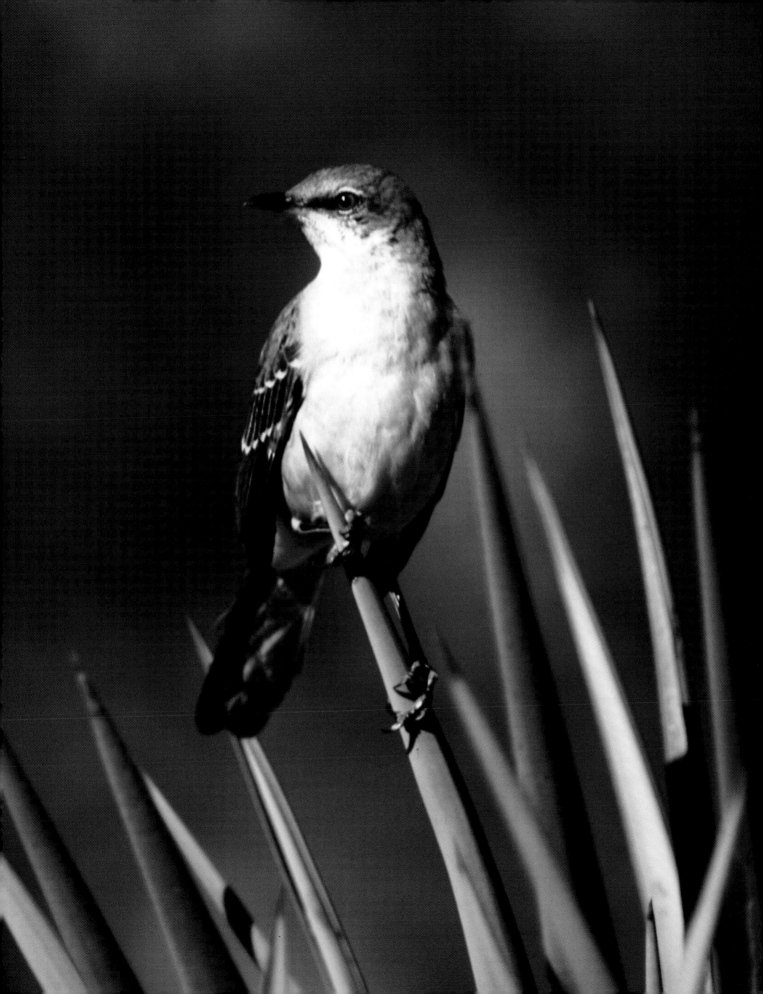

A *focusing screen* is the part of the camera that allows the photographer to visualize the image before taking the photograph. The screen includes a bright image in the camera viewfinder, which is necessary for sharp focusing, especially when using telephoto lenses in low light situations. The split-image focusing screen does not work well with telephoto lenses. Instead, consider a matte ground-glass screen, or other type recommended specifically for telephoto lenses. Also, magnifying attachments can help when using extreme telephoto lenses.

Accessory bright viewscreens, for cameras with interchangeable viewscreens, are impressive and allow sharper focus in dim light situations. These bright viewscreens may require an increase in the ISO setting on the camera to compensate for the brighter image, as the increased light can mislead the camera's light meter.

An *exposure compensation dial* is a device on many cameras that, if you choose to make a compensation for differing lighting situations, allows you to change the amount of light reaching the film by either increasing or decreasing the exposure. This dial lets you use your camera's built-in light meter to set the shutter speed and aperture for a neutral-toned subject.

A *depth-of-field preview control* allows you to pre-visualize the range of sharp focus of your subject and surrounding objects in the foreground and background by stopping down the lens to the pre-set f-stop. You may choose to have everything from near to far in sharp focus, thus using a very small lens aperture (f-stop), or have a narrow depth of field with only your subject in sharp focus (larger f-stop).

Aperture priority capability allows you to select an aperture (f-stop or lens opening) so that the camera's built-in light meter correctly adjusts for the proper shutter

speed for a correct exposure. I use this setting most of the time, and feel that it helps me balance the desired depth of field with the fastest available shutter speed.

THE LENS

A lens contains glass or clear plastic and fits on the front of the camera to gather and focus light onto the film. In much the same way as the iris—the colored portion of the eye—opens up wider to allow more light and closes to a tiny opening in sunlight, most lenses have an iris-type device called a diaphragm, which regulates the amount of light reaching the film. Lenses may produce large, wide-angle fields of view or may magnify the image of the subject as a telescope does. These are appropriately called telephoto lenses.

Award-winning photographs have been taken with all types of lenses. Some lenses and attachments discussed here include wide angle, "normal," telephoto, fixed-focus, zoom, and mirror lenses. Become familiar with the advantages and disadvantages of each type of lens, and choose the lens or combination of lenses that will work for you in given situations. Conventional wisdom suggests purchasing a lens and camera made by the same manufacturer with the lenses mated to a particular camera system.

Lenses seem to be getting better made, less expensive, lighter, and smaller. Keep in mind that a photograph taken with a well-stabilized, moderately priced lens can be just as impressive as one taken by the most expensive lens available, but blurred due to camera movement.

The 300mm f2.8 lens with extra-low dispersion (ED) glass is an excellent lens for basic bird photography. This light, fast lens can be handheld, and gives excellent results when used with a 1.4x teleconverter. A medium zoom lens ranging from 35mm to 200mm is

NIKON 600MM TELEPHOTO LENS. NOTE HOW THE CAMERA'S LENS HOOD IS EXTENDED, AS SUNLIGHT SHINING ON THE LENS CAN CAUSE FLARE. THE GLUED-ON FAUCET WASHERS SERVE AS "GUN SIGHTS" FOR AIMING PURPOSES. THESE "GUN SIGHTS" ARE DUPLICATED 90 DEGREES FROM EACH OTHER FOR CONVENIENT USE WHEN THE LENS IS ROTATED IN A VERTICAL OR HORIZONTAL POSITION.

also good basic equipment. My favorite lens is the Nikon 600mm extra-low dispersion, internal focus (ED-IF) f4 lens, which is a telephoto lens (causes a subject to seem closer than it really is) used alone if possible, but often with a 1.4x teleconverter. Although a drawback is its weight, because it is too heavy to handhold (with the camera, it weighs about 16 pounds), the large f-stop lenses allow a bright image for accurate focusing; permit photography in dim light with slow, fine-grained film; and allow faster shutter speeds for moving birds. A good telephoto lens can isolate and extract a picture within a picture.

A *"normal" lens* (50mm) has a lens focal length setting that resembles the perspective of the human eye. It is in a 35mm camera format. Lenses 35mm down to 16mm, or even shorter, cover the range from wide-angle to ultra-wide-angle lenses.

HOMEMADE DEVICE FOR USING A TELEPHOTO LENS AND A TELECONVERTER AS A SPOTTING SCOPE. I ATTACHED AN EYEPIECE TO AN UPRIGHT PRISM SETUP WITH A CORRECTING INTERNAL MINUS DIOPTER LENS TO ALLOW SHARP FOCUSING. I EPOXIED A CAMERA MOUNT FROM AN EXTENSION TUBE ONTO THE REMOVABLE VIEWING EYEPIECE ADAPTER. YOU CAN OBTAIN EYEPIECES AND APPROPRIATE PRISMS, WHICH WILL CONVERT THE IMAGE FOR UPRIGHT VIEWING AND APPROPRIATE RIGHT-TO-LEFT ORIENTATIONS, FROM ASTRONOMY SUPPLY STORES.

2000MM TELEPHOTO LENS ADAPTED FOR BIRD PHOTOGRAPHY—THE MAGNIFICATION IS 40X.

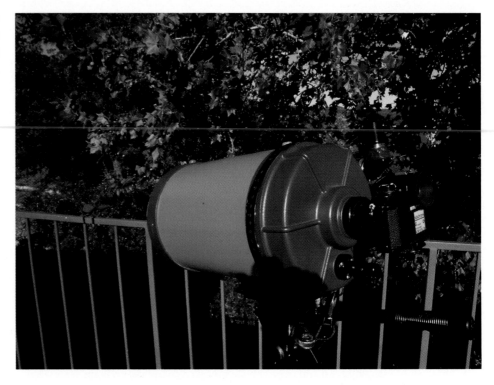

Ultra-wide-angle lenses (15mm–24mm) have two basic forms: rectilinear and fish-eye. Some manufacturers offer satisfactory, inexpensive lenses in this range. Either form can cause perspective distortion, which can be quite disconcerting. The fish-eye is a big, bulging lens, which has an enormous field of view and usually produces pronounced image distortion. It tends to view the subject in a circular manner that seldom lends itself to bird photography. The ultra-wide lenses of rectilinear type have an extremely wide angle of view and produce less distortion of straight lines than a fish-eye. Rectilinear ultra-wide angle lenses are usually fairly slow and can be quite expensive. Both the fish-eye and rectilinear lenses share a remarkably deep

YOU CAN MODIFY ANY TELESCOPE TO USE WITH A CAMERA. THIS 17½-IN. ACROSS, 2000MM F4 HOMEMADE TELESCOPE, MOUNTED ON ROLLERS, HAS A MAGNIFYING POWER OF 40X. LIGHTER AND SHORTER LENSES ARE MORE PRACTICAL, BUT THIS ILLUSTRATES HOW ALMOST ANY SORT OF SPOTTING SCOPE OR TELESCOPE CAN BE USED PHOTOGRAPHICALLY WITH A FEW SIMPLE MODIFICATIONS. HERE'S HOW TO FIGURE THE MAGNIFYING POWER OF A TELEPHOTO LENS WHEN USED WITH A 35MM CAMERA AND A "NORMAL" 50MM LENS:

• 100MM LENS DIVIDED BY 50 = 2 POWER MAGNIFICATION
• 600MM LENS DIVIDED BY 50 = 12 POWER MAGNIFICATION

depth of field, with everything from a few inches from the camera to infinity in sharp focus. These lenses are ideal when the sky is filled with large skeins of birds, stretching from horizon to horizon. The individual birds will be very small, yet the effect can be dramatic. A fun exercise is to get a wide-angle nose-to-lens portrait of a bird, perhaps an albatross or gannet, with wings outstretched and an interesting background. This ultra close-up portrait, taken with a wide-angle lens, can cause an amusing distortion of the bill and facial features.

A *fixed-focus lens* has only one focal length. Generally speaking, it is sharper than a zoom lens. Most fixed-focus lenses have larger apertures, which allow for a brighter focusing screen, faster shutter speed, and a more narrow depth of field (to isolate a subject). Use a 2x teleconverter with a fixed-focus or zoom lens.

Zoom lenses offer the convenience of multiple focal lengths ranging from wide-angle to telephoto, and all sorts of settings in between. These lenses are of far better quality these days than in the past. Zoom lenses are usually slower at higher powers, although some more expensive large lenses may have the capability of a fairly fast lens at all apertures. Many well-made zoom lenses are almost as sharp as the finest fixed-focus lenses, and offer greater versatility.

Telephoto lenses may produce large, wide-angle fields of view or may magnify the subject as a telescope does. Telephoto lenses from 300mm to 600mm and over are most useful, with fast, wide apertures, but they are also heavier and more costly. In general, for serious bird photography, the longest telephoto lens with the largest aperture, preferably with extra-low dispersion (ED) glass, will be most useful. The extra aperture will allow the use of slower, fine-grained film and faster shutter speeds, permitting photographs in dim light situations.

To take a close-up shot of a bird in the distance, you will need telephoto lenses from 400mm to 600mm, as the mid-range telephoto lenses up to around 200mm will be mainly used for photographing birds that are accustomed to the close approach of humans, such as in gardens and around feeders, or from photographic blinds. Remember that with a 35mm format, a 400mm lens will reach out to eight power. The higher power lenses come in handy when photographing distant birds where closer approach is impossible.

Mirror lenses are light, compact, have a fixed f-stop, and are moderate to long. This lens has a fixed focal length within which the path of light bounces back and forth between internal mirrors to produce a telephoto effect. These less expensive lenses are often fairly slow. They may show the characteristic effects of hot (bright) spots and produce doughnut-shaped reflections of bright objects in the picture. Mirror lenses usually do not perform well with teleconverters.

Teleconverters (tele-extenders, lens "multipliers") are small, light, and relatively inexpensive lenses that fit between the camera and lens to increase magnification, usually ranging from 40 to 300 percent. However, even brand name teleconverters may cause some decrease in sharpness. In addition, light loss may range from one to three stops. Some teleconverter lenses can be stacked, resulting in substantial light loss and decrease in sharpness, but still be useful to document a rare bird sighting or other once-in-a-lifetime birding event.

The 1.4x (1.4 power) teleconverter causes a 40 percent increase in magnification and only decreases light by

▷
Barn owl in late evening sunlight, roadside "grab shot," Texas Panhandle. 600mm f4 lens.

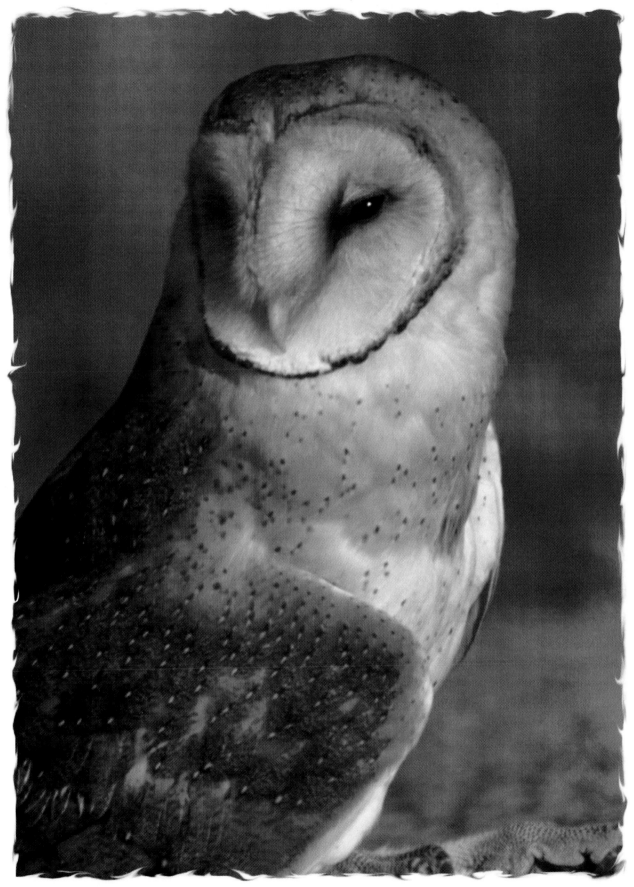

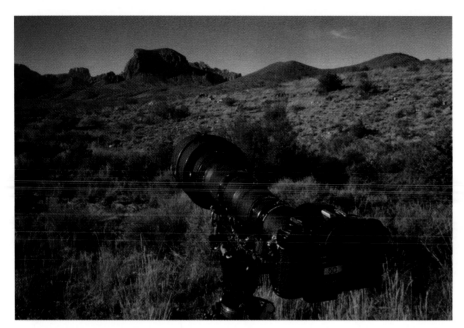

TELEPHOTO LENS SETUP WITH
600MM F4 LENS, LENS HOOD
EXTENDED, AND A 2X
TELECONVERTER. NOTICE
THE NYLON SAFETY CORDS
CONNECTING THE CAMERA
TO THE LENS AND THE LENS
TO THE TRIPOD, AS THESE
MECHANICAL ATTACHMENTS HAVE
BEEN KNOWN TO FAIL.
A LENS HOOD, YOUR HAND,
OR A HAT CAN PREVENT GLARE
FROM SUNLIGHT TOUCHING
THE LENS.

one stop. Most major brands of this teleconverter show insignificant decreases in image quality. The 2x teleconverter (doubler) doubles focal length, but causes two f-stops of light loss, allowing a greater possibility of distortion. Nevertheless, many great photos have been taken with teleconverters.

Lens Diopters (close-up lenses) allow you to take a picture as though through a magnifying glass. They resemble filters and screw onto the front of a lens. Diopters are available in different strengths. You can stack and combine them with extension tubes for closer focusing or to fill the frame with the subject. Disregard the focusing dial on the camera when these lenses are in place, as they cannot be used for photography beyond a certain limited distance.

Lens Tips

The following techniques maximize sharp, clear photographs with any combination of lenses and accessories. Most lenses focus precisely at one or two f-stops less than their maximum aperture. This is worth remembering when you add one or more teleconverters to a telephoto lens, or if you use an off-brand telephoto

lens. For maximum sharpness, of course, the lens and camera setup must be completely stable, perhaps with several supporting beanbags or two tripods—one supporting the camera and one for the telephoto lens. The mirror should be locked up, and the aperture should be stopped or shut down one or two stops.

When you photograph birds flying against the sun on a bright day, use a wide-angle lens and stop down to the smallest aperture. This will cause a striking star-burst effect. The camera's light meter can be fooled by this, making the photo look very dark, so try one or two stops of overexposure. On the other hand, you may like the brilliant star-burst effect of the sun with the rest of the photograph being less illuminated. You can increase this effect by using a star filter.

A telephoto lens with a large lens opening creates a shallow depth of field, which blurs foreground and background objects. This produces "portraits" with just the bird and immediate areas in sharp focus. Remove all unnecessary filters, including skylight or ultraviolet filters that are designed to protect the lens. These could cause reflections or perhaps even slight degradation of optical

quality. Use the very best lens available—the fastest and preferably one made by the manufacturer of your camera.

Teleconverters are very useful with a telephoto lens. With some camera/lens systems, you can stack or combine teleconverters to produce power and magnification, but be aware that using these will cost you quite a bit of light. The more narrow the aperture used, the less light will be available for sharp focusing. A good compromise is 1.4x teleconverters, which cost only a stop of light, as 2x teleconverters (doublers) cost two stops of light. Although stacking can cause loss of image quality, it does bring a distant object up close and personal.

To photograph, say a great auk in dim light a country mile away, use your biggest tripod and lower it for stability to support your longest telephoto lens.

Support your camera with another tripod or monopod. Use your strongest teleconverters, which you can stack, shut the f-stop down two stops from wide open, lock the mirror up or use the auto timer, check the focus with your magnifying loupe attachment, hang a camera bag on the lens to weigh it down, and blast away. On first try, focus sharply by carefully sliding the focusing ring to the point of sharpest focus and then stopping and taking the picture. Do not "see-saw" back and forth on the focusing ring. You will be thus able to fire the camera and catch that once-in-a-lifetime shot when a bird only poses for a few seconds before flying away.

TERNS ON ROOKERY ISLANDS, TX. THE BIRDS APPEAR TO BE FAR MORE CROWDED THAN THEY ACTUALLY ARE, AS 600MM LENS WITH 1.4X TELECONVERTER CAUSES OPTICAL COMPRESSION.

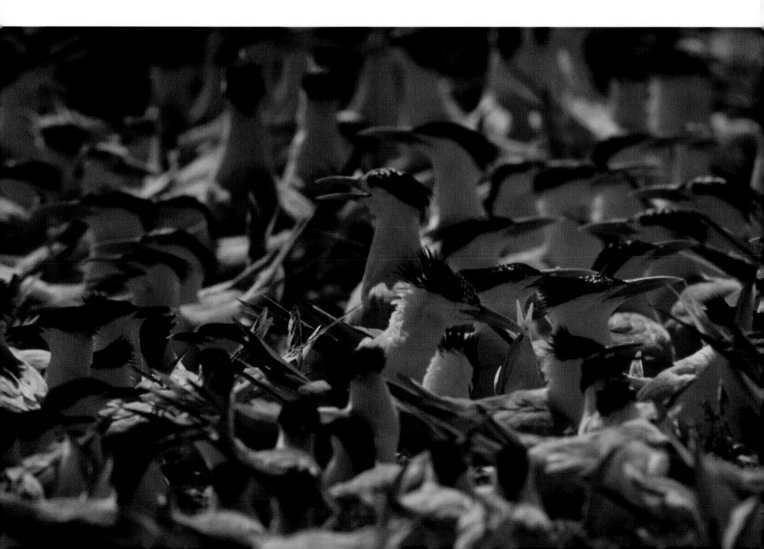

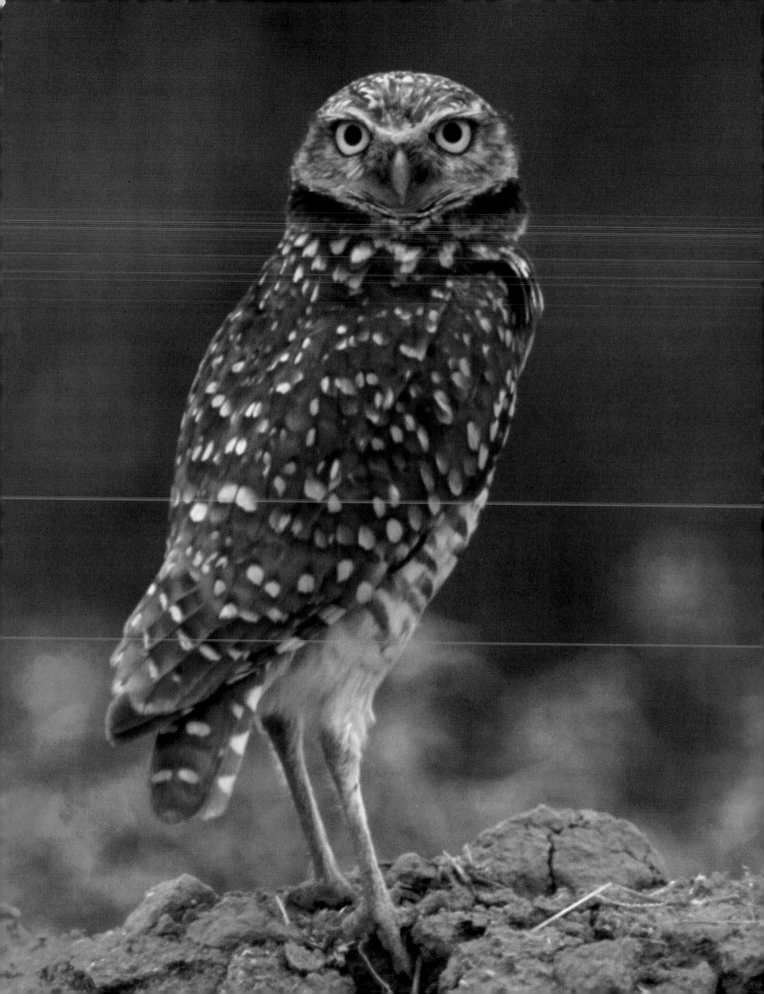

A WIDE-ANGLE LENS CROPPED DOWN TO THE SMALLEST F-STOP (LENS OPENING) WILL
CREATE THIS STAR-BURST EFFECT, WHICH WAS EMPHASIZED BY A CROSS STAR FILTER.

Shutter speeds around $\frac{1}{15}$ second may cause vibration from the camera's mirror,
resulting in blurred photos. Also, if you use a heavy tripod and ball-head mount,
the camera may shake from mirror vibration. Consider using a cable release to trip
the shutter. This won't cause as much vibration as a finger might produce.
Standard cable releases are fairly inexpensive. You can mount them in small tubes
attached to tripod legs or keep them in a photo vest so that there is one handy
when you need it. If you are photographing a stationary bird, consider locking the
camera's mirror. Do this with either the camera's control, if it has one, or use an
automatic timer, which accomplishes the same thing.

◁

BURROWING OWL. I THREW THE GREEN
GRASS BACKGROUND OUT OF FOCUS BY
USING A LONG LENS AT LARGE APERTURE
WITH SHALLOW DEPTH OF FIELD. PHOTO
TAKEN AT SAME LEVEL AS BIRD.

17MM ULTRA-WIDE-ANGLE LENS. THE EAGLE IS TOO FAR AWAY TO BE PICKED OUT IN THIS PHOTOGRAPH WITHOUT PUTTING THE PICTURE UNDER A MICROSCOPE.

SERIES OF PHOTOS OF MATURE BALD EAGLE AT BOSQUE DEL APACHE NATIONAL WILDLIFE REFUGE, NM. COMPARE THE 17MM ULTRA-WIDE-ANGLE PERSPECTIVE TO THE ULTRA-TELEPHOTO MAGNIFICATION WITH TELECONVERTERS. I SET THE F-STOP DOWN BY TWO, SINCE THE SHARPEST FOCUS OF MOST LENSES IS ONE OR TWO STOPS LESS THAN FULL APERTURE.

100MM TELEPHOTO ZOOM LENS, 2X
MAGNIFICATION.

300MM TELEPHOTO ZOOM LENS, 6X
MAGNIFICATION.

600MM TELEPHOTO ZOOM LENS, 12X
MAGNIFICATION.

600MM TELEPHOTO ZOOM LENS WITH 2X
TELECONVERTER, 24X MAGNIFICATION.

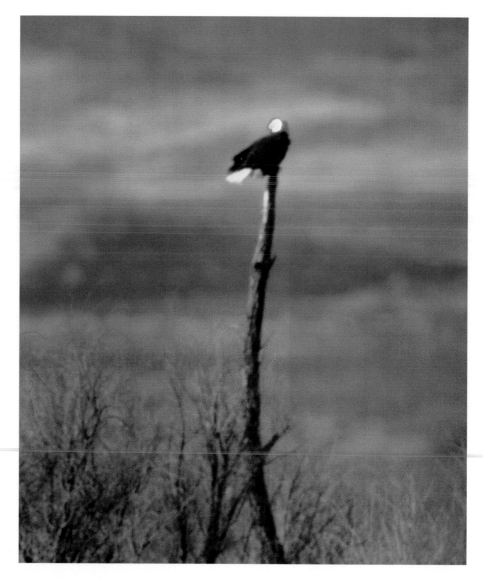

600MM WITH TWO 2X TELECONVERTERS AND ONE 1.4X TELECONVERTER, WELL OVER
60X MAGNIFICATION. ALTHOUGH FAR FROM BEING A SHARP PHOTOGRAPH OF A BALD
EAGLE, IT IS CERTAINLY RECOGNIZABLE AND WOULD WORK FOR DOCUMENTATION OF
A RARE BIRD APPEARANCE. THIS SORT OF SETUP AND TECHNIQUE COULD COME IN
HANDY IF AN IVORY-BILLED WOODPECKER SHOWED UP A COUNTRY MILE AWAY AND
WOULD NOT LET YOU GET CLOSE ENOUGH TO TAKE A PORTRAIT.

▷

PORTRAIT OF A BALD EAGLE, GLACIER
NATIONAL PARK, MT. EXPOSED AS
METERED BY NIKON CAMERA,
600MM LENS, 1.4X TELECONVERTER.

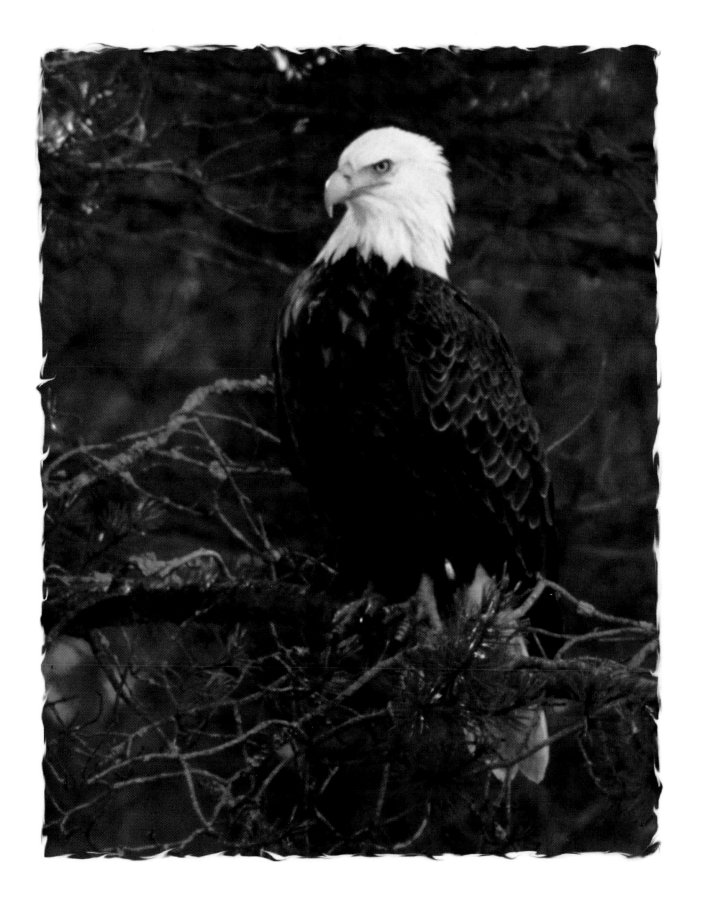

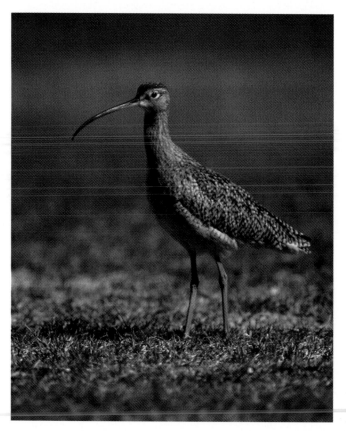

Long billed curlew, Texas coastal plains. Note the shallow depth of field this telephoto lens produces, 600mm lens f4, wide open.

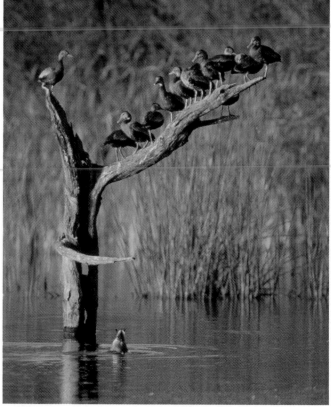

Black-bellied whistling ducks in morning convocation, in pond at Santa Ana NWR, South Texas. 600mm f4 lens, Fujichrome 100 film, 1.4x teleconverter.

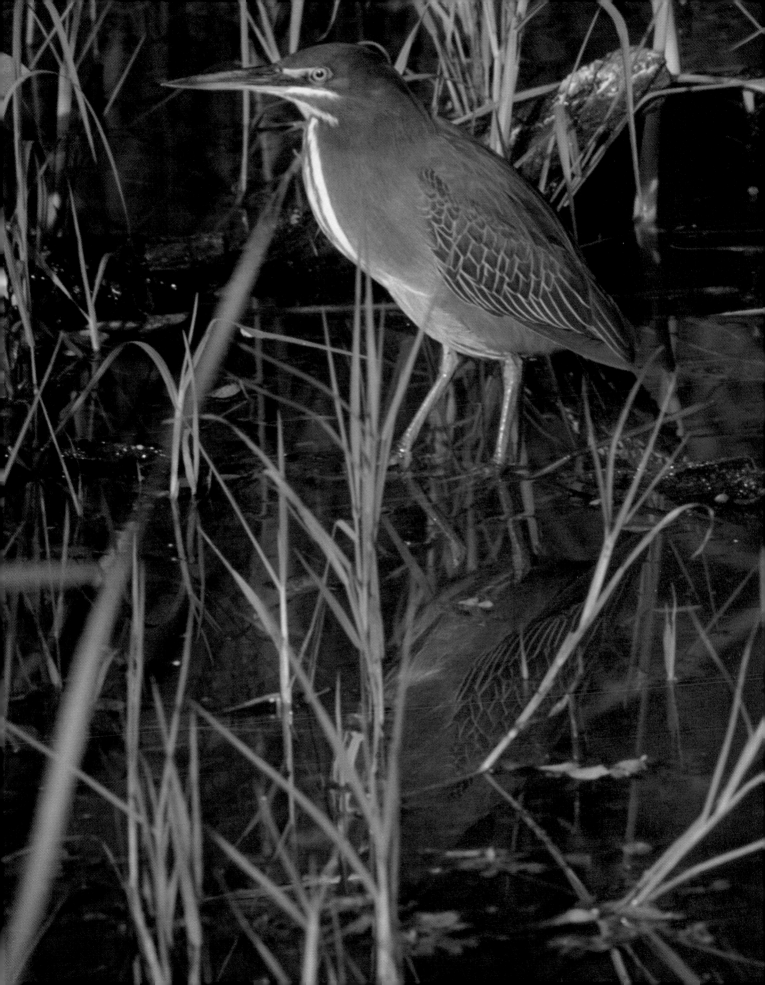

Dawn scene, Santa Ana National Wildlife Refuge, TX. Fujichrome 100 film, 24mm wide-angle lens, photo blind.

◁ ◁

Green-backed heron, Santa Ana National Wildlife Refuge, TX. This refuge, the "crown jewel" of the national wildlife refuge system, has it all: photo blinds, ponds, waterways, and lots and lots of other colorful birds, easily photographed up close and personal. 50mm–300mm zoom lens.

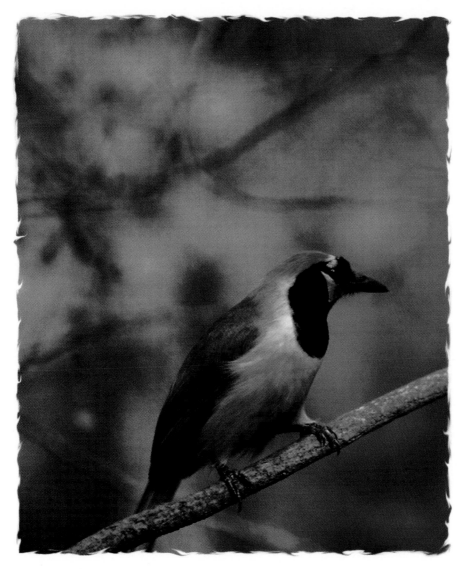

Green jay, Santa Ana National Wildlife Refuge, TX. Fujichrome 100 film, 70mm–200mm wide-angle lens, photo blind.

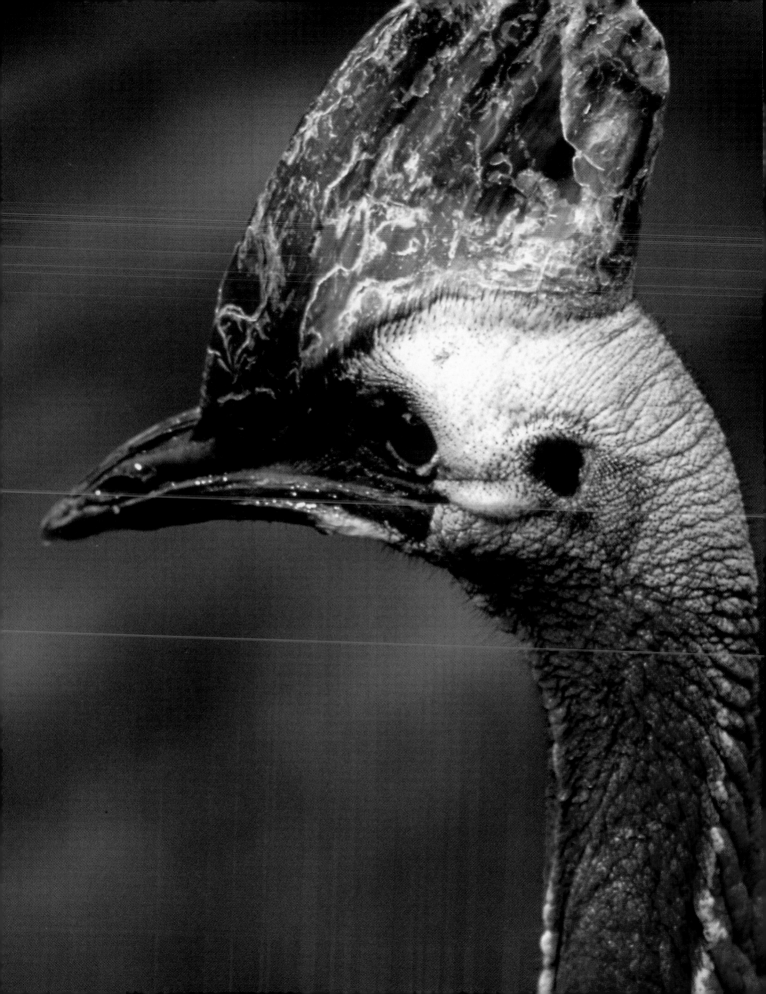

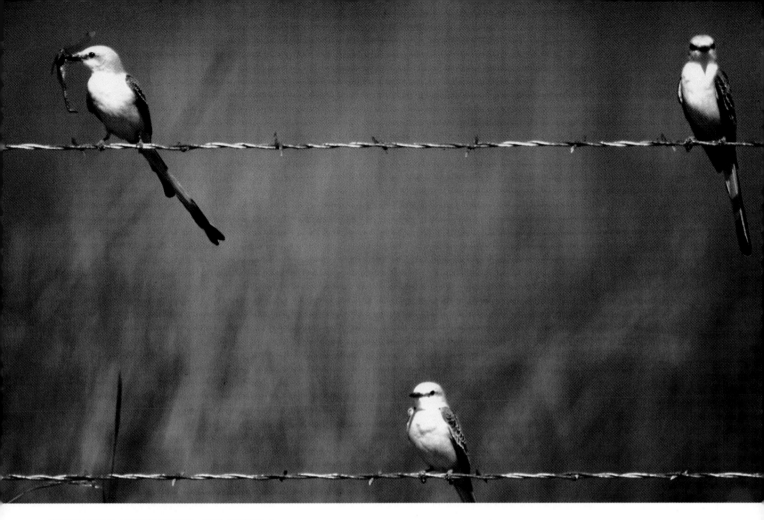

SCISSORTAIL FLYCATCHERS, ONE EATING A
BLUE DRAGONFLY, VICTORIA, TX. EXAMPLE
OF ROADSIDE BIRD PHOTOGRAPHY. AUTO
BLIND, BEANBAG STABILIZATION, 600MM
LENS, 1.4x TELECONVERTER.

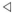 ◁

CASSOWARY, SAN ANTONIO ZOO, TX.
EXTENSION TUBES ALLOW 600MM F4 LENS
TO FOCUS UP CLOSE. NOTICE THE
ISOLATION OF THE SUBJECT FROM
SHALLOW DEPTH OF FOCUS.

BLACK-CHINNED HUMMINGBIRDS FEED FROM A SUGAR WATER DEVICE, WHICH IS MOUNTED INSIDE A BANK OF ARTIFICIAL FLOWERS. AT THE UPPER RIGHT OF THE PHOTO, YOU CAN SEE THE RESERVOIR FOR THE SUGAR SOLUTION. SHUTTER SPEED OF 1/2000 SECOND DID NOT FREEZE THE HUMMINGBIRD'S WING MOTION: AN ULTRA-SHORT FLASH UNIT IS NECESSARY TO ACCOMPLISH THIS. I DID NOT USE A FLASH UNIT FOR THIS PHOTO. 300MM F2.8 LENS WITH EXTENSION TUBE ALLOWED CLOSE FOCUSING.

THE FLASH

In contrast to the old-timey flash bulbs, which only worked once, today's flash units are reusable, battery-operated devices. Ultra-sophisticated "smart flash" units are available, but for basic bird photography, almost any sort of a flash unit will give good service. You can purchase various flash devices that combine multiple flash units and attach to the camera; these are very useful for close-up work. A variable flash with an automatic flash metering capability is a nice option to look for when purchasing a flash unit.

Dedicated flash units interact with a camera to automatically adjust intensity or duration of flash; that is, the unit communicates with your camera's electronics to allow use of the automatic flash in various modes, as explained by the instruction book accompanying the flash units. These units are worth considering.

"Smart flashes" are fancy, fairly expensive, and sophisticated devices that interact with various electronic gadgets in the camera to add just the right amount of light. These units come with instruction manuals that are about the size of a brain surgery textbook.

Wide-angle flash attachments spread out the light to allow uniform illumination of bird photos taken with the a wide-angle lens.

Flash tips

A flash photo should not look like it has been taken with a flash. Make sure there are no objects closer to the flash unit than the subject, because this will cause those objects to appear white and unnatural. Experiment with the flash to get a feel for how your unit works in your hands. You may want to determine your flash unit's "guide number," as it will indicate the power of each individual flash unit as applied to various films. For example, a guide number of 64 indicates that a bird 8 feet away

MOTHER FLAMINGO FEEDS BABY AT THE REMARKABLE GLADYS PORTER ZOO,
BROWNSVILLE, TX. A TRIPOD-MOUNTED 300MM F2.8 LENS WITH A 1.4X
TELECONVERTER AND AN EXTENSION TUBE ALLOWED A CLOSE-UP, FRAME-FILLING
PHOTO OF THIS FAMILY MOMENT.

◁ ◁

WHITE PELICAN AT TEXAS ZOO, VICTORIA,
TX. THIS ELEGANT LITTLE ZOO SHOWCASES
TEXAS' NATIVE BIRDS AND ANIMALS AND IS
"PHOTOGRAPHER FRIENDLY." 600MM F4
LENS WITH EXTENSION TUBE ALLOWED
CLOSE FOCUS.

would be correctly exposed at a setting of f8. In other words, distance multiplied by f-stop determines the guide number for various film speeds. The farther away the bird is, the more light is required. A bird 16 feet away would require a larger lens opening of f4. Going the other direction, at 4 feet, you would use f16. Run field tests to see what your guide number will be and to see how your flash unit will perform in the situations where you will be using it. In the great outdoors, your flash unit may not operate as powerfully as the instruction book says it will. Indoor flash may be much brighter than outdoor flash, since walls and ceilings bounce and reflect quite a bit of light. The flash unit may be only half as strong outside.

You may use flash as the main source of illumination or as a "fill flash" at reduced intensity. If you use flash on sunny days, make sure that no more than one catchlight reaches the bird's eye, as it looks odd for a bird's eye to have several lights present in the reflection. A catchlight is a reflection of light in the bird's eye from either flash or sunlight.

Elaborate studio-type setups for bird photography can be made, from which stunning hummingbird photographs are possible using primary lights, multiple "fill flash" units, and even backlights to illuminate the bird from behind.

Fill flash, which is the use of a flash unit at less than the power needed to completely light up a photograph, can be very helpful for filling in shadow details of a bird. If your flash unit has fractional settings, try them and see how you like the effect. If your unit does not have these settings, place your finger over part of the flash unit to reduce the flash output by a fourth or a half or so, depending upon how much of the flash your finger is covering. Use the adjustments described in the flash unit's instruction manual.

The lower the flash power, such as one-fourth power or so, in a variable power unit, the shorter and faster the flash will be. This feature is helpful for photographing the ultra-fast wings of a hummingbird, for instance. This will also allow a much faster recharging or regeneration time of your flash unit so that you can use the next flash more quickly. A maximal power flash takes longer to recharge and also has a considerably longer duration, and you will probably notice that it is more difficult to capture fast moving images on film when using full power flash settings. Of course, the advantage is that the stronger the flash setting, the greater the distance at which you can use the flash. Individual flash units may have varying amounts of power, and the light output indicated by the manufacturer may or may not operate according to your camera and lens setup specifications.

Flash synchronization is the coordination of an artificial flash unit firing and illuminating a photograph during the time when the camera's shutter is open to expose the photographic film. Flash synchronization varies between cameras, but usually the faster the shutter speed at which a flash unit can synchronize, the better, and the more likely you will eliminate "ghosting" from your photos. "Ghosting" occurs when photographing a moving bird at a slow shutter speed (i.e., the wings blur from the ambient light, but have an odd-looking sharp image, as frozen by the flash). The maximum flash synchronization speed for most 35mm cameras is $\frac{1}{250}$ second.

An adjustable flash unit will produce its shortest burst of light when set at the lowest possible setting. Using the flash unit's instructions, set the flash and camera to fire with the recommended setting for the distance from the bird to the flash at the lowest possible intensity. You will probably be very pleased with the photos you will obtain by using this technique. Photographs using a flash of brief enough duration to stop, literally, the image of a speeding bullet, can create remarkable photographs of flying birds.

Use a "projecting/telephoto" Fresnel lens setup to extend the light over a narrow area for an extended distance. You can purchase these setups or make them using the Fresnel lens, which you can buy from Edmund Scientific's catalog or most photography stores. Mount the setup in front of a telephoto lens. This eliminates uneven lighting of the foreground and concentrates the light on a bird at a distance.

The light from a flash unit is usually "color-corrected" to resemble the color temperature and photographic effect of the bright noonday sun, with its rather harsh illumination. Consider taping a very light, amber-tinted piece of cellophane over the flash unit to produce a lovely, warm, rich color of the sun in early morning and late evening. This technique basically gives you access to photography's "golden hours" whenever you wish.

A flash remote cord allows you to place the flash unit some distance from the camera, away from the direct axis line. This is helpful when photographing through glass in zoos to avoid reflection of the flash. When photographing through glass, place the flash directly against the glass. Usually, using a flash even in the close quarters of a confined bird in an aviary, will not disturb the bird. However, be sensitive to this and do not take flash photos if anyone objects or if the bird seems disturbed by this. If a bird is behind bars or in a cage, try to find a non-illuminated area where the birds or wire is not brightly lit, or shiny, and use a long-focus lens at the largest possible aperture. Take advantage of the short depth of field, and simply focus out the bars. This technique works best if the bird is not too close to the wires.

When a flash unit is recharging between flashes, the "ready light," which indicates when the flash can be used again, may actually come on, although the charge is not built up to the maximum intensity. If you wait an additional five or ten seconds before using the flash again, the flash should be a bit brighter for most units.

▷

EASTERN MEADOWLARK SINGS ON FENCE POST. NOTE THE CATCHLIGHT REFLECTION IN THE EYE AND FEATHER DETAIL. THIS LARGE LENS OPENING CAUSED A SHALLOW DEPTH OF FIELD AND THREW THE GREEN FIELD IN THE BACKGROUND PLEASANTLY OUT OF FOCUS. THE TRICKY PART OF TAKING SUCH A PHOTO IS RELEASING THE SHUTTER AN INSTANT BEFORE THE "KODAK MOMENT." KODACHROME 64 FILM, AUTO BLIND, BEANBAG STABILIZATION, 600MM F4 LENS, 1.4X TELECONVERTER, 1/125 SECOND CAUGHT THE PEAK OF ACTION.

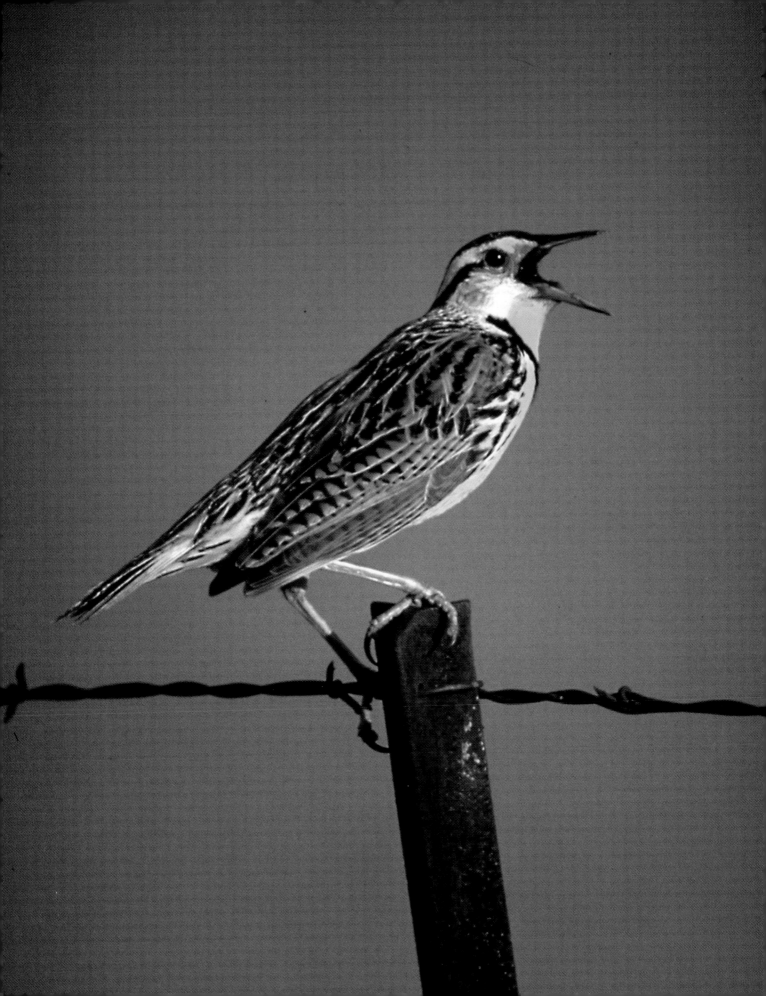

GREAT HORNED OWL AT NIGHT, TX. KODACHROME 64 FILM, FULL POWER FLASH, 300MM LENS.

▷

SPARROW ON FROZEN TWIGS AT BOSQUE DEL APACHE NATIONAL WILDLIFE REFUGE, NM. NOTICE BLURRED BACKGROUND CAUSED BY SHALLOW DEPTH OF FIELD (DEPTH OF FOCUS) OF 600MM F4 LENS, WIDE OPEN, ALONG WITH CONTRAST OF BACKLIGHTED ICE ON TWIGS.

THE JOY OF BIRD PHOTOGRAPHY

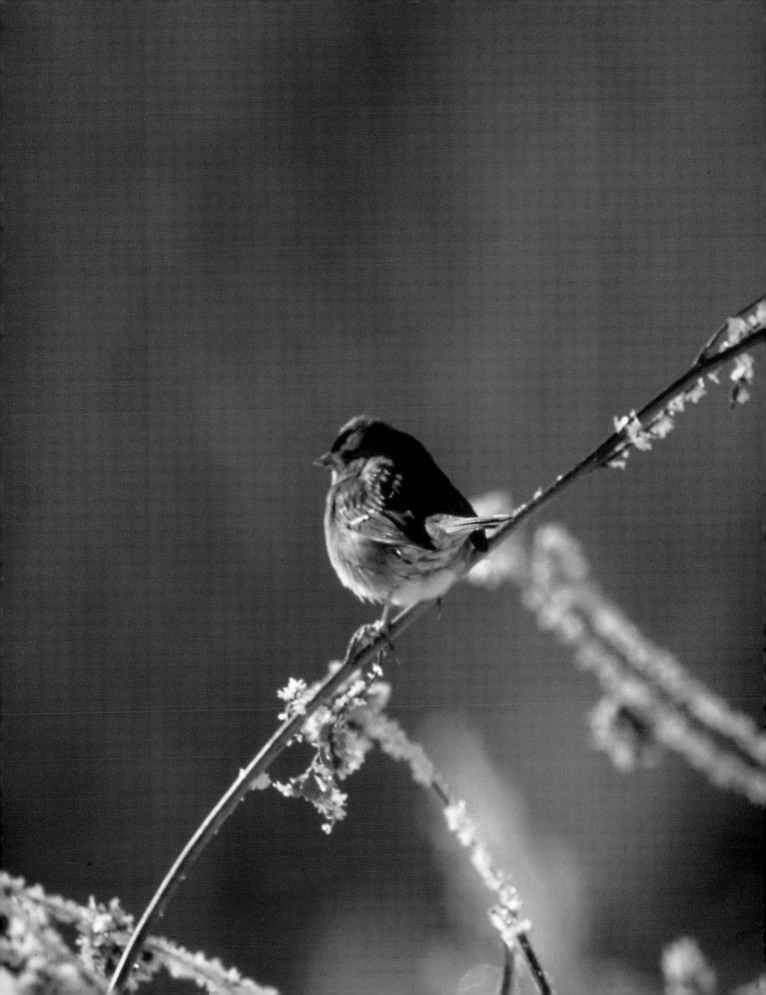

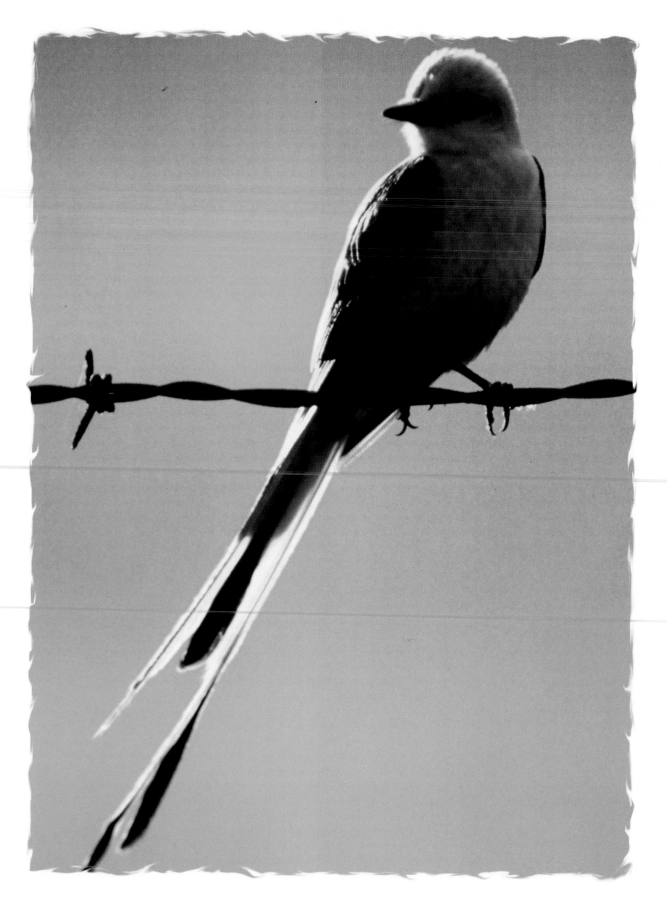

THE JOY OF BIRD PHOTOGRAPHY

Sandhill cranes in courtship display at Bosque del Apache National Wildlife Refuge, NM. Backlighted, transilluminated wings add color to a cold, clear morning.

◁

Exciting rim lighting of scissortail flycatcher. Sun is behind bird. An additional f-stop of exposure from camera's meter was given to compensate for backlighting.

▷ ▷

Crowned crane from Africa photographed in bright sunlight at San Antonio Zoo, TX. Extension tubes allow frame-filling close-ups with long telephoto lens. Tripod-mounted 600mm f4 lens was positioned to select a dark background so that the spectacular crown glows like strands of gold.

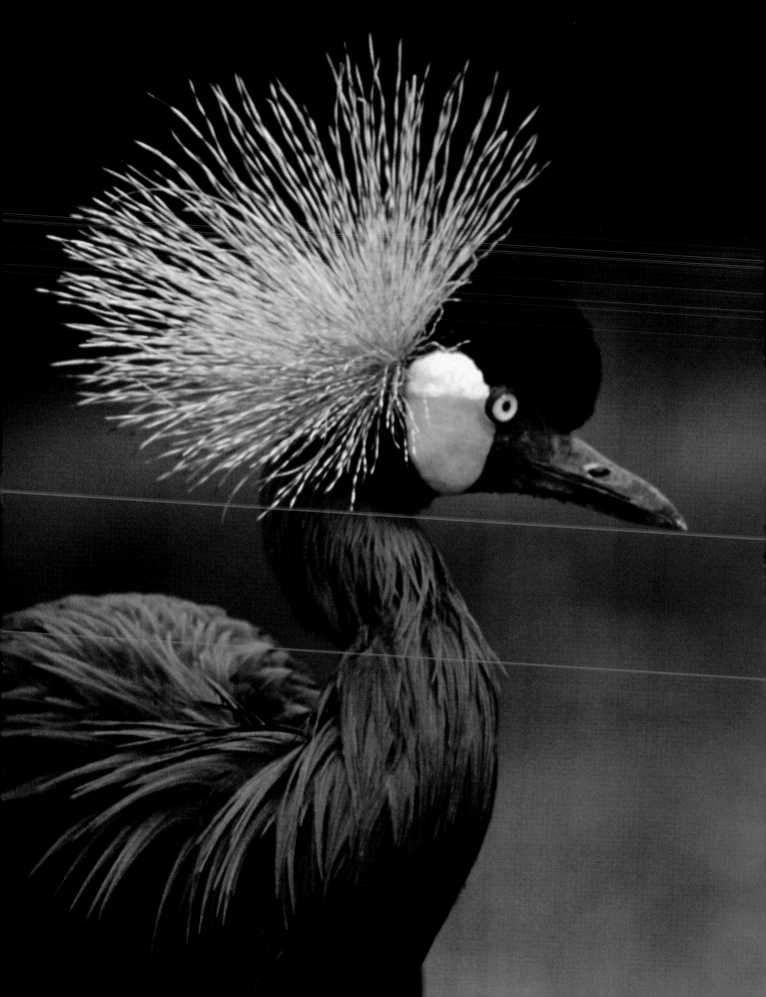

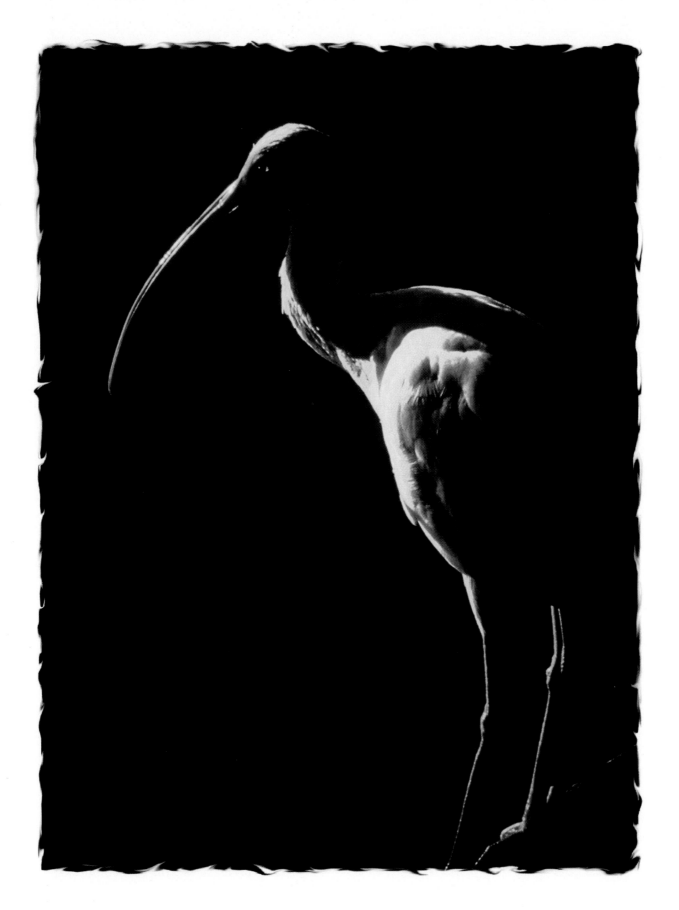

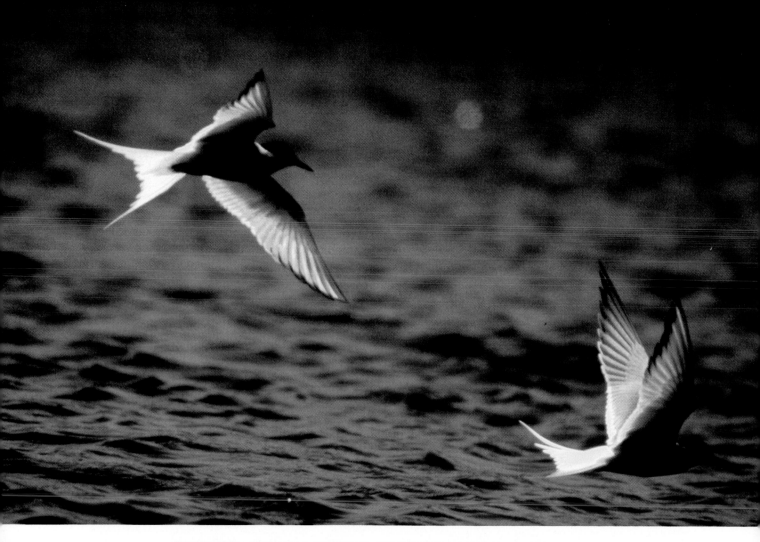

ARCTIC TERN, CHURCHILL, MANITOBA. NOTE TRANSILLUMINATED WINGS.
KODACHROME 64 FILM, 600MM F4 LENS, 1/500 SECOND.

◁ ◁

WHITE IBIS WITH SIDE ILLUMINATION,
UNDEREXPOSED TWO STOPS FOR STRIKING
CONTRAST. EVERGLADES, FL. TRIPOD,
300MM F2.8 LENS.

▷

WHITE IBIS, DING DARLING NATIONAL
WILDLIFE REFUGE, FL. TAKE PLENTY OF
TIME TO COMPOSE A REFLECTION PICTURE
SO THAT IT LOOKS THE SAME IF VIEWED
UPSIDE DOWN. TRIPOD, 300MM LENS.

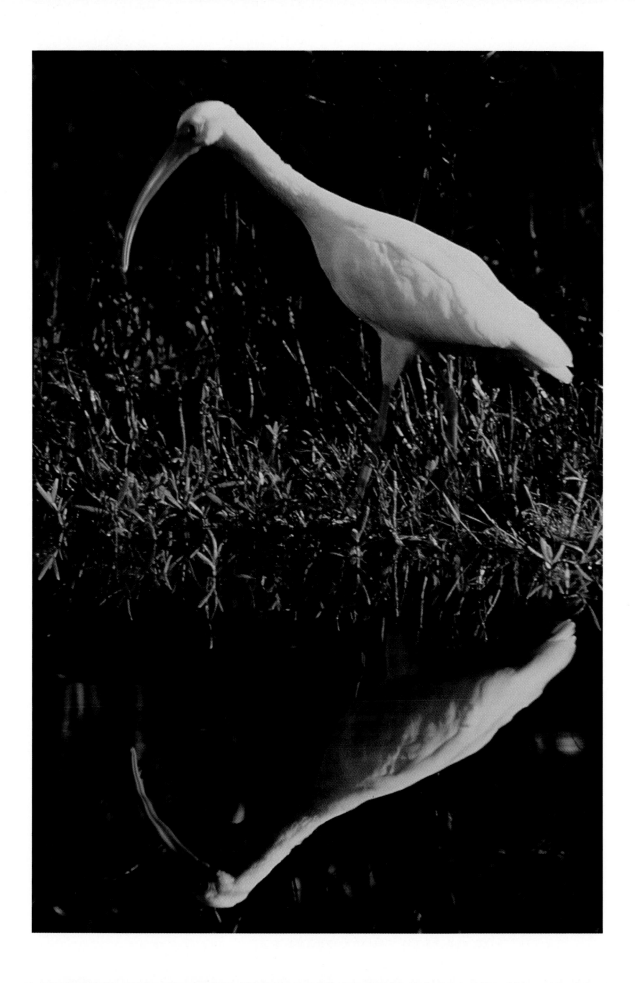

SERIES OF PHOTOGRAPHS OF WHITE PELICANS ON TEXAS COAST DEMONSTRATE HOW THE CAMERA'S LIGHT METER CAN BE ADJUSTED FOR DIFFERENT PHOTOGRAPHIC EFFECTS.

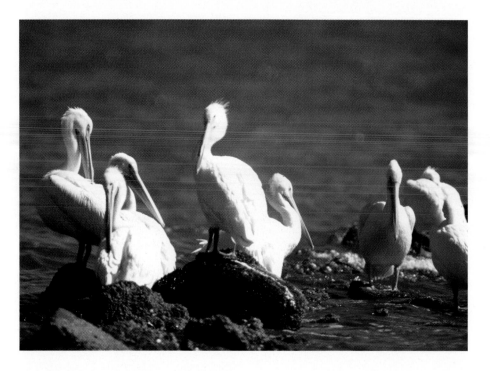

ONE AND A HALF STOPS OF EXTRA LIGHT.

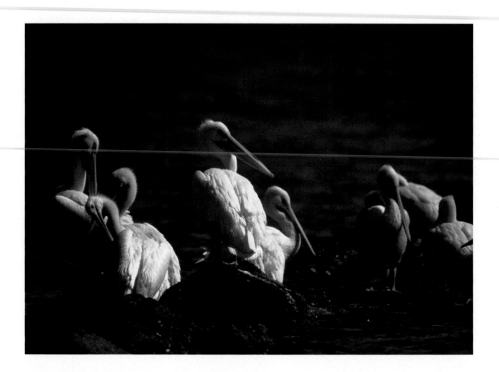

AS METERED BY CAMERA.

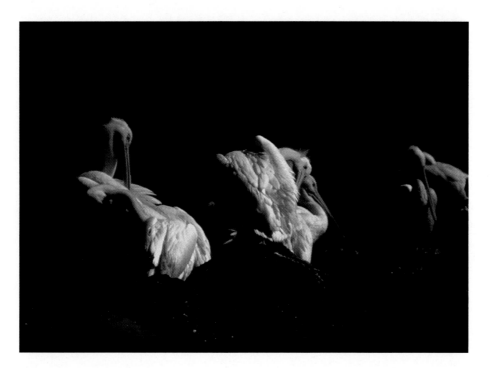

MINUS ONE STOP OF LIGHT.

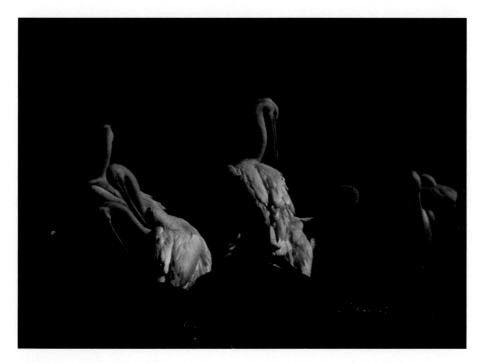

MINUS TWO STOPS OF LIGHT USING THE CAMERA'S EXPOSURE COMPENSATION DIAL.

TO TAKE STABILIZED PHOTOGRAPHS WITH LONG TELEPHOTO LENSES AND
TELECONVERTERS, USE TWO TRIPODS. NOTICE THE QUICK-RELEASE ATTACHMENTS AND
THE TWO ATTACHED SOFT POUCHES, WHICH CONTAIN ADDITIONAL LENSES OR
TELECONVERTERS. ALSO NOTE THE PLASTIC HOSE HOLDERS FOR SOUND-PROOFING THE
SNAPS ON NYLON CORDS, WHICH SERVE AS SAFETY CORDS TO ATTACH TO THE LENS AND
CAMERA IN CASE OF MOUNTING FAILURE. TRIPODS ARE PADDED WITH PIPE INSULATION
WRAPPED IN BLACK DUCT TAPE FOR CAMOUFLAGE PURPOSES AND COMFORT IN
CARRYING OVER THE SHOULDER FOR LONG DISTANCES. THIS PADDING IS USEFUL IN
FREEZING WEATHER, AS METAL TRIPODS CAN BE EXTREMELY UNCOMFORTABLE TO
TOUCH IN BELOW-ZERO WEATHER.

THIS DEVICE—A GOLF CART PAINTED BLACK
(FOR CONCEALMENT PURPOSES) WITH RUG
PADDING—IS VERY HANDY FOR
TRANSPORTING PHOTO EQUIPMENT OVER
ROUGH TERRAIN. NOTICE THE CLASP
HOLDING THE CAMOUFLAGED, COLLAPSIBLE
STOOL, WHICH IS VERY HANDY IN PHOTO
BLINDS. A LARGE CANVAS CONTAINER
UNDER THE SEAT STORES OTHER OBJECTS.
YOU CAN SLIP THE CAMERA BAG OVER THE
GOLF CART ON THE ATTACHED HOOK FOR
COMFORT AND CONVENIENCE.

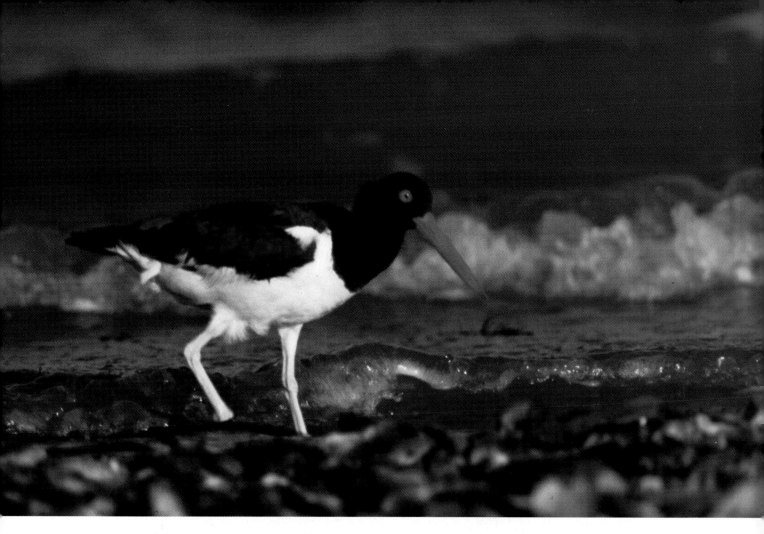

AMERICAN OYSTERCATCHER. NOTICE THE HORIZONTAL, BIRD-LEVEL PERSPECTIVE AND THE "CATCHLIGHT" IN THE EYE. KODACHROME ISO 64 FILM, F4 SETTING, BUT USE OF 1.4X TELECONVERTER COST LOSS OF ONE STOP OF LIGHT; THEREFORE, EFFECTIVE F-STOP WAS 5.6.

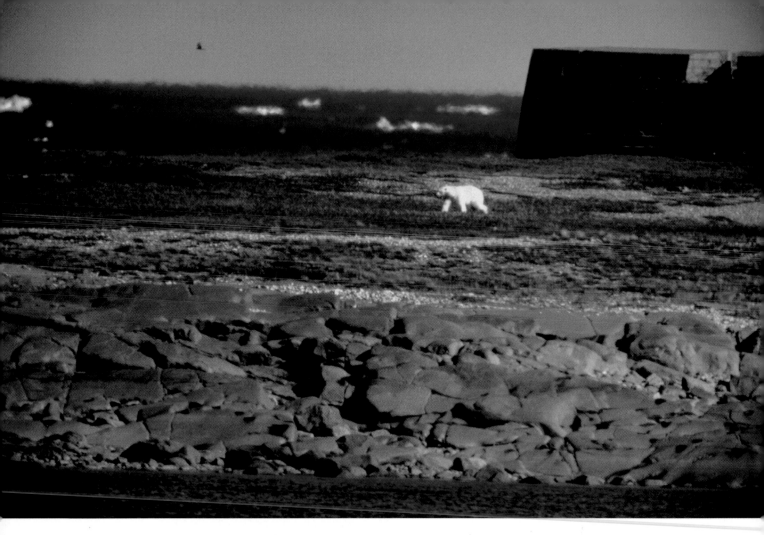

POLAR BEAR NEAR FORT CHURCHILL, MANITOBA, ON THE HUDSON BAY. PHOTOGRAPHED WHILE WATCHING THE RAPTORS FLYING OVER ICEBERGS WHEN A POLAR BEAR SUDDENLY WANDERED PAST. NIKON 600MM F4 LENS, 2X DOUBLER.

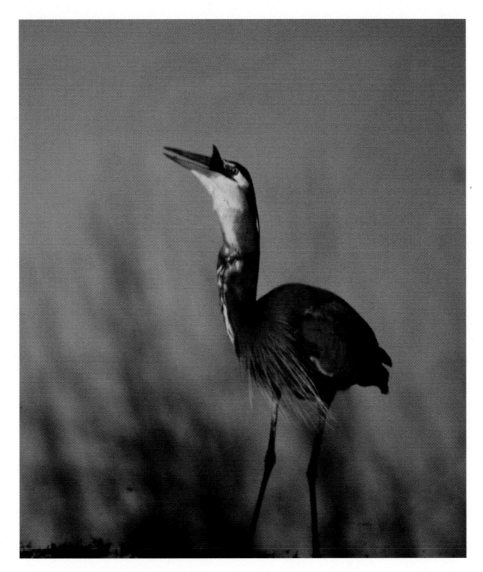

Great blue heron swallows a fish, Texas, 600mm f4 lens.

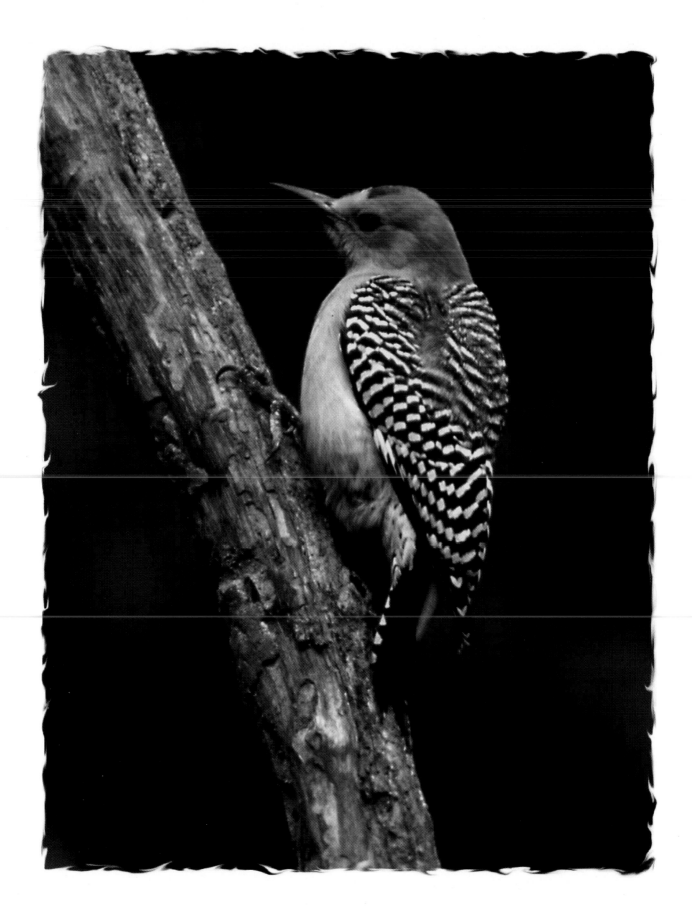

THE JOY OF BIRD PHOTOGRAPHY

GOLDEN-FRONTED WOODPECKER,
SANTA ANA NATIONAL WILDLIFE
REFUGE, TX. NOTE THE VERTICAL
CAMERA POSITION AND STRONG
DIAGONAL LINE OF TREE LIMB
UPON WHICH THE BIRD IS
PERCHED. KODACHROME 64 FILM,
TOKINA ZOOM 80-200 ATX F2.8
GLASS LENS, A VERY SHARP AND
RELATIVELY INEXPENSIVE LENS.

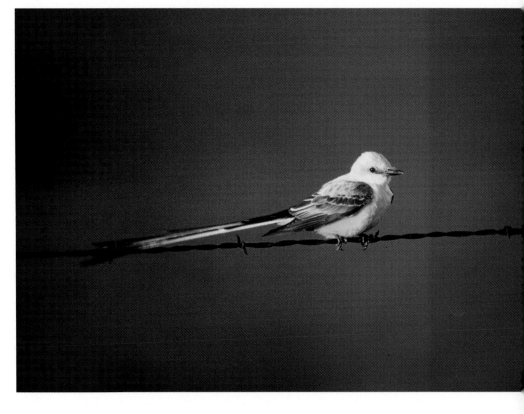

SCISSOR-TAILED FLYCATCHER.
NOTICE THE PLEASING COLOR
CONTRAST AND THE 600MM F4
LENS, WIDE OPEN, AND 1.4
TELECONVERTER WITH SHALLOW
DEPTH OF FIELD SEPARATED
BIRD FROM THE BACKGROUND.

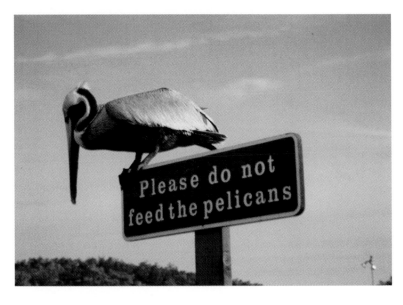

BROWN PELICAN SITS ON SIGN, HOPING
FOR THE BEST, EVERGLADES NATIONAL
PARK, FL. A "GRAB SHOT." NIKON
50—300MM ZOOM LENS.

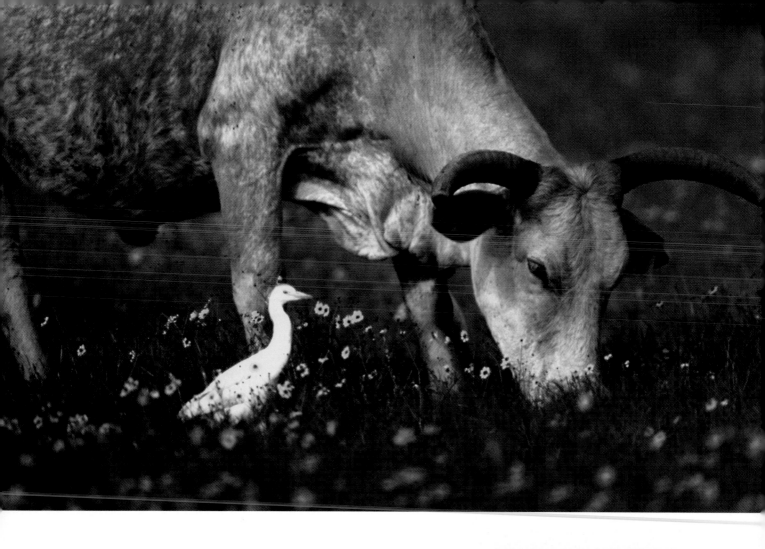

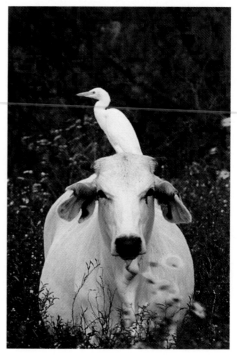

The well-named cattle egret with cow
and wildflowers, Texas. Auto blind,
600mm f4 telephoto lens.

THE JOY OF BIRD PHOTOGRAPHY

ACCESSORIES

Extension tubes are short devices that fit between the camera and the lens. They allow you to take a picture of a bird that would otherwise be too close to photograph. This can happen in a photo blind (device or object that conceals you, so you can photograph in close-up situations without disturbing the subject) or in a home garden. There is no glass element in an extension tube, so there is no distortion, but the tube does cause a slight decrease in the amount of light reaching the lens, because the light has farther to travel. This may result in the need for increased exposure. You may want to consider one or several extension tubes that will mate your lens to your camera. Make sure that the extension tube(s) you purchase will allow all of the functions of your lens and camera. You can either use these tubes independently or stack them, depending on how close the bird is.

Extension tubes both give and take away in terms of maximal and minimal useful focusing distance of any given lens. In other words, when you are using an extension tube, you will be able to photograph objects that are closer to you, but you will not be able to use the lens near the infinity setting. An extension tube will allow you to photograph a bird with whatever magnification your telephoto lens allows, plus a slight increase in magnification from the extension itself. In general, the closer you can focus, the more limited the maximal distance will be for sharp focus farther away from you. An extension tube is a must for the close-up subjects often encountered in controlled situations, such as in zoos or wildlife rescue stations, where you may be photographing a bird at point-blank range.

If you combine an extension tube with a teleconverter lens, often the teleconverter will work better if you place it next to the camera body. If you add an additional teleconverter lens to a long-focus (or telephoto) lens, a short extension tube may allow them to mate (if it will not otherwise fit), and still be within the full range of focus through infinity.

Spotting scopes act as a telephoto lens and vice versa. This device is useful because it happens all the time: You spot a splendid view of a distant bird through your spotting scope—wonderful lighting, perfect composition—but no camera! Remember, almost all spotting scopes have attachments for cameras available, and the spotting scope then becomes a telephoto lens. Questar, Meade, Celestron, and many other spotting scope manufacturers sell a device known as a "T-ring" to couple your single-lens reflex camera to the spotting scope when the eyepiece is removed. Simply order the appropriate camera adapter and you are in business.

There are many times when you may wish to just enjoy watching a bird after you have taken photographs, but the camera viewscreen does not have the wide, sharp field of view that the spotting scope offers. Then, an eyepiece adapter as a viewing screen is called for to replace the camera. You can purchase these from various manufacturers, including Nikon, and camera stores. Also, you can fashion a setup for using a telephoto lens as a very effective spotting scope with improved performance. This can save you money and help you avoid the inconvenience of carrying a camera, telephoto lens, and spotting scope. Many telephoto lenses have sharper and faster optics than some spotting scopes, and a good eyepiece adapter can allow the telephoto lens to double as a spotting scope, with better optical performance than many expensive spotting scopes.

To use your telephoto lens as a spotting scope, you will need either a porro prism, for straight-through viewing, or a star diagonal, for upright viewing. A two-inch star diagonal with aluminized bright coating is ideal, especially when used with a two-inch wide-angle eyepiece. These larger dimensions provide a brilliant

view with the widest possible field, and you can interchange eyepieces for close-up looks. These items are available from astronomy catalogs. There is a tricky part, however. You may need an additional lens to allow distant focusing. This can be epoxied into the system. Depending on the optical distance from the telephoto lens to the eyepiece, try a 15- to 30- diopter minus lens, which you can obtain from opticians or Edmund Scientific Company. Attach the viewing setup to the telephoto lens with a T-ring, which will mate with your brand lens, or epoxy to the star diagonal or porro prism, whichever you choose. This unit can give a sharper, brighter, and wider-field image than almost any spotting scope on the market, with a fair-sized telephoto lens.

ASSORTMENT OF FILTERS WITH A 300MM F2.8 LENS. SOME LONG TELEPHOTO LENSES HAVE REAR-MOUNTING FILTER PLACEMENT OPTIONS, BUT THEY ARE EXPENSIVE. HERE IS HOW TO MAKE YOUR OWN FOR A LOT LESS: SIMPLY PURCHASE FILTER MATERIAL, AND TRIM AND MOUNT THE FILTERS, USING BALSA WOOD OR OTHER MATERIAL. NOTICE THE POLARIZER, WHICH I SIMPLY EPOXIED INTO A HANDMADE MOUNT. CUSTOM-MADE SIMILAR POLARIZING SETUPS CAN COST OVER $200. I MADE THIS ONE FOR AROUND $15. I ADJUSTED THE POLARIZER TO THE PROPER ORIENTATION AND INSERTED IT INTO THE CAMERA. NOTICE THE GRADUATED NEUTRAL-DENSITY FILTERS, WHICH CAN EITHER BE NEUTRAL, GRAY, OR COLORED.

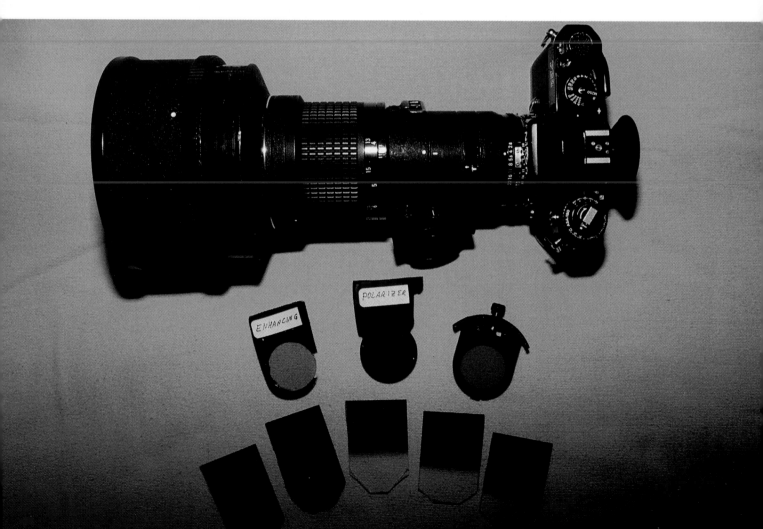

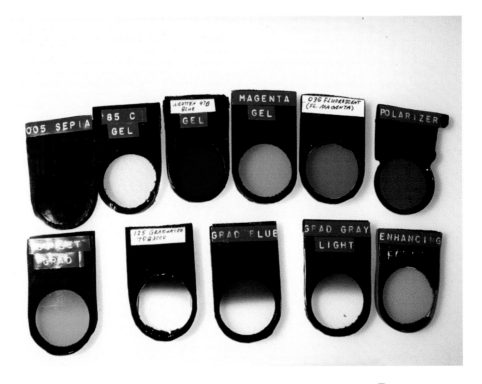

FILTER ASSORTMENT FOR TELEPHOTO LENS WITH REAR RECEPTACLE. FILTERS THAT WOULD FIT OVER THE FRONT OF LARGE TELEPHOTO LENSES ARE HARD TO FIND AND VERY EXPENSIVE.

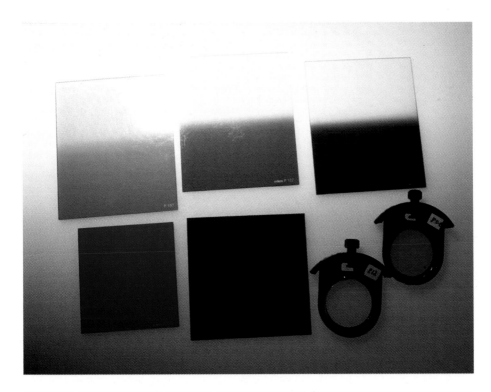

COLORED AND GRADUATED NEUTRAL-DENSITY FILTERS. IT IS OFTEN MORE CONVENIENT TO BUY LARGE-SIZED FILTERS TO FIT YOUR LARGEST LENS, AND THEN EITHER HOLD THEM OR MOUNT THEM, USING ADAPTERS, IN FRONT OF SMALLER LENS.

Filters are transparent pieces of glass or plastic that fit on or in a lens to cause special effects, such as adding or enhancing color, or the magic of polarization. They give you control over the way light affects a scene. If used sparingly, filters can enhance the mood and change the "feel" of an image, and they are fun to experiment with. Filters can add depth and richness to photographs, which might otherwise be dull and boring. Try to find a filter or combination of filters that will work for you. This is another area of photography where individual preferences can be utilized to produce a winning bird photograph. Some filters never to leave home without include polarizers, warming filters, and graduated neutral-density filters.

Some photographers like to keep a light warming filter on the lens at all times for lens protection; others protect the lens with a clear ultraviolet or similar filter. I use either a warming or ultraviolet filter to protect my lenses. Many photographers' expensive front lens elements have been saved from damage due to falls and impacts because of the presence of a relatively inexpensive lens-protecting filter. Some photographers think that an extra layer of glass significantly detracts from lens sharpness. I think, that when photographing into the sun, a filter certainly can take away from lens sharpness.

You can modify filters made out of gelatin, glass, or plastic to fit into the rear receptacles of some long telephoto lenses. These can be cut out with glass cutters and simply dropped into place. This can be a very inexpensive and handy way of adding color to a scene without paying a prohibitively high price for a filter, which would fit only over the front of a large telephoto lens. Another cost-cutting measure is to buy oversized filters that fit onto your largest lens, and then use these filters for all of your lenses by holding them in front of the lens. In addition to the economic savings, it is more convenient to have less equipment when traveling.

Try to find the combination of filters that works best for you, and consider stacking them. Good combinations often include graduated neutral-density filters plus a polarizer, and also a blend of graduated neutral-density filters. In other words, you can combine graduated neutral-density filters with color-adding filters to add depth and richness to a blue sky or color to a sunset. You can combine filters of any sort, but remember to watch the corners for darkening or vignetting. To check for vignetting, set lens to minimal f-stop, engage the depth-of-field preview control, and look at the image while pointing the camera at a bright object. Vignetting will appear as darkening in the corners.

Polarizers come in two basic types: linear and circular. To determine which type of polarizer you will need, check your camera's instructions. Some automatic cameras require circular polarizers, which are usually the more expensive of the two. There can be differences in effectiveness if you use the wrong kind of polarizer, and light meters in the camera can be fooled by a linear polarizer if a circular one is required. Polarizers can cause the loss of between two and three stops of light, thus darkening a sunlight-illuminated blue sky, almost to the point of darkness. If a polarizer is rotated to low intensity, it can greatly enhance a rainbow, or, if totally rotated to the point of maximal polarization effect, it can make reflections and rainbows totally disappear. These filters greatly enhance the color of feather plumage and, by removing reflections, can also bring out colors in flowers and foliage. Polarizers also eliminate glare, allowing you to photograph birds, such as anhingas, which swim underwater.

Anhinga swims in pond, Everglades National Park, FL. To photograph this underwater bird, I used a polarizing filter to cut the reflection and glare. Nikon 50–300mm zoom lens.

House finch on purple sage. Tiffin enhancing filter, a rare earth-containing filter, creates an interesting enhancement of warm colors.

Warming filters restore the color balance when photographing in dim light, at high altitudes, in snow, shade, and to remove the "blue." Published photographers frequently use these filters to add a slight increase of color, and they keep the filter on the camera much of the time to protect the lens.

Ultraviolet light (UV) filters reduce haze caused by ultraviolet light, especially in scenes that involve high altitudes and long distances on hot days. They also act as lens protectors.

Neutral-density filters, used with small f-stops for greater depth of field, allow slower shutter speeds and longer exposure times. When there are differences in brightness, you should use a split-field neutral-density filter. Otherwise, your slide film might not be able to handle these differences, and your photo will result in a loss of detail or an unnatural appearance. Graduated-density filters are available in various colors to add warmth to a sunset or sunrise on an overcast day. Try light orange for early morning or late evening photos of birds feeding.

If you photograph birds that are at varying distances from your camera, you may notice that you are unable to take the exposure at a slow enough shutter speed to allow a small lens opening, which will give maximum depth of field. To correct this problem, use neutral-density filters, in varying degrees of darkness, to allow deep zones of sharpness.

Use a neutral-density filter to photograph a stationary bird standing in front of moving water. The filter will create a long exposure time and a varied and blurred background.

Change the orientation of graduated neutral-density filters so that sunlight is darker or brighter not just from the top to bottom, but also from one side to the other. You can place these filters so that the sun seems to be coming from one side with the other portion of the slide being in relative darkness.

Experiment with other filters to create your own special look. The magenta-colored filter, which is used with color film, can add a beautiful magenta tint to sunrise or sunset photos. The 85-B filter adds a pleasant, warm, golden color simulating the rich light around sunrise or sunset. The Tiffin enhancing filter can markedly bring out yellows and reds in bird plumage, foliage, and red sandstone rocks, as well as sunsets. This filter, which is made of didymium glass, gives remarkable color, and can be combined with a polarizer. Star filters create brilliant star-burst effects of the sun. These filters have one or several intersecting, reflective wires embedded in a filter, which then screws into an adapter in front of the lens. Some star filters resemble screen wire (do-it-yourselfers take note).

▷ ▷

OSPREY ON PHOTOGENIC NEST IN FRONT OF SNOW-CAPPED MOUNTAINS, WYOMING. A SALMON/AMBER OR PINKISH-COLORED WARMING FILTER CORRECTS THE COLD, BLUE FEELING SEEN AT HIGH ALTITUDES. SMALL F-STOP (F22) WITH GOOD DEPTH OF FIELD.

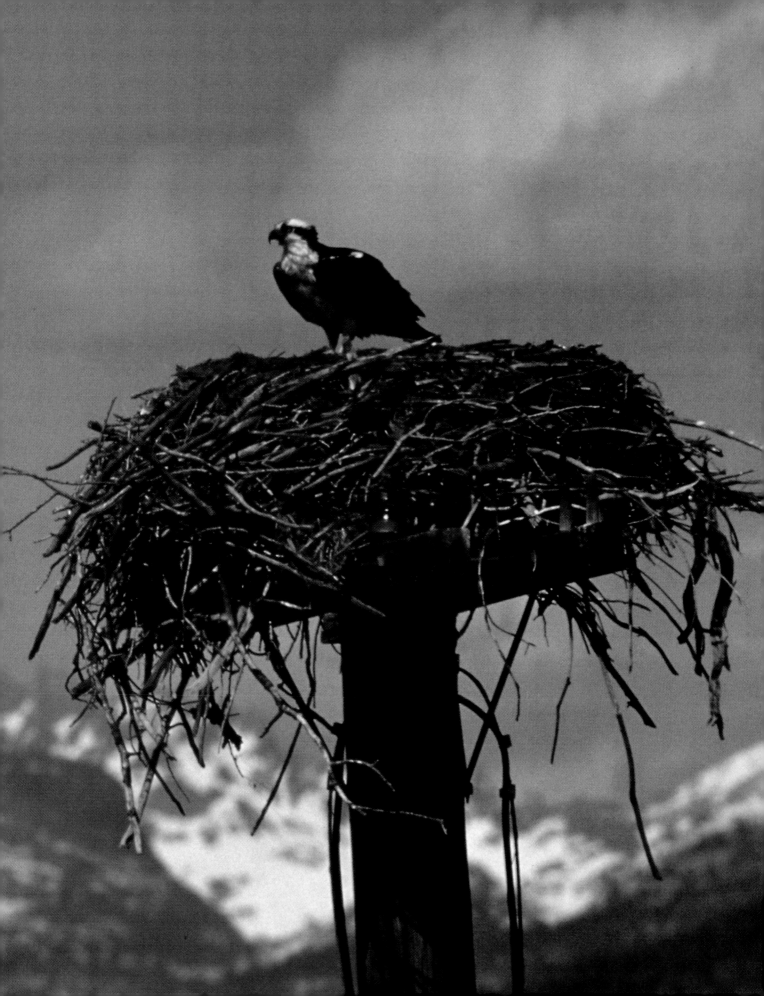

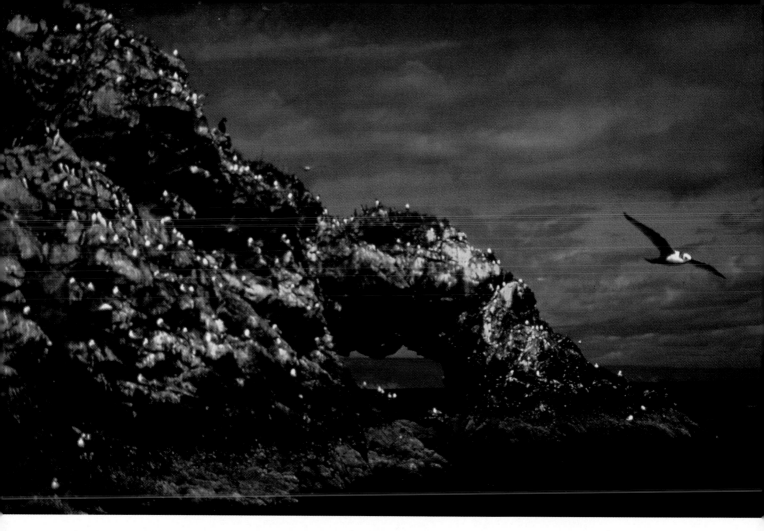

ROOKERY ISLANDS, ARE A HAVEN FOR THOUSANDS OF BIRDS. NOTICE HOW THE POLARIZING FILTER DARKENS THE BLUE COLORS OF THE SKY AND, BY REDUCING REFLECTIONS, INCREASES THE COLOR SATURATION. "GRAB SHOT," FUJICHROME 100 FILM, 24MM LENS, 1/2000 SECOND.

THE JOY OF BIRD PHOTOGRAPHY

VULTURE, BIG BEND NATIONAL PARK, TX. MANY PEOPLE THINK THAT THE COLORS BROUGHT OUT BY SOME FILTERS CAN BE "TOO MUCH OF A GOOD THING." TIFFIN ENHANCING FILTER, EKTACHROME 100 FILM.

SANDHILL CRANES, TEXAS COASTAL PLAINS. DARK AMBER FILTER, FUJICHROME 100 FILM, 600MM F4 LENS.

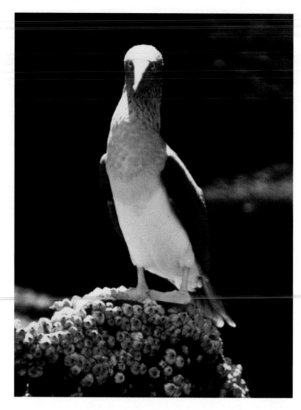

BLUE-FOOTED BOOBY. TOKINA 80–200MM F2.8 LENS,
KODACHROME 64 FILM. MONOPOD STABILIZATION.
SOME BIRDS FLYING FREE ON THE GALAPAGOS
ISLANDS HAVE BEEN BANDED FOR RESEARCH
PURPOSES, AS THIS BIRD HAS.

Stabilization

The three most important telephotography tips are stabilization, stabilization, and stabilization! Holding the camera steady is almost as important as having film in it. A shaking, unsteady camera ruins many photos, almost as much as all other problems combined. With long lens/telephoto photography, stabilization is absolutely crucial for sharp photographs. Remember that a very expensive, but unstabilized lens cannot hope to match the quality results of a more modestly priced "off-brand" lens used with some of the following stabilization techniques.

MONOPODS AND TRIPODS

You can purchase monopods and tripods, which vary in price and solidarity, but a few extra refinements can make a big difference in convenience and effectiveness. Tripods are more stable than monopods, but monopods are much more portable. Whichever support you use, consider a quick-release attachment to lock the camera and lens to the support. If you use this attachment, you will not waste time screwing the threaded bolt into the camera mount.

Monopods are one-legged devices that support the camera and lens. They are not as inherently stable as a photographic tripod, but they are lighter and more portable. If you use a monopod, you should consider purchasing a ball head, which you can find at camera stores, to screw onto the top of the monopod.

This ball head, which holds a quick-release attachment, allows you to set your camera at any angle. You can even hold your camera over your head and use the timer for delayed shutter release to capture otherwise inaccessible subjects, such as a nest, or to photograph over crowds. Do-it-yourselfers take note to the following suggestions, which will make a monopod super stable.

To correct a monopod's lack of lateral stability, use a hose clamp to attach a few feet of ornamental chain to the upper part of the monopod (you can purchase these items at a hardware or garden-supply store). This forms a loop, which you can stand in with both feet spread apart, to stop sideways movement. Using the same hose clamp, you can attach a small coin purse or pouch to hold the chain when not in use.

Construct chest pods (hinged stabilizing extensions that contact the chest) from two eight-inch pieces of aluminum tubing. With hinges, fasten the chest pods and hose clamps to the monopod. These should brace against your chest at a 45-degree angle to each other. You can use slower shutter speed when you use these pods. Use crutch tips to pad the chest pods and to make the foot of the monopod silent, which is necessary for wildlife photography, and also to prevent scratching up floors. A piece of Velcro holds the crutch tips to the monopod when not in use. Chest pods are also useful for supporting a spotting scope. You can carry this "super monopod" on your belt or backpack.

Tripods are three-legged devices that support the camera and lens. You can use a tripod as a monopod by simply holding the tripod's legs together. The tripod's support is basically stable and, until recently, it was thought that the larger and heavier the tripod, the more stable the product; that is, until the introduction of space-age lighter materials, which are said to offer excellent stability, although at a greatly increased cost.

I use elastic nylon shock cord with swivel snap hooks to attach my cameras and lenses to tripods in case of camera mount failure. However, you can also use quick-release devices, which are available at camera stores and through custom specialty manufacturers. These units allow rapid attachment and replacement of cameras and lenses without having to go through the frustration of having to use conventional screw-mounting hardware. The better units are solid and are unlikely to release prematurely, although any sort of attachment can unpredictably give way because of metal failure or other causes.

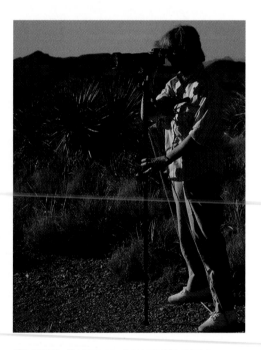

MY WIFE, BARBARA, DEMONSTRATING MONOPOD SETUP AND 50-300MM ZOOM LENS. NOTICE THE ANCHORING CHAIN LOOP WHICH IS STORED IN A SOFT POUCH ATTACHED TO THE MONOPOD. THIS IS STOOD ON FOR LATERAL STABILITY. THE HINGED ALUMINUM TUBE CHEST STABILIZING MOUNTS FURTHER SECURE THE SETUP. THIS OUTFIT IS LIGHT, FAST AND EASY TO USE IN MANY PHOTOGRAPHIC SITUATIONS AND DOES A GREAT JOB OF HELPING GET SHARP PHOTOS.

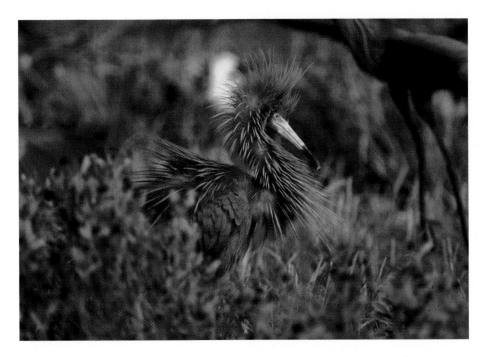

REDDISH EGRET, ROOKERY ISLANDS, TX. BOAT TOURS IN EARLY SUMMER VISIT
THESE SMALL ISLANDS. BOAT WAS BEACHED FOR STABILITY, 600MM LENS, 1.4X
TELECONVERTER, TRIPOD.

You can mount a camera on the tripod's extendable center post, to allow you to
both elevate and lower the camera. This is useful for taking photos of subjects
that are near ground level. However, since the center post on most tripods, if
extended, adds a bit of increased play, the sharpness of the image may suffer. If
you have a light-to-medium weight tripod and use it to support a heavy
telephoto lens, it is probably best not to use the center post, and some
authorities even recommend removing the center post and mounting a ball head
or other camera mount directly to the tripod platform for greater stability. The
following tips will help make your tripod more stable.

To make a small tripod more stable, drill a hole in the center, attach a hook,
and hang a heavy camera bag there. Or you can lay a heavy bag on top of the
telephoto lens/camera setup.

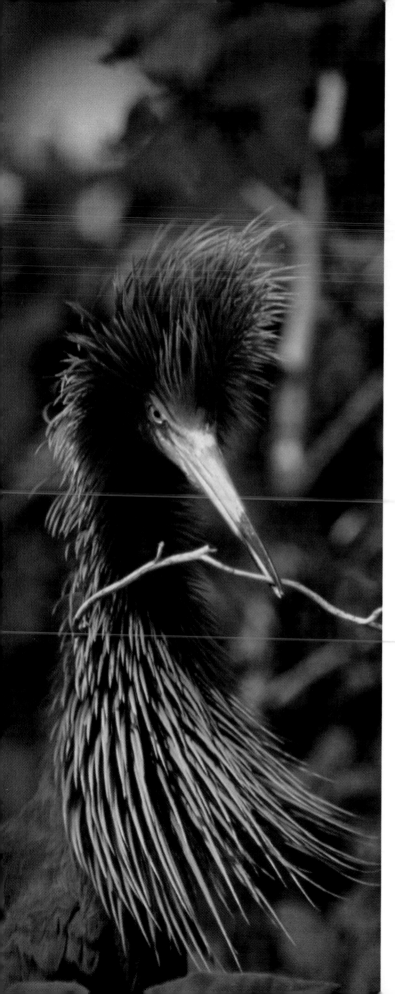

Attach a ball-head setup to a small tabletop tripod. This setup will allow you to take photographs at ground level, and you can lean it against a tree or wall, or hold it against your chest, which may be helpful when photographing flying birds. Ball heads come in many configurations and price ranges, with the high-end units costing several hundreds of dollars. Ball heads allow smooth camera movements for tracking or panning the flight of a bird. A drawback is the phenomenon of "ball-head flop." The unit is inherently top heavy and the entire camera/lens setup can flop down, risking equipment damage and injured fingers. Wimberly mounts and homemade devices can prevent "ball-head flop."

Use two tripods, one under the lens and one under the camera body, to stabilize the camera/lens setup. Hang weights onto the tripod and/or gently lay a weighted object, such as a beanbag, over the telephoto lens. You might also try using a homemade or purchased stabilizing metal strap that fits between the camera and the tripod/lens mount apparatus.

Another technique is to place your hand over the camera and push it down onto a stabilized mount, whatever this may be, and use a tripod with its legs set as low to the ground as possible. Lower the center post of the tripod and use the larger and more stable legs, extended only as far as necessary, to gain maximum stability. Experiment by bracing yourself with feet spread apart. Hold onto the tripod with one hand, and, with the other hand, brace the camera against your cheek with some stabilizing pressure.

REDDISH EGRET PRESENTS TWIG IN COURTSHIP DISPLAY.

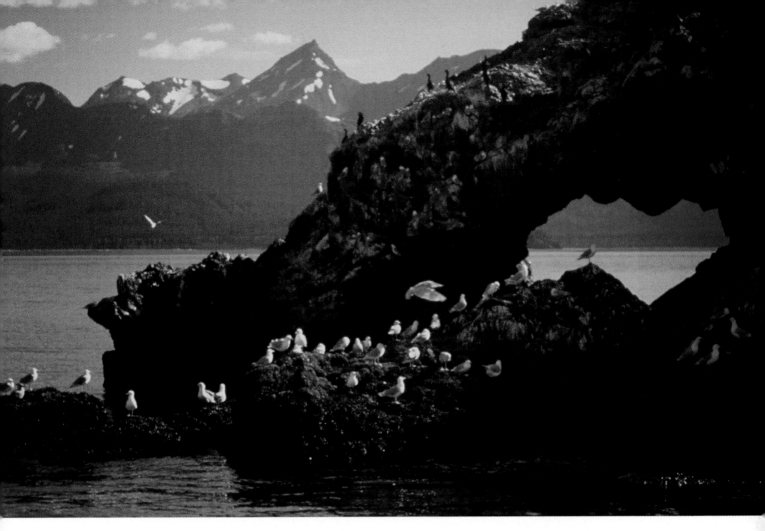

Bird islands near Homer, AK. Photographed from boat with a monopod stabilizer and fast 300mm f2.8 lens.

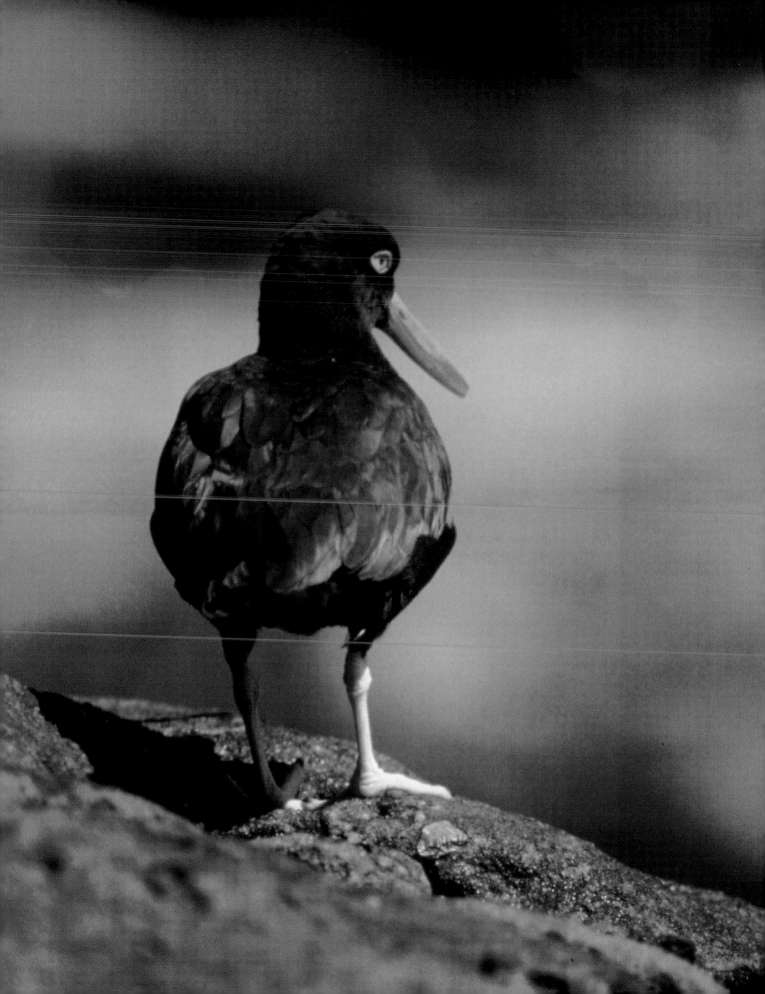

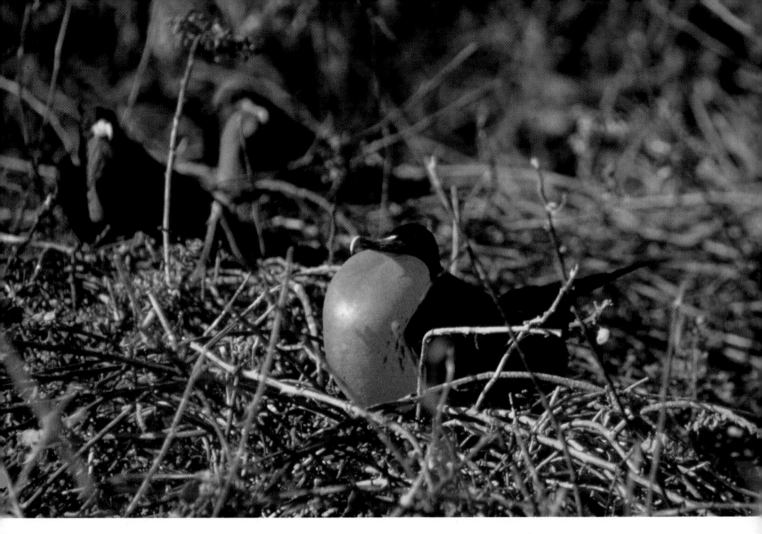

Magnificent frigate birds display ballooning throat pouches, Galapagos Islands. Monopod stabilization, Tokina 80–200mm f2.8 lens.

▷

Flightless cormorant spreads its stubby wings, Galapagos Islands. This is a living laboratory of evolution! Monopod stabilization, Tokina 80–200mm f2.8 lens.

◁

Black oystercatcher, Pacific Coast. These birds move very rapidly and one must move with them. Therefore, I used a monopod setup with rubber crutch tips to allow safe, stable photography. Wet, slippery rocks and breaking waves added another challenge. Note how sunlight glows on bill. 600mm lens.

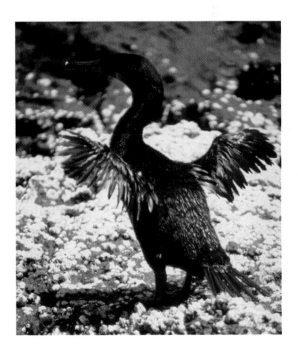

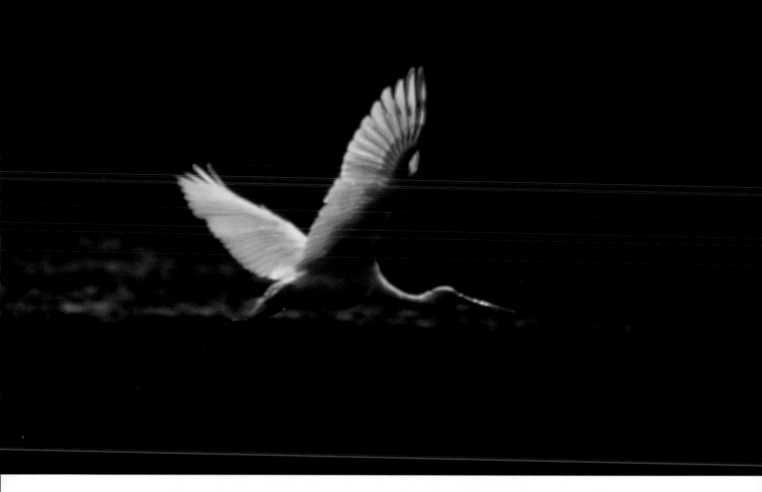

FLYING ROSEATE SPOONBILL. TRIPOD WITH BALL-HEAD MOUNT ALLOWS PANNING OF CAMERA, 50–300MM ZOOM LENS, 1/500 SECOND, KODACHROME 64 FILM.

THE WELL-NAMED BLUE-FOOTED BOOBY, GALAPAGOS ISLANDS. SPECIAL MODIFIED MONOPOD STABILIZATION, TOKINA 80–200MM F2.8 LENS.

Beanbags

A beanbag is a very solid camera mount and may be the least expensive and the best support for a telephoto lens. Use a big beanbag, a "super beanbag," or perhaps two beanbags. For rock-solid support when you photograph from an automobile window, hood, or roof, simply lay the camera over the bean-filled bag. You can also lay a beanbag over a picnic table, tree limb, or an opening in a photo blind for camera support. One big beanbag (or two smaller ones) can support a long telephoto lens, "fore and aft," under the lens and camera.

Either purchase or sew a simple cloth bag of subdued color and of whatever size supports the lens and camera. For traveling purposes, choose a bag with either zippered or Velcro-type closures. This will allow you to carry the empty bag in a suitcase, and fill it on arrival at the photo site. Beans work best, but small rocks or various packing materials also work.

Window Mounts

Window mounts offer camera/lens stabilization when you photograph from an automobile. You can purchase a window mount ready-made or you can make one out of plywood and paint it black. Store-bought window mounts often attach to the window glass and may not support a heavy telephoto lens. A large compartmentalized or double beanbag works well as a window mount for super-stable photographic lens support. Use camouflage netting to conceal any activity inside the auto.

BEANBAG STABILIZES A 600MM F4 LENS. MY WIFE, BARBARA, USES THE JEEP'S SUNROOF AS A MOBILE PHOTO BLIND.

LONG TELEPHOTO LENS ON WINDOW MOUNT MADE OF PLYWOOD AND PAINTED BLACK. HOMEMADE BEANBAG WITH TWO SEGMENTS TO SUPPORT LENS ON LONG AXIS. THIS "SUPER BEANBAG" HAS A ZIPPER SO THAT IT CAN BE FILLED ON LOCATION AND COLLAPSED TO THE SIZE OF A HANDKERCHIEF FOR TRAVELING.

▷ ▷

LESSER YELLOWLEGS, CHURCHILL, MANITOBA. THIS ARCTIC PORT, THE "POLAR BEAR CAPITAL OF THE WORLD," SWARMS WITH NESTING BIRDS IN EARLY SUMMER. BEANBAG STABILIZATION, AUTO BLIND, 600MM LENS, VERTICAL CAMERA POSITION.

▷ ▷ ▷

ACORN WOODPECKER POSES FOR JUST A MOMENT, ARIZONA. BEANBAG STABILIZATION, AUTO BLIND, VERTICAL POSITIONING, 600MM F4 LENS.

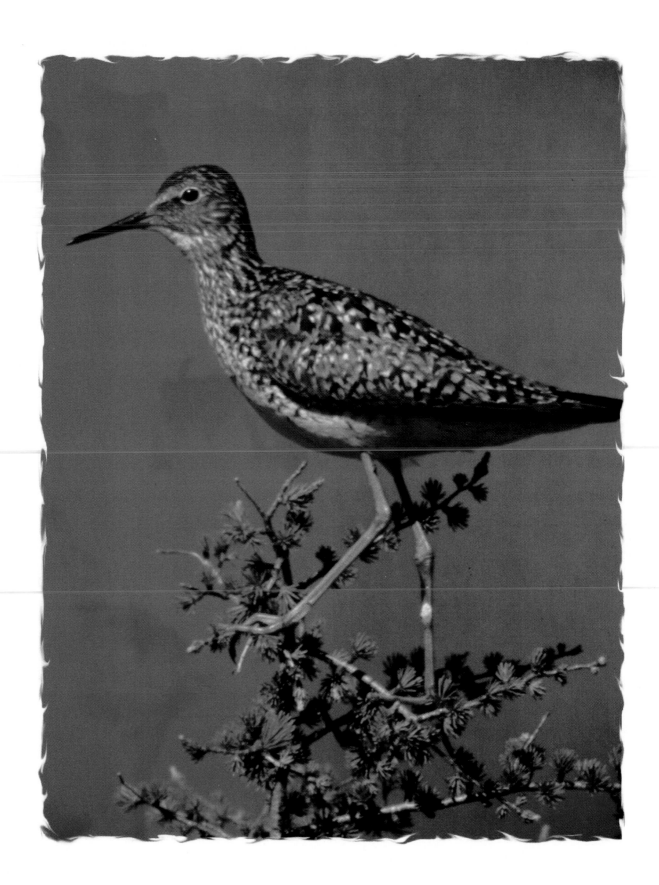

THE JOY OF BIRD PHOTOGRAPHY

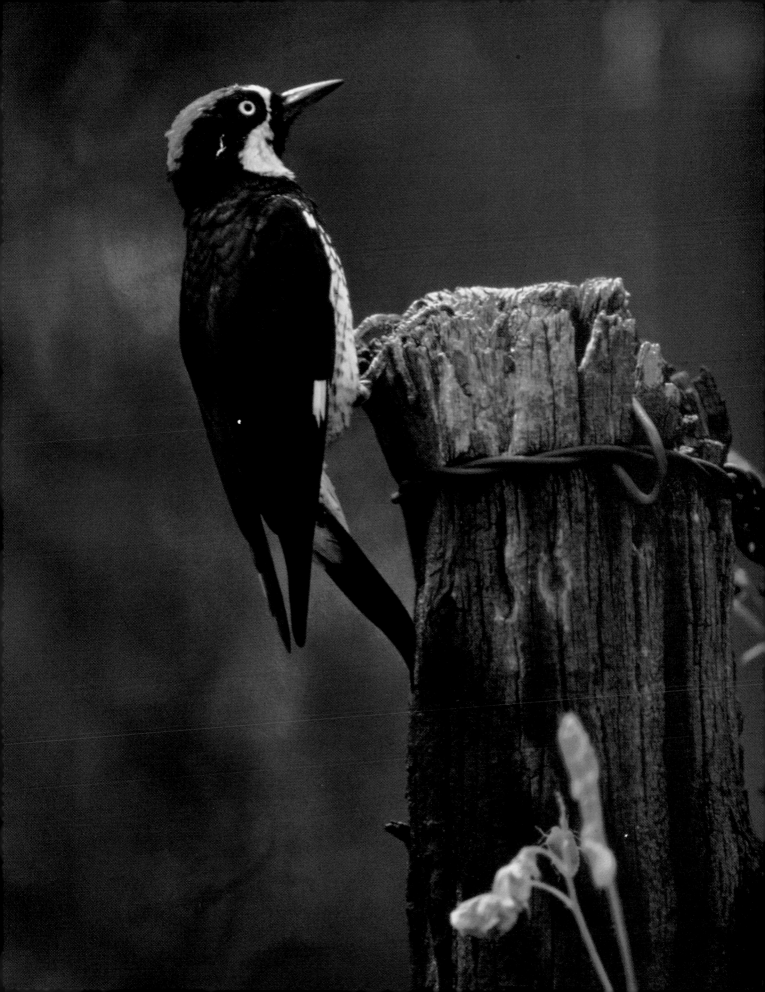

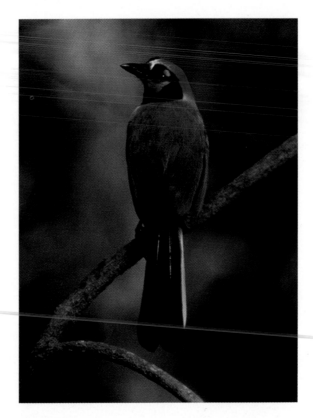

GREEN JAY PHOTOGRAPHED WITH TOKINA ZOOM
80-200 ATX S.D. F2.8 LENS AT SANTA ANA NWR,
TEXAS. FUJICHROME 100 FILM.

Film

Use whichever kind of film you prefer. There are advantages and disadvantages to almost any format. Most professional photographers use slide film in the 35mm format with a slower ISO (formerly known as ASA) rating, perhaps 50 or 100. Also, the industry standard for book and magazine publications is slide film in the 35mm format. To determine which type of film is slide and which is print, simply look at the name of the film. If the extension includes the word "chrome," the film is for slides. If the word ends with "color," the film is for prints. Kodachrome 25 film, with ultra-fine grain and accurate color rendition, has been the gold standard. Kodachrome 64, highly regarded by professional photographers, is faster with outstanding color and sharp grain, plus archival quality if kept in a cool, dark location. Kodachrome 200 is useful in dim light situations, although it generates somewhat grainier images.

You should store film in the refrigerator or freezer, and your slides, negatives, and prints in a dark, cool area that has low humidity. You can place slides and negatives in archival-safe plastic sleeves or pages. The labels on these sleeve packages should indicate if it is archival-safe.

Print film creates a negative image that is used to make a print. It has many advantages over slide film and may offer greater sharpness, even when you use a much faster film speed. Print film allows greater latitude in exposure, and the

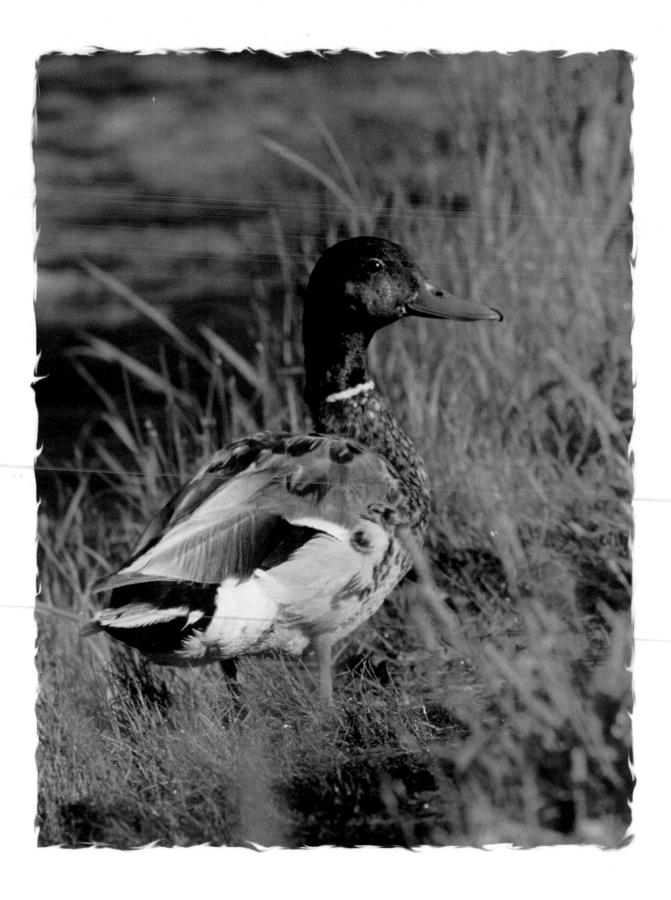

THE JOY OF BIRD PHOTOGRAPHY

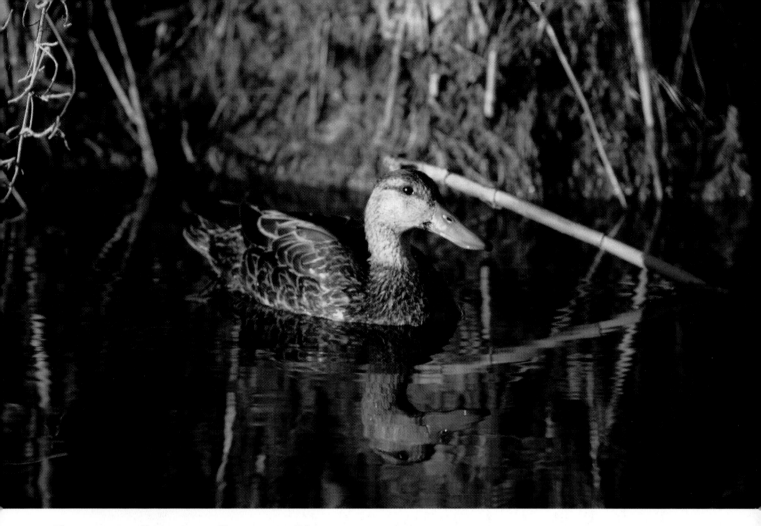

Mottled duck, Texas coast. Kodachrome 64 film enhances the bright, realistic, and natural-appearing colors, 600mm f4 lens.

◁

Mallard duck, Rochester, MN. Fujichrome 100 film emphasizes the greens of the drake's head, 50–300mm zoom lens.

printing process can correct minor exposure differences. Print film can be converted to slide photographs with some laboratory manipulation. However, it is easier to make prints from slide film, and less expensive, than to convert print film to slides. Usually, slide film can only handle some five stops of light. In other words, with slide film, it is difficult to expose accurately both a white and black brightly illuminated subject in the same frame. Print film does not present the same degree of difficulty.

Slide film (transparency) records the positive image on film and can be used for slide projection as well as for making prints. Slide films with speeds of ISO 50 or 100 usually produce a fine grain and rich color. Fast slide films, ISO 400 or greater, will have larger film grains that may be visible on magnification or projection, and may or may not be desirable. The graininess can create a rather pleasant moody effect.

New films produce so-called disadvantages. For example, dark backgrounds may seem to turn black. A bird in bright sunlight in front of a dark background, photographed with the richly colored Fujichrome Velvia and Elite series film, may cause the background to look like black velvet—a striking effect!

"Professional" film is usually a bit more costly and denotes a precisely aged film with uniform color characteristics. Kodak and Fuji label several of their films as professional. "Non-professional" film, which is simply any film not labeled as professional, may have color changes from batch to batch.

FILM TIPS

Sometimes color films change their color response and photographic sensitivity when used in low-light situations. This is called reciprocity failure and reciprocity color shift. Color film exposed longer than

a second or two may become less sensitive and require exposure compensation of up to two or more times the usual exposure. This varies greatly; you can usually find recommendations about this in the film's package. Some color films may show color shifts into magenta or other colors of the rainbow. That effect can be quite pleasing, or, if you want the result to look more natural and true to life, you can use a filter that is recommended by the film's manufacturer.

Use color print film to handle the contrast extremes that are found in bright light situations. Bright sunlight can allow the fastest of shutter speeds to stop the motion of flying birds, but this light is likely to cause sharp shadows and severe contrast between light and dark, which slide film does not capture well. Color print film is much more forgiving.

For slide film photography, try the effect of overcast, even foggy or misty days, with the soft light and very

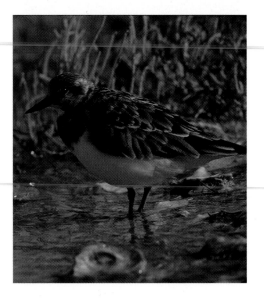

RUDDY TURNSTONE, TEXAS COAST. FUJICHROME VELVIA FILM PRODUCES RICH, ENHANCED "LIQUID CANDY" COLORS, ALONG WITH A VERY FINE GRAIN. MANY PROFESSIONAL PHOTOGRAPHERS EXPOSE THIS ISO 50 FILM AT ISO 40 FOR BETTER COLOR RENDITION.

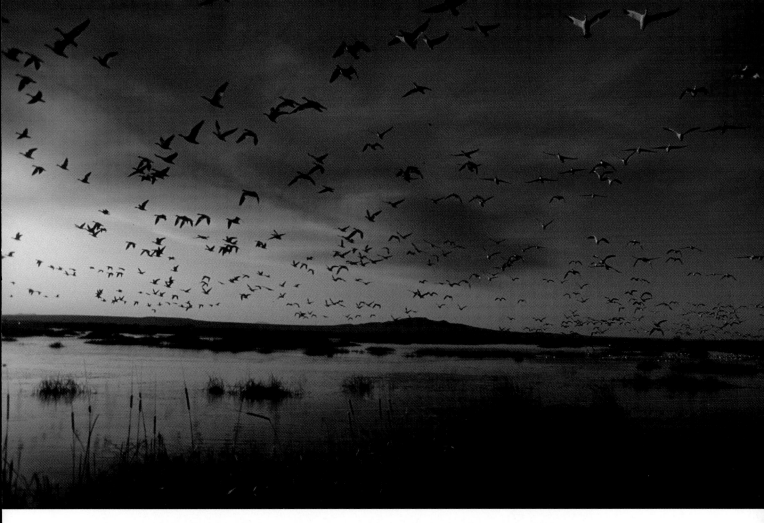

SUNRISE SPECTACULAR AT BOSQUE DEL APACHE NATIONAL WILDLIFE REFUGE, NM.
THOUSANDS UPON THOUSANDS OF GEESE, DUCKS, AND SANDHILL CRANES, WITH AN
OCCASIONAL WHOOPING CRANE, FLY NOISILY JUST OVER YOUR HEAD AT THIS POPULAR
REFUGE. FUJICHROME 100 FILM, 1/250 SECOND, 24MM WIDE-ANGLE LENS.

limited contrast between the lightest and darkest subjects. This can bring out
remarkable richness in colors. Pre-dawn, twilight, and dusk can be interesting
times to photograph also, just remember to stabilize the camera to allow extra
light due to longer exposure required.

To produce richer color saturation and to intensify the mood of a slide, you can
slightly underexpose the film by approximately one-third f-stop, set the camera's
film speed dial at 125 instead of 100 for ISO 100 film, and use the camera's
built-in light meter as indicated.

Some professional photographers like to use slow, fine-grained film to take the
photo, and then use a technique called push-processing to develop the film.
Push-processing is altering the development time, as though the film had been
taken at a different ISO setting, to change the finished result of the film. This process

"WARRIORS IN THE MIST." TWO TURKEY GOBBLERS DISPLAYING FOR AN ADMIRING, APPRECIATIVE HEN. FUJICHROME 100 FILM, PRE-SUNRISE, FOGGY, 600MM F4 LENS.

BLACK-BELLIED PLOVER, TEXAS COAST. I PHOTOGRAPHED THIS ON A SLIGHTLY OVERCAST DAY, WHICH ALLOWED THE KODACHROME 64 FILM TO RECORD BOTH THE WHITE AND THE BLACK TONES ACCURATELY. IF THE DAY HAD BEEN BRIGHT AND SUNNY, THE CONTRAST WOULD HAVE BEEN TOO GREAT FOR ACCURATE PHOTOGRAPHIC REPRODUCTION. PHOTO BLIND, 600MM F4 LENS, EXPOSED AS METERED BY CAMERA.

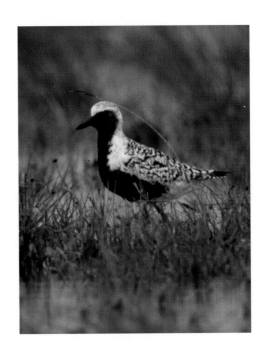

◁
MALE CARDINAL IN SAGE BUSH. FUJICHROME 100 FILM'S COLOR ENHANCEMENT TURNS THE BACKGROUND TO BLACK VELVET— A NICE EFFECT! 600MM LENS.

MULESHOE NATIONAL WILDLIFE REFUGE, TX. SANDHILL CRANES FLY IN FRONT OF A FULL MOON. THE TRICK HERE IS TO POSITION YOUR AUTOMOBILE IN LINE WITH FLYING FLOCKS OF BIRDS IN RELATION TO THE FULL MOON, DURING TWILIGHT, BEFORE THE SKY GETS TOO DARK. KODACHROME 64 FILM, 600MM F4 LENS, 1/250 SECOND.

allows the photographer to use a relatively slow film, such as ISO 100, with its sharp grain and excellent color, as though it were an ISO 200 film. Many different films can be push-processed. If you are going to use this development technique, you should take all of the frames on the roll at the same setting. Some photographers keep a spare camera body loaded with different speed film for use in reduced light situations.

▷

GREEN JAYS, SANTA ANA NATIONAL WILDLIFE REFUGE, TX. FUJICHROME 100 FILM PRODUCES GLORIOUS GREENS AND BLUES, DESCRIBED AS "LIQUID CANDY COLORS." TOKINA ZOOM 80–200 ATX F2.8 LENS.

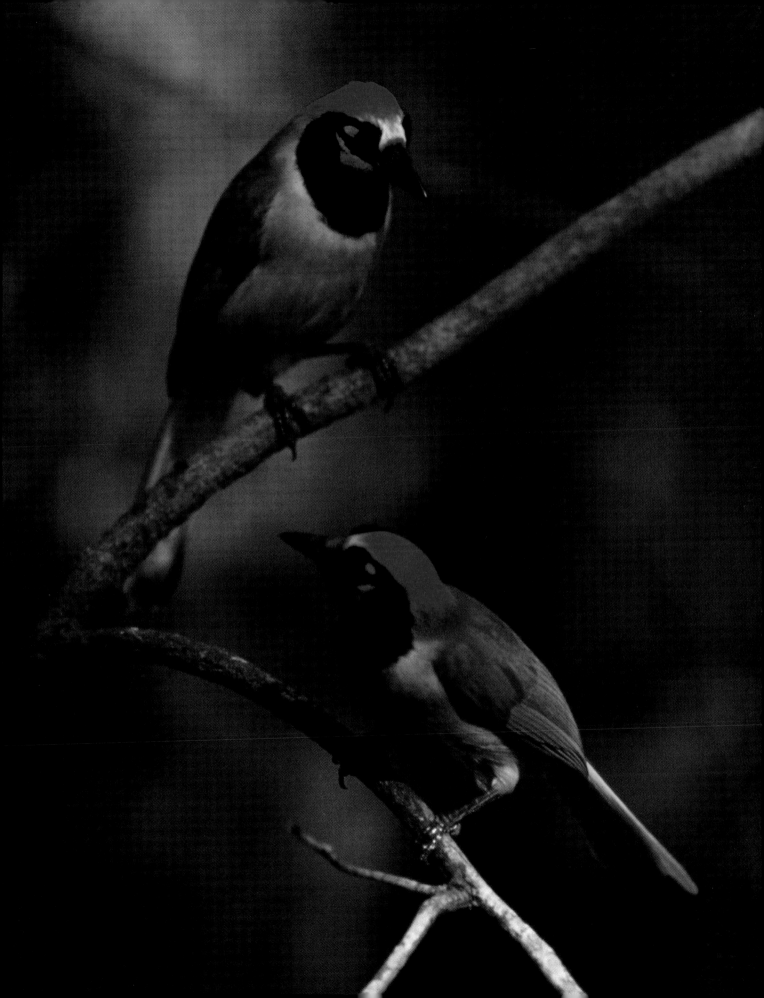

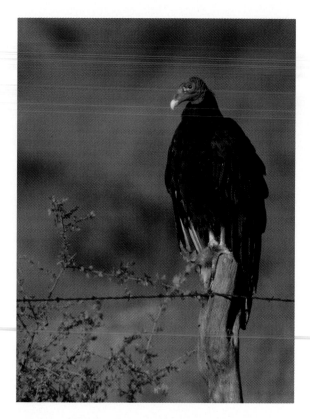

TURKEY VULTURE, TEXAS COASTAL PLAINS, ROADSIDE PHOTOGRAPH. NOTICE THE PLEASANT CONTRAST OF RED HEAD AND GREEN FIELD BACKGROUND. FUJICHROME 100 FILM, 600MM F4 LENS, WITH 1.4X TELE-EXTENDER, BEAN BAG WINDOW MOUNT, AUTO PHOTO BLIND, EXPOSED AS METERED.

Photographic Blinds

Photographic blinds conceal the photographer so he or she can photograph in a close-up situation without disturbing the subject. You can find blinds at U.S. national wildlife refuges. Some of the very best include the Santa Ana National Wildlife Refuge in South Texas and the wildlife viewing area at the Chamber of Commerce in Jackson, WY, which overlooks an elk refuge. The latter has a pond that is surrounded by shorebirds, ducks, migratory warblers, black-billed magpies, and trumpeter swans.

To construct your own blind, use plywood, or, for a more temporary blind, cardboard (e.g., a large refrigerator box with camera ports cut out with a knife). Spray paint in camouflage colors. Make sure that backlighting does not cause an outline or silhouette of yourself, as this may scare off birds. You can also build floating blinds around wading inner-tube setups and cover with military-surplus camouflage netting or other camouflage material, such as the kind that resembles tree bark. Floating blinds allow you to drift fairly close to shore birds, wading birds, ducks, and geese. A large-brimmed hat with a knitted arrangement that fits around the top of the hat works as a portable blind. L.L. Rue Co. and Lepp Enterprises sell a variety of portable photo blinds that are easy to set up.

FROM THIS BLIND AT THE SANTA ANA NATIONAL WILDLIFE REFUGE IN TEXAS, YOU
CAN OFTEN SEE KINGFISHERS, GREAT KISKADEES, GREEN JAYS, AND MANY OTHER
SOUTH TEXAS/MEXICAN "SPECIALTIES."

▷

KING RAIL AT DAWN WITH GOOD SUN
CATCHLIGHT IN EYE, ANAHUAC NATIONAL
WILDLIFE REFUGE, TX. AUTO BLIND,
300MM F2.8 LENS.

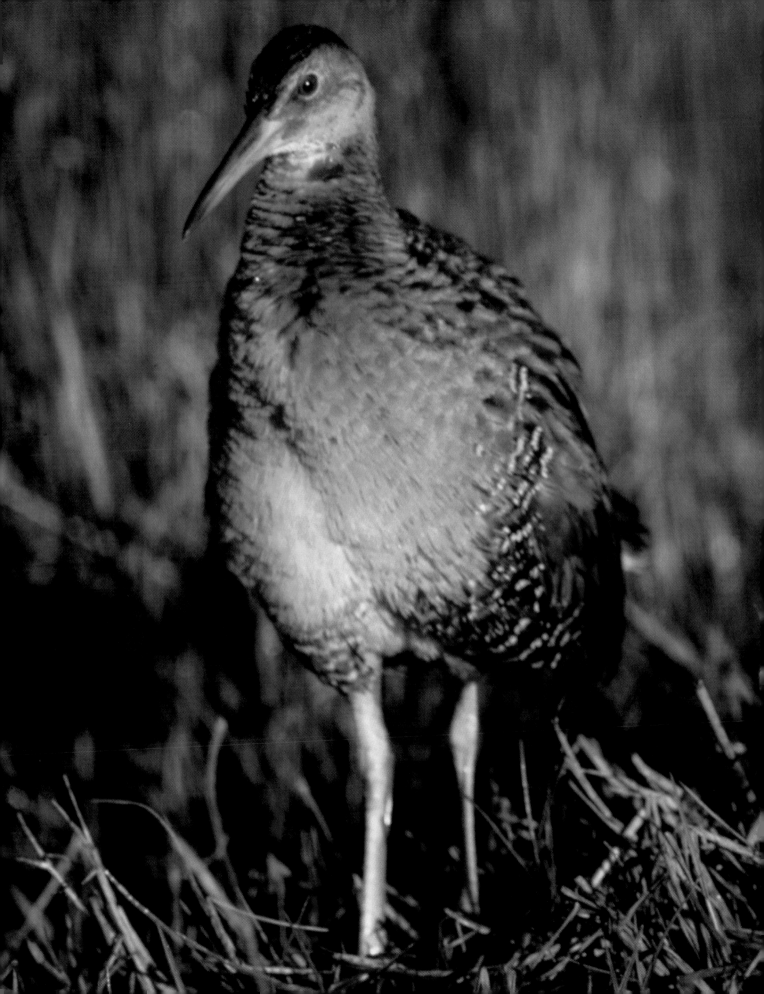

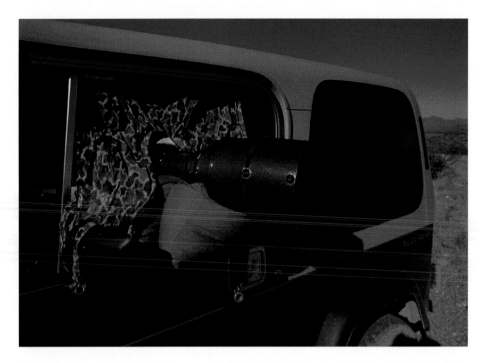

BEANBAG, WINDOW MOUNT, AND CAMOUFLAGE NETTING HUNG FROM INSIDE OF JEEP TO CONCEAL ACTIVITY INSIDE. TINTED WINDOWS ALSO CONCEAL MOVEMENT. THIS IS SET UP BEFORE DRIVING UP TO BIRD. I TOOK SEQUENTIAL "INSURANCE SHOTS" AS I SLOWLY AND CAREFULLY APPROACHED THE DISTANT BIRD.

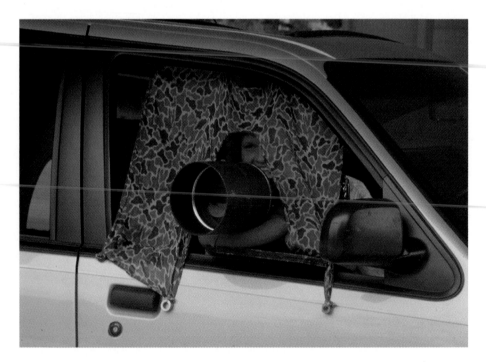

MY WIFE, BARBARA, PHOTOGRAPHING FROM A MOBILE PHOTO BLIND.

An automobile makes an ideal mobile photographic blind. Most wild birds, especially those in national wildlife preserves and parks, are quite accustomed to motor vehicles, as long as the person stays in the automobile. If you open the door, more than likely, away they will go. Move slowly and consider using camouflage netting to make semi-opaque curtains, which will conceal you and assure that all the bird can see will be a stationary telephoto lens. It helps if the automobile's windows are tinted. If you want to photograph a bird that is down the road in the distance, set up the lens and camera before you reach the site from which you wish to take the photo. Approach slowly and coast to a stop when you reach a place where the lighting is best and the background is striking and photogenic. Try to get as close as possible and remember, SAFETY FIRST! Pull completely off any roads or highways. Be sure to turn the engine off, as engine vibration can ruin a photo. If you are approaching a bird that is in the distance and which might fly away, you should take sequential photos as you get closer. Use a window mount for camera/lens stabilization. Whichever type of blind you use, it is important to be as still and as quiet as possible, making necessary movements very slowly.

DELIGHTFUL, SOCIABLE BLACK-BELLIED WHISTLING DUCKS SHARE A PERCH ON TOP OF THE NEST BOX IN DEEP SOUTH TEXAS. "GRAB SHOT" FROM AUTO, 600MM F4 LENS.

SANTA ANA NATIONAL WILDLIFE REFUGE, SOUTH TEXAS. PHOTO BLIND. 24MM
LENS, FUJICHROME 100 FILM, #127 TIFFIN 812 WARMING FILTER. FILTER
BRIGHTENS UP THE OTHERWISE COOL, BLUISH TINT OF THE EARLY MORNING
DAYBREAK.

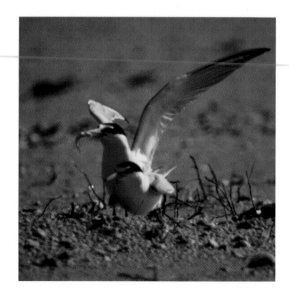

LEAST TERNS OFFERING MINNOW IN
COURTSHIP DISPLAY, TEXAS COAST.
AUTO BLIND, 600MM F4 LENS, 2X
TELECONVERTER.

VIEW FROM INSIDE AUTO PHOTO BLIND.

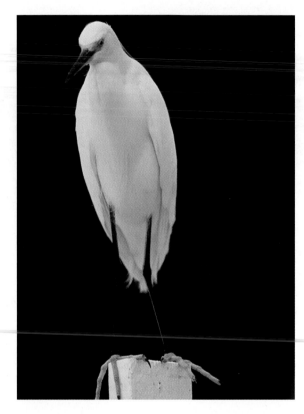

SNOWY EGRET WITH "GOLDEN SLIPPERS" SITTING ON
WHITE POST ON SANIBEL ISLAND, FL. THE BIRD WAS
UNDEREXPOSED ONE STOP FROM THE CAMERA/METER
READING TO AVOID WASHED-OUT APPEARANCE.
300MM LENS, TRIPOD.

Composition: Bringing It All Together

Composition is the true art of photography. It involves a sense of balance within the picture. You can achieve balance in photos by creating a feel that everything fits in a way that is comfortable for the viewer. Before you start composing your own bird photographs, you should look at photographs and paintings that you enjoy and ask yourself why you like them, how you feel about the placement of the main subject of interest, and if you prefer a photo in which everything is in focus or one in which just the subject is sharply defined. Once you are aware of what you like, it will be easier to compose your own. The following tips will help you create breathtaking photographs of birds.

- Watch birds or take a birding course to familiarize yourself with their activities and behavioral patterns. Understanding bird behavior can help you photograph takeoff times for flying bird photography. For instance, cranes often start stepping forward before takeoff, while swans may telegraph their takeoffs by nodding to other birds. Raptors, such as hawks and eagles, may defecate just before they lift off. If a bird is jittery, makes lots of noise, and seems agitated, it might be about to fly away. This would be a good time to capture a takeoff.

- Follow the "Rule of Thirds" by dividing the viewfinder screen into thirds with imaginary vertical and horizontal lines. Place the bird subject where these lines intersect. This intersection then becomes one of the "cardinal points."

- On the other hand, a bird might look more natural if placed squarely in the center of the frame. Experiment and use what looks and feels right to you.

- Gauge the placement of a bird in the camera viewfinder by the flow of the bird's posture and attention. Make sure the bird has lots of room to fly or look into. Allow a flying or swimming bird space to enter the frame instead of taking the photo as it is about to move out of the picture.

- Place a small bird in an obscure corner of a wide-angle photo. The contrast between the bird and the relative intensity of the background, perhaps the ocean, can lead to a very dramatic photo.

- If the bird is moving, gently ease into a position that will allow you to set up your camera and wait for the bird's approach. Remember to take sequential photos as you approach a bird, as birds have a way of flying off before you are finished. Have your light meter settings in place, your camera and tripod ready to go, and plenty of film left in your camera.

- Ask yourself if the subject would look better placed horizontally or vertically. Tall birds, such as herons and egrets, often seem to fit better in vertical framing. A woodpecker on a snag or tree trunk often looks best when photographed as a vertical image. Horizontal composition may give a feeling of tranquility and peace; whereas, vertical composition is more often associated with tension and drama. Remember that book and magazine covers often require vertical photographs.

- Separate the bird from the background, making sure that its bill does not blend in and get lost in foliage. Colored backgrounds of foliage or flowers are usually more pleasing than the sky. A distracting background can be beautiful if it is thrown out of focus with a large f-stop setting on your camera. Use the depth-of-field preview button to see whether changing the f-stop to blur the background improves the picture.

- Change your angle-of-view up, down, or sideways to arrange the best background to complement the bird photograph. This can make the difference between an okay photo and a calendar shot. You may not have to move far to do this. Try to line up just the right background light and color to set off the bird's plumage in a pleasing way.

- Take photos from the same plane as the bird, rather than from above or below. This will seem more natural. The exception, of course, would be a flying bird, which is more than likely going to be a bit higher than the photographer, perhaps even directly overhead. The viewpoint

from which you photograph the bird can add a lot to the effect and impact of the photo.

🐦 Look for striking color combinations. Use one of the most important tricks in bird photography: Find a colorful background. Try photographing reddish birds with a brilliant yellow or green background. Purchase a color wheel at an art supply store to understand which colors complement each other.

🐦 Photograph birds with related objects that tie into the bird's ecology. For instance, take photographs of roadrunners with lizards, shorebirds with crabs, and so forth.

🐦 Search the edges and corners of your camera's viewfinder to make sure there are no distractions or unwanted objects. Usually simpler is better. Too many objects in a scene can make a photo look busy and distracting.

🐦 Use the depth-of-field preview button to see if the emphasis on the bird and the background is what you really want. You may choose to have just the bird isolated, or you may wish to have the bird in sharp focus along with an interesting background. The choice is yours.

Remember that your bird photography should be for enjoyment and pleasure, and you are the best judge of what you like. The best tip seems to be simply to take the photographs that you like best, the way you want them to appear.

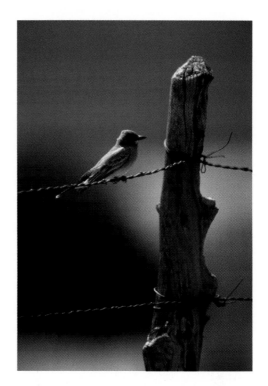

KINGBIRD ON FENCE WIRE NEAR DAVIS MOUNTAINS PARK, WEST TEXAS. THIS IS AN EXAMPLE OF THE "RULE OF THIRDS." I PLACED THE BIRD IN ONE OF THE FOUR POINTS OF INTERSECTION—THE "CARDINAL POSITION"—OF TWO PARALLEL HORIZONTAL AND TWO VERTICAL LINES, WHICH DIVIDE THE FRAME INTO THIRDS. AUTO BLIND, 600MM LENS.

▷ ▷

BARROW'S GOLDENEYE SURROUNDED BY REFLECTIONS OF SKY AND TREES YELLOWSTONE NATIONAL PARK, WY. THIS IS AN OPPORTUNITY FOR DO-IT-YOURSELF CROPPING PRACTICE TO CREATE A PICTURE WITHIN A PICTURE: TRY HOLDING CARDBOARD INDEX CARDS AROUND THIS BIRD IN DIFFERENT POSITIONS. YOU MIGHT PREFER THIS PHOTOGRAPH AS A HORIZONTAL IMAGE, OR A CLOSELY CROPPED VERTICAL SHOT. THIS BOOK HAS A CHAPTER ON WAYS TO IMPROVE AN IMAGE AFTER A PHOTOGRAPH IS TAKEN, AND MANY PHOTOGRAPHS LEND THEMSELVES TO CREATIVE MANIPULATION.

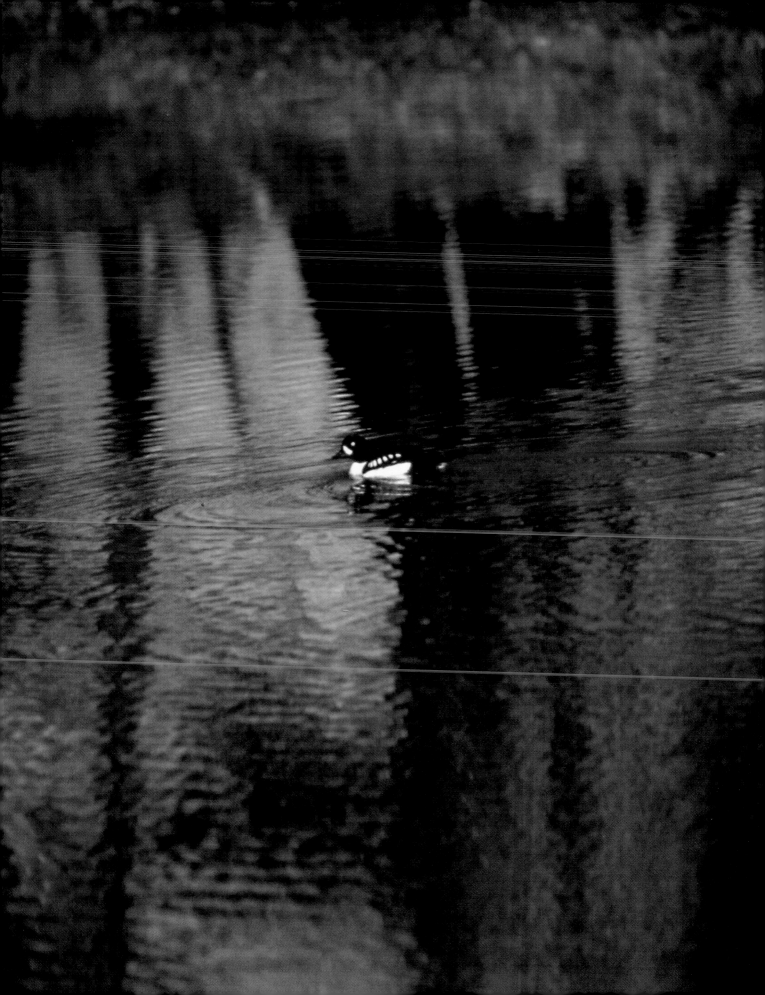

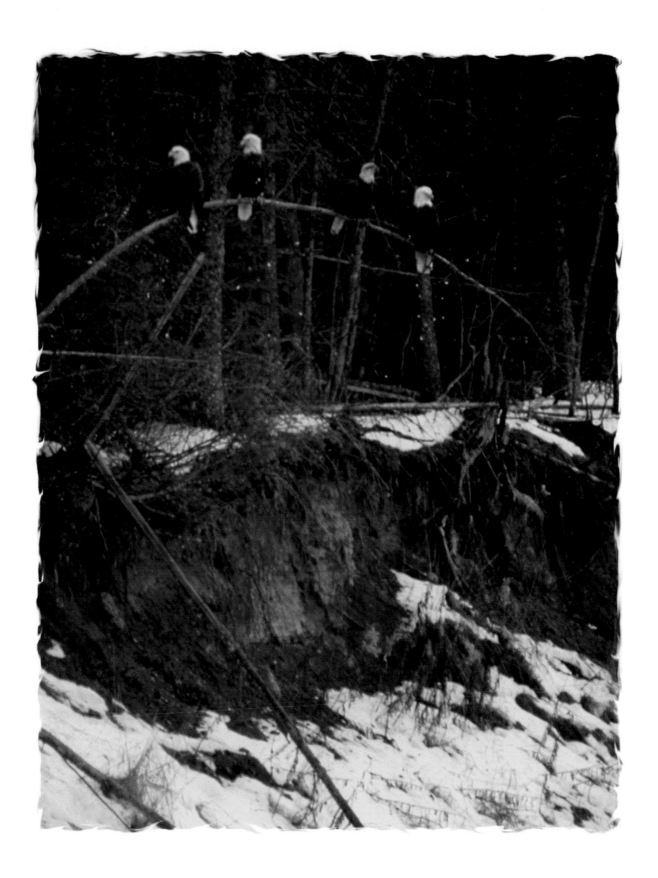

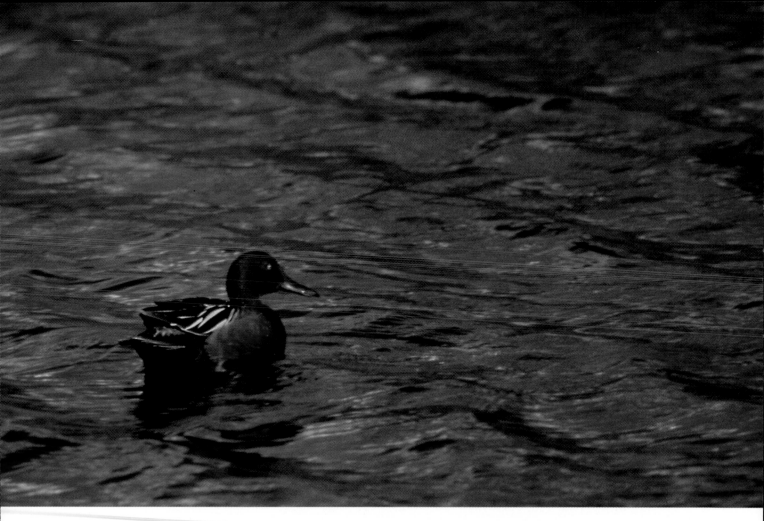

CINNAMON TEAL, JACKSON, WY. A REFLECTED BARN IN BACKGROUND ADDS COLOR
TO THE WAVES. I PLACED THIS PRETTY LITTLE DUCK IN ONE OF THE FOUR
"CARDINAL POSITIONS" OF THE FRAME, THE POINT OF TWO HORIZONTAL AND
VERTICAL INTERSECTING LINES. 50–300MM ZOOM LENS.

◁
FOUR BALD EAGLES ON ARCHING TREE,
GLACIER NATIONAL PARK, MT.
THE LOOPING SYMMETRY IS AN
APPEALING COMPOSITION. 600MM LENS.

FOCUSING

Sharp focusing is crucial. A sharp bird photograph starts with a bright image in the viewfinder. A large-aperture lens lets in lots of light for a bright photograph. Attachments for the viewfinder (bright matte-type, unlined focusing screen) are available, such as the Beatty Intense Screen II, which magnify the image and allow precise focusing in dim light. However, these devices may affect your light meter reading. Some photographers prefer a viewfinder that is divided by lines. These are useful for subject placement, but it is often best to avoid a split-field viewfinder, as it does not work well with telephoto lenses.

Try the quick focusing technique by going directly to the point of sharpest focus without rocking the focus ring back and forth. Get good at this and you will catch more photos of that special moment. Keep both eyes open at all times, as this will prevent eye strain and allow your other eye to be aware of movement and other photographic opportunities. Don't wait too long to take a photograph if there is a chance that a bird might move or fly away before you can take the perfect shot. Remember that a fair bird photo is better than no photo.

EXPOSURE

You can take many beautiful photographs using the built-in, automatic exposure meter (measures light entering lens and automatically sets the shutter speed and f-stop) within your camera. I use the camera's meter and occasionally add or subtract light, opening up or stopping down, depending on what sort of effect I want. A spot meter or optional light meter is handy also, but most cameras have built-in meters which, when used with a telephoto lens, create an effective spot meter (measures the light reflected from a small portion of the subject, allowing only that portion of the photo to be properly exposed). The camera instructions explain how to set and lock an exposure, which is metered on either the bird, the background, or a combination, called matrix or weighted metering.

If you do not want to use your camera's automatic exposure meter, you can obtain the basic setting for manual exposure by using the guide numbers that are in every roll of film. For example, the bright sunlight exposure for Kodachrome 64 film (64 is film speed) is 1/125 second (shutter speed) at f11 (f-stop or f-number). You can simply set your camera's exposure and f-stop setting to this, or the equivalent setting, such as 1/50 second at f8, and so forth. Increase or decrease exposure as directed in the film's instructions for cloudy, bright, overcast days, etc. You can manually increase or decrease the f-stop with the exposure compensation dial on your camera, or you can change the ISO setting (film speed)—higher numbers decrease the exposure.

Some professional photographers either estimate the exposure or use a meter to evaluate the light from a gray card. A gray card reflects 18 percent of the light shining on it. A light meter reading taken from a gray card that is in the same light as the photographic subject gives the correct exposure. Some photographers may choose to use the camera's light meter to evaluate the exposure from various objects that they know will have this 18 percent reflectance in the same light that bathes their bird subject. A basic principle is to use a meter that averages the entire scene. If you are photographing a white bird in a dark background and the bird occupies a small percentage of the frame, underexpose the photo by decreasing the f-stop by one less than the meter indicates. Otherwise, the bird will appear too white and washed out. On the other hand, photographing a dark bird in a very light background will probably require adding a stop of light.

TRUMPETER SWANS, GRAND TETON NATIONAL PARK, WY. I UNDEREXPOSED THE FUJICHROME 100 FILM BY ONE-HALF STOP FROM CAMERA'S METERED SETTING. OTHERWISE, BIRDS MIGHT HAVE LOOKED TOO PALE AND "WASHED OUT." NIKON 50–300MM ZOOM LENS, TRIPOD.

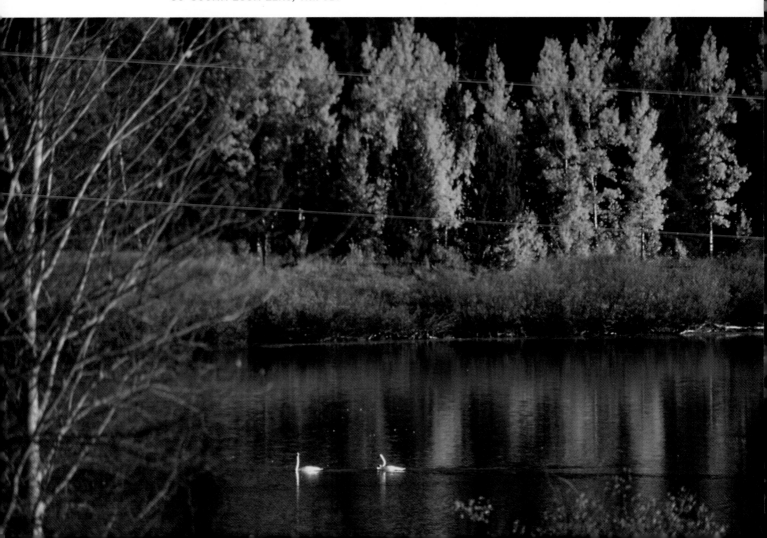

Some photographers prefer the increased richness and saturation of colors gained by slight underexposure, and routinely set their exposure meter at minus one-third f-stop. Underexposure darkens the image, which leads to somber, moody images that range from rich saturation to darker areas of an image turning almost totally black. This can be a very pleasing effect resembling black velvet. I set my camera at minus one-third f-stop and then make further adjustments by simply decreasing the exposure by a full stop or so, as in the case of white birds in dark settings. Other photographers insist on precise, accurate exposure. I think it is a matter of personal preference. Slide film overexposure causes a light, washed out, ethereal appearance that can be quite pleasing in certain circumstances.

A full-frame photo of a very dark or very light bird will fool the light meter, making both birds appear dull gray. Correct this problem by adding an f-stop or so of light for the black bird (to blacken the black). Play with test photos. It is easier than you'd think, and you'll soon automatically correct for each different lighting situation.

Remember the "Sunny Sixteen Rule" and you can get by without a light meter if you have to: With a shutter speed of one divided by the film speed (the ISO number), f16 on a sunny day, your photographs will be properly exposed. Subtract a stop for progressively decreasing light conditions; add a stop for brilliantly illuminated seashore or snow photographs. For example, on a bright day with Kodachrome 64 film, you can use 1/60 second at f16 or the equivalent exposure f-stop combination. The same photograph can take on different moods if you add or subtract one or two stops of light. Try it! You will soon get a feel for this, and you will like the effect.

WADING BIRDS IN FRONT OF SETTING SUN. I ADDED AN ADDITIONAL STOP OF LIGHT TO THE CAMERA'S METERING TO KEEP THE SLIDE FROM BEING TOO DARK. DO NOT LOOK AT THE SUN THROUGH A CAMERA VIEWFINDER, ESPECIALLY WHEN USING A TELEPHOTO LENS, BECAUSE OF THE RISK OF EYE DAMAGE.

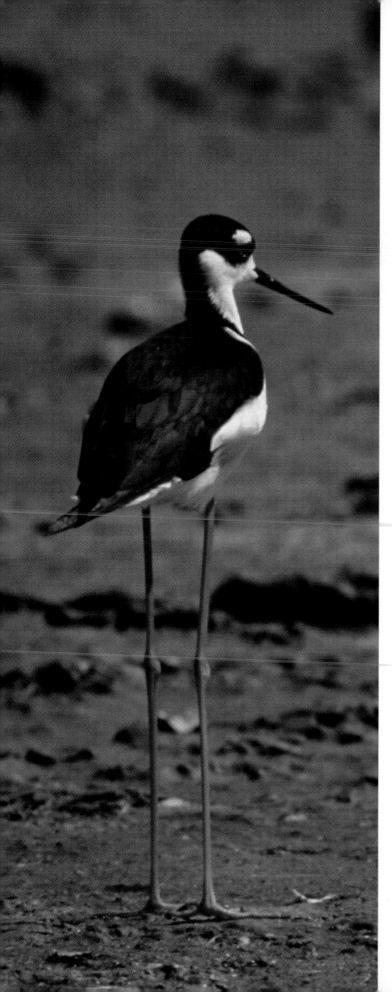

Bracketing

Bracketing has many facets. Bracket an interesting bird scene by taking exposures slightly over or slightly under your usual needed exposure. Bracket by experimenting with different films, as different films will record a bird in a scene differently, often over- or under-emphasizing colors. Bracket with different focal lengths of lenses for different perspectives. Try wide-angle lenses where perspective will be spread out; and long-focus (telephoto) lenses where perspective will be compressed, so everything will look squeezed together. Bracket with and without filters. Bracket with different depths of field: shallow and deep. See how the birds would look if isolated from the environment with a shallow depth of field using the largest available lens aperture, and contrast this to deep depth of field with a tiny lens aperture. Bracket for perspective—close-up versus far away, i.e., the bird being alone versus the bird being part of a panorama. Bracket positions in the scene. In other words, try placing the bird in various positions in the viewing field. Do not limit yourself by placing a bird in just the "cardinal position(s)."

◁

BLACK-NECKED STILT, A VERY WELL-NAMED BIRD, NEAR INDIAN POINT PARK, CORPUS CHRISTI, TX. NOTE VERTICAL CAMERA POSITIONING. I USED SILVER TAPE ON THE SLIDE TO CREATE A PANORAMIC EFFECT IN A VERTICAL DIRECTION. FUJICHROME 100 FILM, EXPOSED AS METERED.

▷

SPARROW ON FENCE POST. NOTICE PLACEMENT OF BIRD IN UPPER CENTRAL POSITION, COLORFUL ALGAE ON POST, AND PLEASANT CONTRAST OF OUT-OF-FOCUS BACKGROUND. 600MM F4 LENS WITH 1.4X TELECONVERTER.

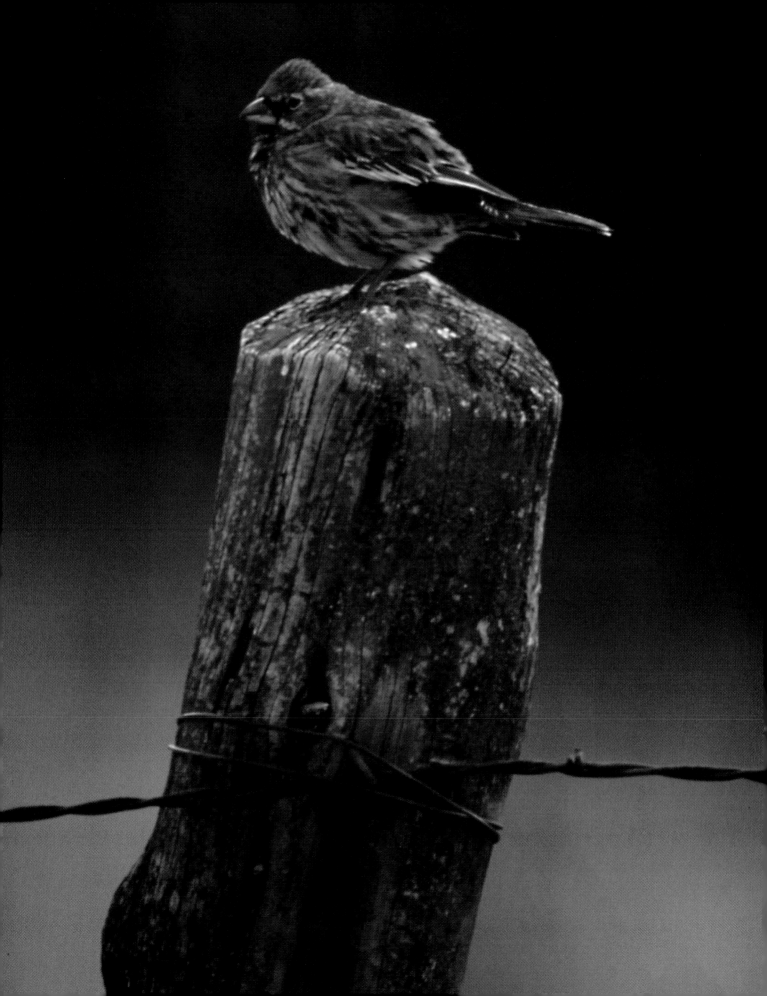

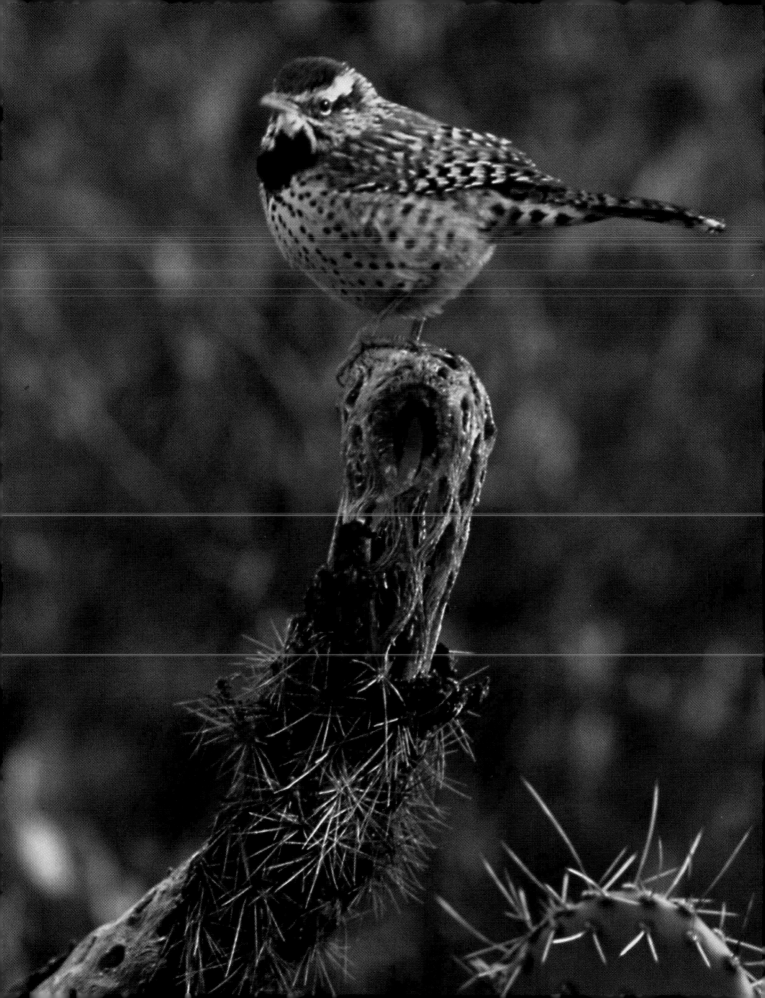

"Magic hour" photograph of Canada geese at Rochester, Minnesota's famous Silver Lake. The rich, warm light of the setting sun makes this a favorite time to take pictures; backlighting causes the glow. Notice the diagonal line entering the lower left corner. Ultra-wide-angle lenses have remarkably deep depth of field, so everything is in focus from nearby objects to infinity. 17mm wide-angle lens.

◁

Cactus wren portrait. The strong diagonal line of the cactus perch fits nicely in vertical positioning. 80–200mm zoom lens.

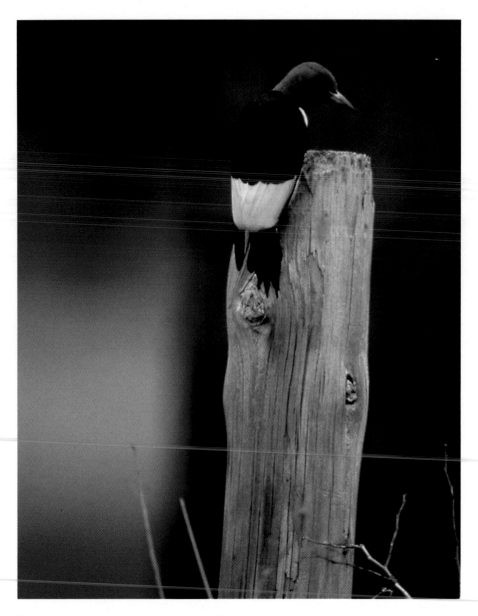

Red-headed woodpecker on post. Note vertical image and bird's position in frame. This composition fits magazine and book covers. "Grab shot," 600mm lens, f4.

▷

Starling in winter plumage, Pacific Coast. Notice the triangular composition, vertical camera position, and strong diagonal of branch. Photographed by Barbara P. Grove with handheld Nikon 50–300mm zoom lens.

SHOREBIRD DWARFED BY WAVES FOLLOWING STORM ON GULF COAST. I DELIBERATELY
FRAMED THIS BIRD IN THE LOWER LEFT CORNER OF THE VIEWFINDER TO EMPHASIZE
THE SIZE OF THE WAVES AND TO ADD INTEREST AND PERSPECTIVE. FUJICHROME 100
FILM, 50–300MM ZOOM LENS.

PHAINOPEPLA, A WEST TEXAS ROADSIDE
PHOTO. NOTE RED EYE, THE PLACE TO
FOCUS A BIRD PHOTOGRAPH, AND STRONG
DIAGONAL OF PERCHING TWIG. THERE IS
A PLEASING OUT-OF-FOCUS, BLURRED
BACKGROUND OF ENHANCING COLOR.
AUTO BLIND, BEANBAG STABILIZATION,
600MM LENS.

▷

ROADRUNNER, WEST TEXAS. NOTE BLUE
SKY BACKGROUND, DIAGONAL LINES OF
BRANCHES, VERTICAL COMPOSITION. THE
BIRD'S EXTENDED CREST IS SPRING
TERRITORIAL BEHAVIOR DISPLAY. AUTO BLIND.

▷ ▷

GREAT EGRET, ROOKERY ISLANDS, TX.
VERTICAL POSITION AND COMPOSITION
ALLOWED THE BIRD SPACE TO MOVE INTO.
PHOTOGRAPHED FROM BOAT, 600MM
F4 LENS.

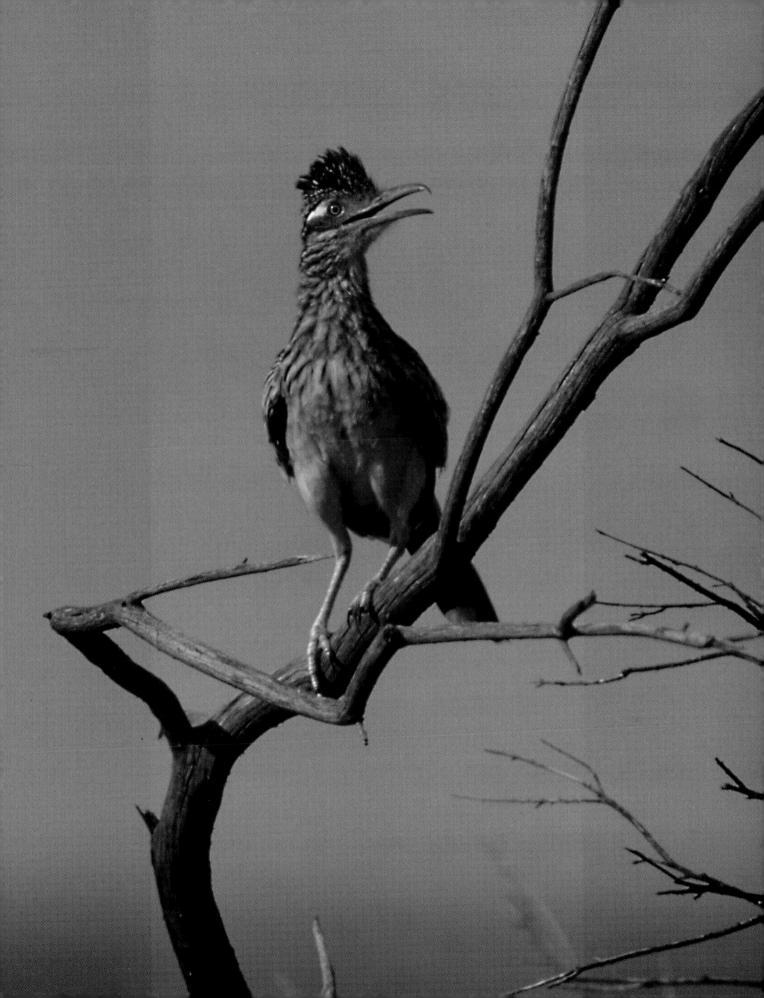

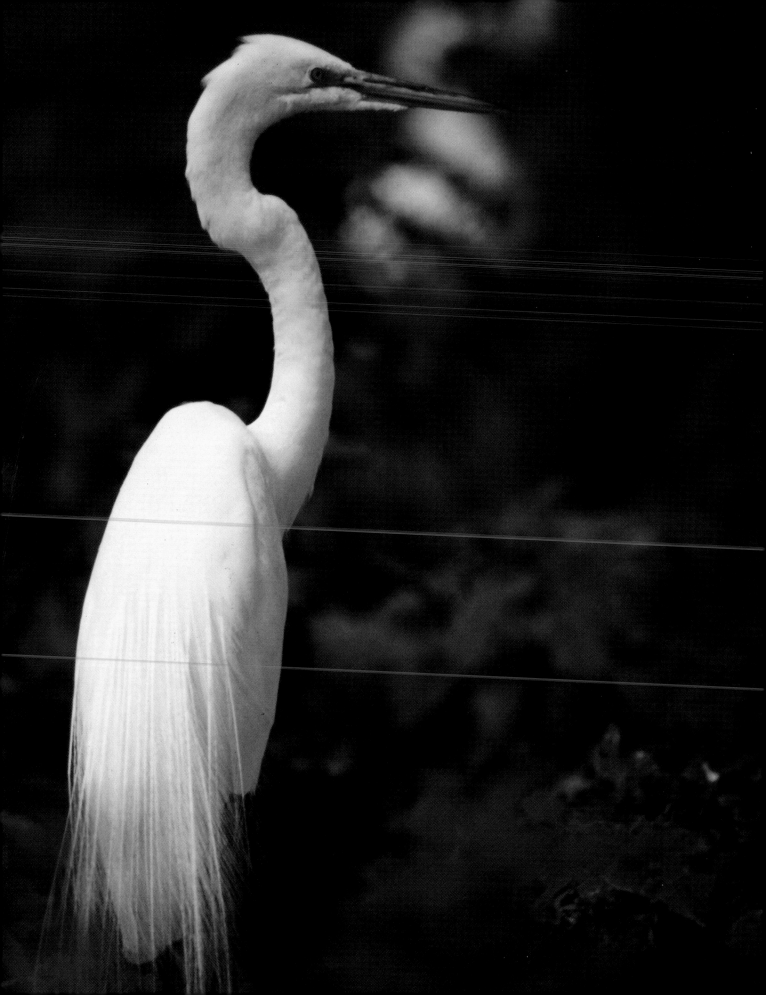

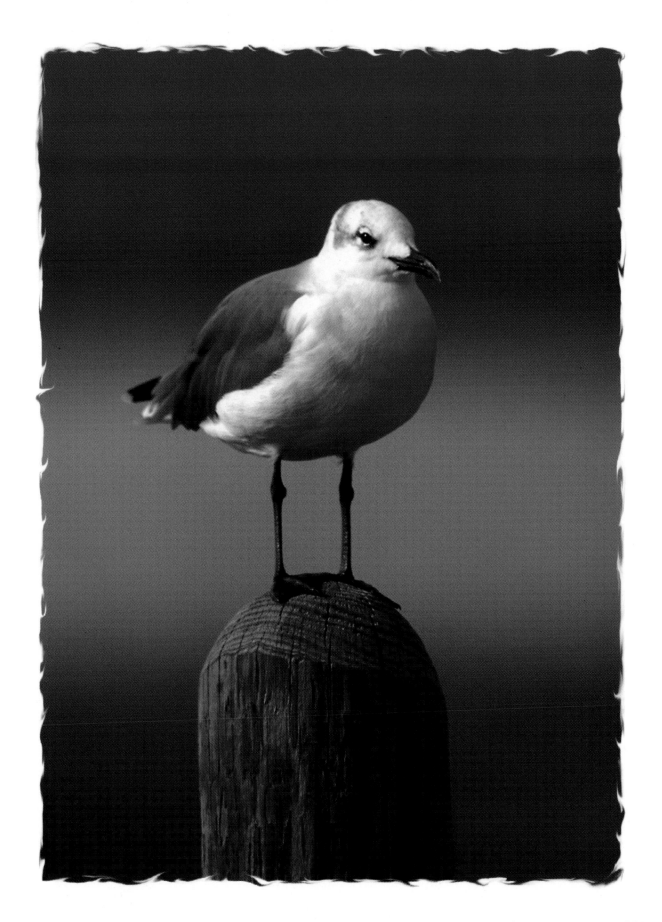

White-crowned sparrow on a very cold winter morning, Bosque del Apache National Wildlife Refuge, NM. Notice vertical camera positioning and upper central placement of this perching bird. Auto blind, 600mm f4 lens.

◁ ◁

Gull perched on top of post, Canadian Maritimes. Pleasant layered, color-contrasting background. Fujichrome 100, 600mm f4 lens, as metered by camera.

▷

Crested caracara, ("Mexican eagle"), a South Texas specialty. Note how the background and bird colors enhance each other. A color wheel shows nice color combinations to look for in your bird photography. Old, reliable 600mm f4 lens.

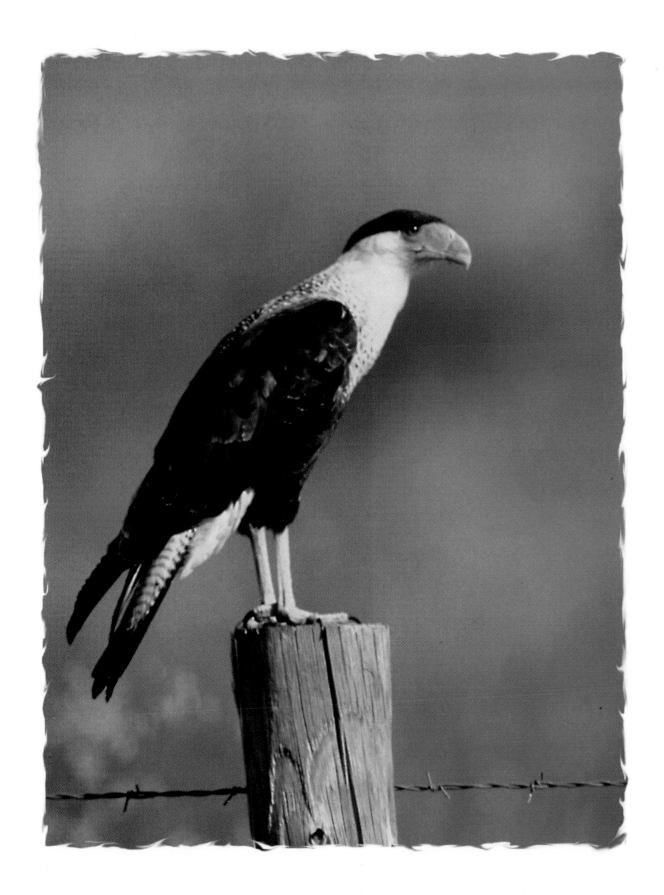

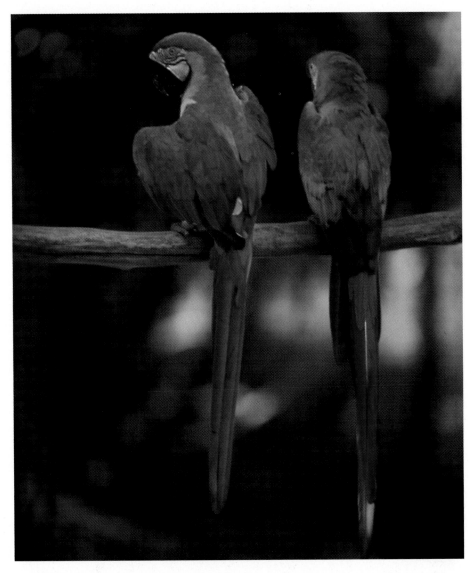

Macaws, Upper Amazon River Basin camp. Birds and perch are illuminated by a spot of sunlight. I separated the subjects from the background. Kodachrome 64 film, Tokina 80–200mm f2.8 zoom lens.

◁

Dawn scene with cormorants and full moon, Ding Darling Wildlife Sanctuary, FL. Notice the triangular composition of cormorant, moon, and moon reflection. This wildlife photo drive is a great place to see, enjoy, and photograph many of Florida's bird specialties in their breeding plumage (winter and early spring) at almost bill-to-lens distance.

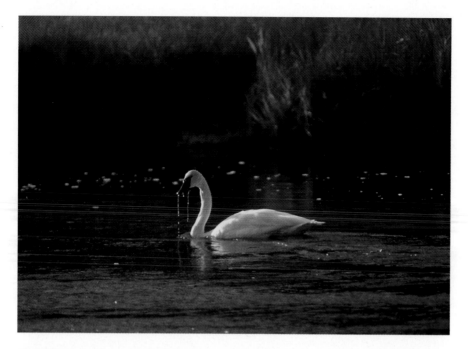

TRUMPETER SWAN, NEAR VISITORS' CENTER IN JACKSON, WY. I UNDEREXPOSED BY APPROXIMATELY ONE-HALF STOP FROM METERED EXPOSURE. KODACHROME 64 FILM, 600MM, F4, TRIPOD-MOUNTED LENS.

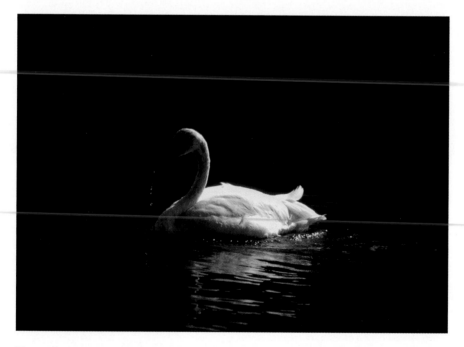

TRUMPETER SWAN, JACKSON WY. I DELIBERATELY UNDEREXPOSED BY TWO FULL STOPS FROM METERED EXPOSURE TO DEMONSTRATE INTERESTING, INTENSE MOODY PORTRAIT.

THE JOY OF BIRD PHOTOGRAPHY

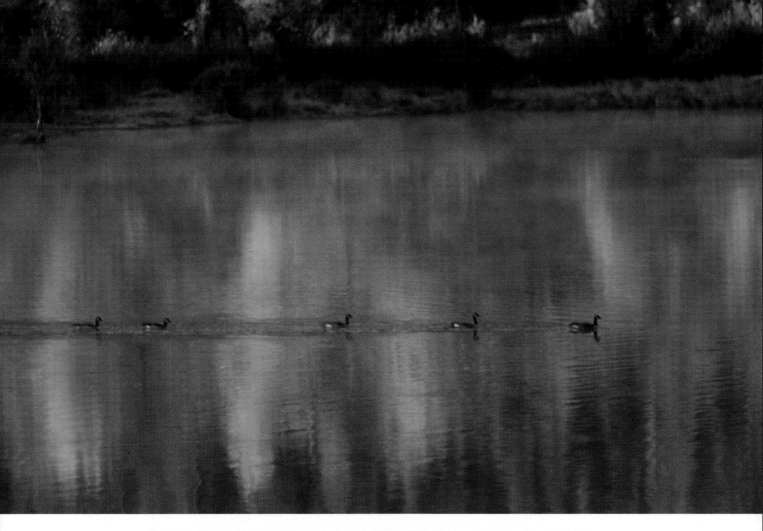

CANADA GEESE, GRAND TETON NATIONAL PARK, WY. FALL COLORS IN REFLECTIONS ADD LIFE TO THE PICTURE. NIKON 50–300MM ZOOM LENS, EXPOSED AS METERED.

◁

COMMON MOORHEN WITH COLORFUL REFLECTIONS IN WATER. VERTICAL CAMERA POSITIONING SEEMS TO FIT THE REFLECTIONS OF BIRD'S NECK AND REEDS. KODACHROME 64 FILM, 600MM F4 LENS, EXPOSED AS METERED.

◁ ◁

YELLOW-HEADED BLACKBIRD REFLECTION IN NORTHERN MINNESOTA POND. THE "C"-SHAPED COMPOSITION OF A SINGING BIRD WAS AN ATTRACTIVE LATE AFTERNOON SIGHT. FUJICHROME 100 FILM, 600MM F4 LENS.

Scrub jay in backyard photo setup demonstrates bird placement in cardinal position using the "Rule of Thirds." The bird looks more natural photographed looking into the camera, rather than away from it. This garden "bird studio" has concealed sources of dripping water and birdseed that are out of sight of the camera.

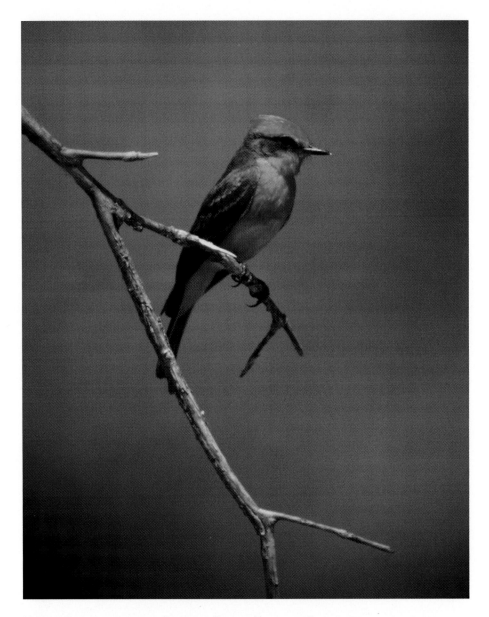

VERMILION FLYCATCHER, CENTRAL TEXAS. THIS BIRD'S BEAUTIFUL COLORATION CONTRASTS NICELY WITH GREEN FIELD BACKGROUND. MANY PHOTOGRAPHERS LIKE TO ROUTINELY SET THEIR ISO SETTING ABOUT A THIRD OF A STOP HIGHER THAN THE FILM'S RECOMMENDED SETTING TO CAUSE SLIGHT UNDEREXPOSURE AND RICHER HUES. KODACHROME 64 FILM, 600MM F4 LENS.

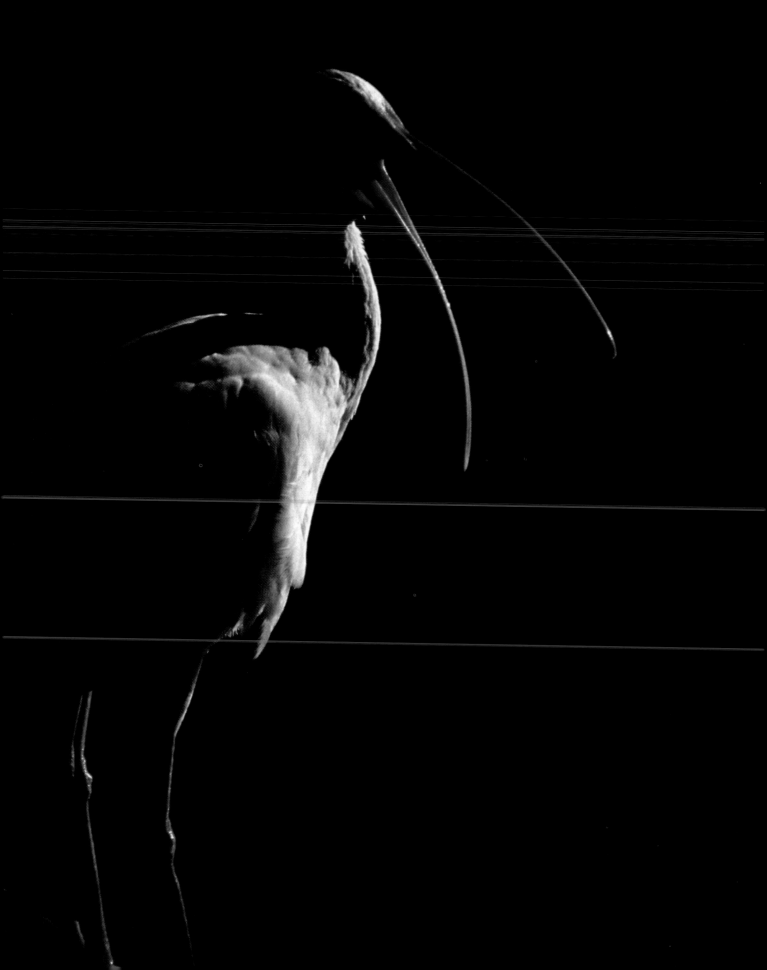

PURPLE GALLINULE, ANAHUAC NATIONAL WILDLIFE REFUGE, TX. NOTE THAT EYE IS
IN SHARP FOCUS. IF A BIRD'S EYE IS SHARPLY FOCUSED, WE TEND TO IGNORE OTHER
PARTS OF THE BIRD BEING OUT OF FOCUS. KODACHROME 64 FILM, EXPOSED AS METERED.

▷

LARGE RAPTOR ON FENCE POST. THE TRICK
HERE IS TO START TAKING PHOTOGRAPHS
IN A SERIES AS YOU SLOWLY DRIVE CLOSER
TO THE BIRD, IN CASE IT SHOULD SPOOK
AND TAKE OFF. A SLOW, GENTLE APPROACH
WILL USUALLY GIVE YOU THE PICTURE
THAT YOU WANT. 600MM F4 LENS WITH
2X TELECONVERTER.

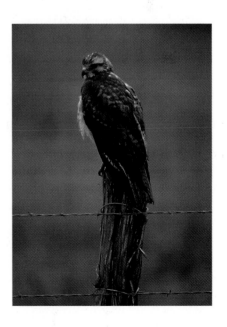

◁

WHITE IBIS. I DELIBERATELY
UNDEREXPOSED KODACHROME 64 FILM
TO EMPHASIZE RIM LIGHTING.

ACTION PHOTOGRAPHY

Flying bird photography is a wonderful test of coordination, and you can expect to use up quite a bit of film. The results, however, will be worth it. It is handy to have an extra camera body with a fresh roll of film nearby when you are doing serious flying bird photography, as there might be a once-in-a-lifetime photo opportunity that occurs just as you get to the end of a roll of film. You can use a different speed film in the backup camera body to expand your choices.

When you photograph flying birds, use the fastest available shutter speed, with the lens as wide open as possible. Using a faster shutter speed to "freeze" a flying bird depends on the direction the bird is going, the speed of travel, and the distance from you. Basically, you will need a faster shutter speed to freeze a bird that is close to you and flying fast across your field of vision. A bird flying overhead might fool the light meter, so try adding perhaps one or so f-stops of exposure to avoid having a dark-looking bird in front of a properly exposed sky.

The focal length of your lens causes a "catch 22": The greater the magnification and image size of the rapidly moving bird, the faster the shutter speed will need to be. For a telephoto lens, this usually means a heavy, large aperture lens is necessary. The longer the telephoto lens and the larger the lens aperture, the greater the weight of the lens, and the greater the expense. A compromise is the 300mm f2.8 lens, sometimes with a 1.4x teleconverter, using a shoulder stock, monopod, or ball-head attachment. The large beanbag is also very useful for photographing flying birds with the beanbag either laid across a car, or held up against a tree. Remember that teleconverters and filters, especially polarizers, may decrease the amount of light, and, therefore, slow the shutter speed. Auto-focus units, which have been perfected and are quite expensive, allow a good percentage of "hits" on flying birds. Some of these units use predictive focus technology.

Catch the action at the peak: A bird "stalling out" while landing with its feathers extended could be a striking photographic subject. Pan with your camera as the bird passes. Some very beautiful photographs have been taken this way at fairly slow shutter speeds, with a deliberately blurred background contrasting a sharply focused subject.

To photograph birds such as swallows or skimmers, which fly in a repeated "touch and go" pattern, freeze the action by pre-focusing on another subject, such as a leaf floating in the water, and fire the shutter when the bird flies past this point. If you use this technique, keep both eyes open and use the eye that is not actively observing the scene in the viewfinder to judge the approach of your subject. You will probably have the bird in focus if you open the lens as wide as possible with the best light, which will result in the appropriate shutter speed and a corresponding depth of field.

Birds and airplanes usually take off and land into the wind. To photograph this action, position yourself so that you will have a combination of favorable wind direction and sunlight. You can capture striking, dramatic photos of many water birds and ospreys either taking off or landing. The national wildlife refuges and various ponds where migrating ducks, geese, and shorebirds gather during migration can be excellent locations for this type of action photography, in which a motor-drive camera may be useful.

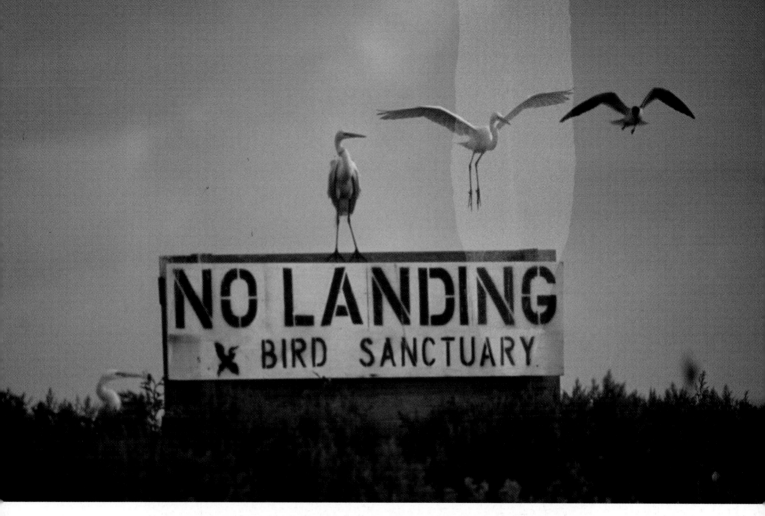

If you photograph a bird in front of moving water or a waterfall, such as a
dipper or a shorebird, try a longer exposure to allow the water to blur on
purpose. Try ⅛ or ¼ second or longer for a very pleasing blurring of a waterfall.
A stationary bird, such as a heron or egret, might stand perfectly still for an
even longer exposure. Use a very small f-stop and consider the use of one or
more neutral-density filters. These add no color to the photos, but restrict the
amount of light, allowing longer exposure time. You can also use the polarizing

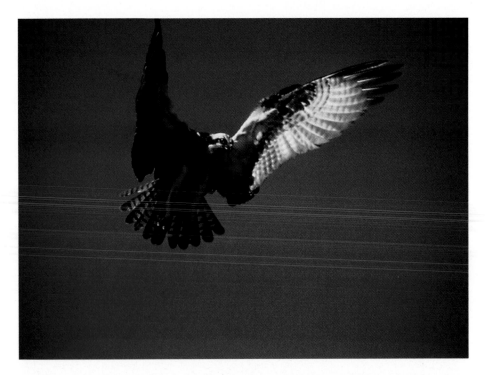

OSPREY LANDS ON NEST. THE NEST (NOT SHOWN) IS BESIDE A HIGHWAY NEAR PINEDALE, WY. THE BIRDS SEEM USED TO PHOTOGRAPHERS. 1/1000 SECOND, 600MM LENS.

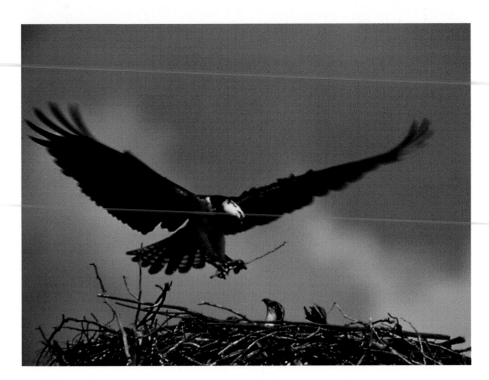

OSPREY IN FLIGHT, DING DARLING WILDLIFE SANCTUARY, FL. MONOPOD-MOUNTED NIKON 300MM F2.8 LENS ALLOWED SHUTTER SPEED OF 1/2000 SECOND WITH KODACHROME FILM. BIRDS, AS DO AIRPLANES, USUALLY LAND AND TAKE OFF INTO THE WIND. YOU CAN COORDINATE WIND DIRECTION, LIGHT, AND CONCEALMENT TO ORCHESTRATE YOUR ACTION BIRD PHOTOGRAPHS.

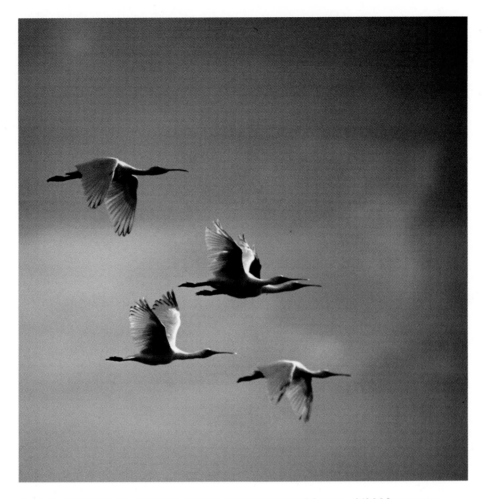

Flying roseate spoonbills, Texas. Kodachrome 64 film, 1/1000 second, 300mm f2.8 telephoto lens.

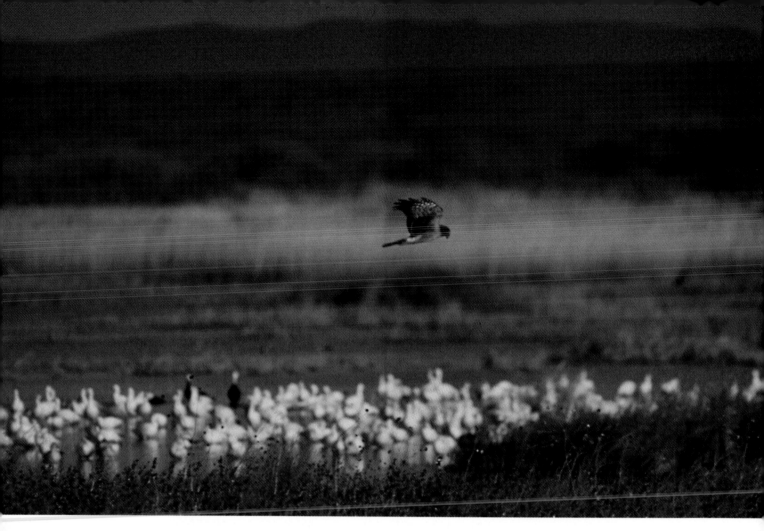

NORTHERN HARRIER, FORMERLY KNOWN AS "MARSH HAWK," BOSQUE DEL APACHE
NATIONAL WILDLIFE REFUGE, NM. THIS BIRD FLEW INTO THE WIND, WHICH SLOWED
ITS AIR SPEED DOWN SO THAT THE MOTION WAS FAIRLY WELL STOPPED BY 1/500
SECOND. FUJICHROME 100 FILM, 600MM F4 LENS, BEANBAG MOUNT.

DIAGONAL SKEIN OF FLYING SNOW GEESE AND
MOON, BOSQUE DEL APACHE NATIONAL
WILDLIFE REFUGE, NM. I USED A SPECIAL
MONOPOD MOUNT THAT I TUCKED IN MY BELT,
SO MY ENTIRE BODY COULD PIVOT. THIS IS A
STABLE MOUNTING TECHNIQUE FOR FLYING
BIRD PHOTOGRAPHY. EXPOSED AS METERED,
1/2000 SECOND, 300MM F2.8 LENS.

filter this way, and for extremely long exposure, you can stack two polarizing filters on top of each other with one being rotated to cause the desired darkening of the image.

SILHOUETTES

Silhouettes of birds can be very eye-catching. The high contrast between a bird and a bright backlighting source can take on a pleasant monochromatic tone. The trick is to find a bird in front of a bright background, so the bird image will appear jet black. This might be a bird that is strongly backlighted, such as one perching in a tree, or wading in water in front of the sun, moon, or brightly lit sky.

The rising and setting sun can create an effect like molten fire. Ask yourself whether you want to have the sun appear dark or bright in a photograph. When photographing a bird that is in front of the sun or a liquid golden pool of sunlight in the water, using the recommended exposure "as is" in the camera, may cause part of the scene to look jet black. The effect will

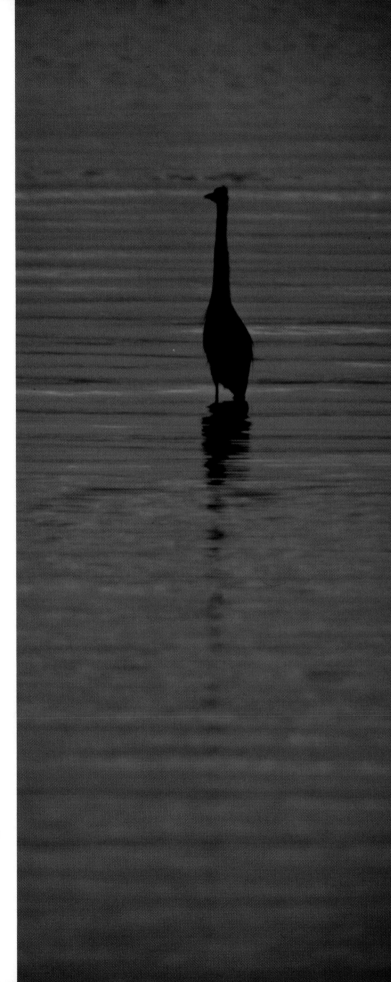

SILHOUETTE OF GREAT BLUE HERON AT SUNRISE, TEXAS. THIS SHOWS HOW A BACKLIGHTED BIRD, PHOTOGRAPHED AS METERED BY THE CAMERA, CREATES A SILHOUETTE PORTRAIT. I EMPHASIZED THE VERTICAL FRAMING BY APPLYING SILVER CROPPPING TAPE DIRECTLY TO THE SLIDE TO CREATE A TALL, NARROW IMAGE.

"V" OF SNOW GEESE WITH BOTH RIGHT-TO-LEFT AND LEFT-TO-RIGHT ORIENTATIONS.
"FLOPPING," OR REVERSING, THE IMAGE CHANGES HOW A PICTURE "FEELS." THERE
IS A FAIR AMOUNT OF OPEN SPACE IN THE FRAME FOR THE BIRDS TO FLY INTO.
FUJICHROME 100 FILM, 1/1000 SECOND, 300MM F2.8 LENS, MODIFIED MONOPOD.

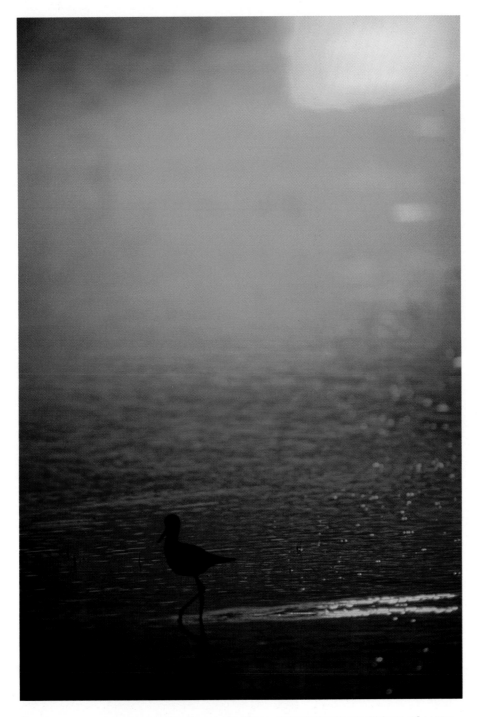

SILHOUETTE OF BLACK-NECKED STILT. VERTICAL ORIENTATION OF 600MM F4 LENS, EXPOSED AS METERED, FUJICHROME 100 FILM.

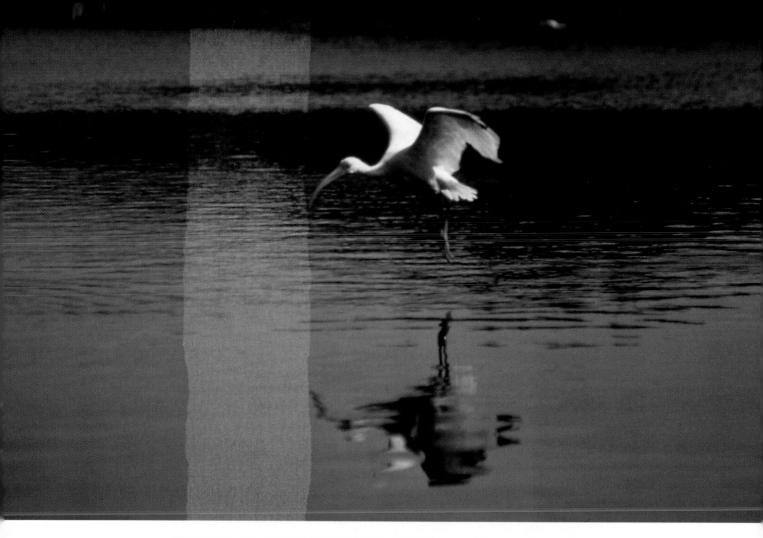

WHITE IBIS. THE FAMOUS MRAZIC POND AT EVERGLADES NATIONAL PARK, FL,
ATTRACTS ALMOST AS MANY PHOTOGRAPHERS AS IT DOES BIRDS, AND THERE ARE
LOTS OF BIRDS! KODACHROME 64 FILM, 1/500 SECOND, 50–300MM ZOOM LENS.

▷

ARCTIC TERN WITH CONTRASTING COLORS.
POSITION YOURSELF TO CAPTURE THE BIRD IN
GOOD LIGHT WITH A NICE BACKGROUND.
KODACHROME FILM, 1/1000 SECOND, 600MM
F4 LENS.

PRE-DAWN SILHOUETTE OF GREAT HORNED OWL
PERCHED ON CACTUS STALK, BIG BEND NATIONAL
PARK, TX. EKTACHROME 64 FILM, EXPOSED AS
METERED, 600MM F4 LENS, BEANBAG STABILIZATION,
AUTOMOBILE MOUNT.

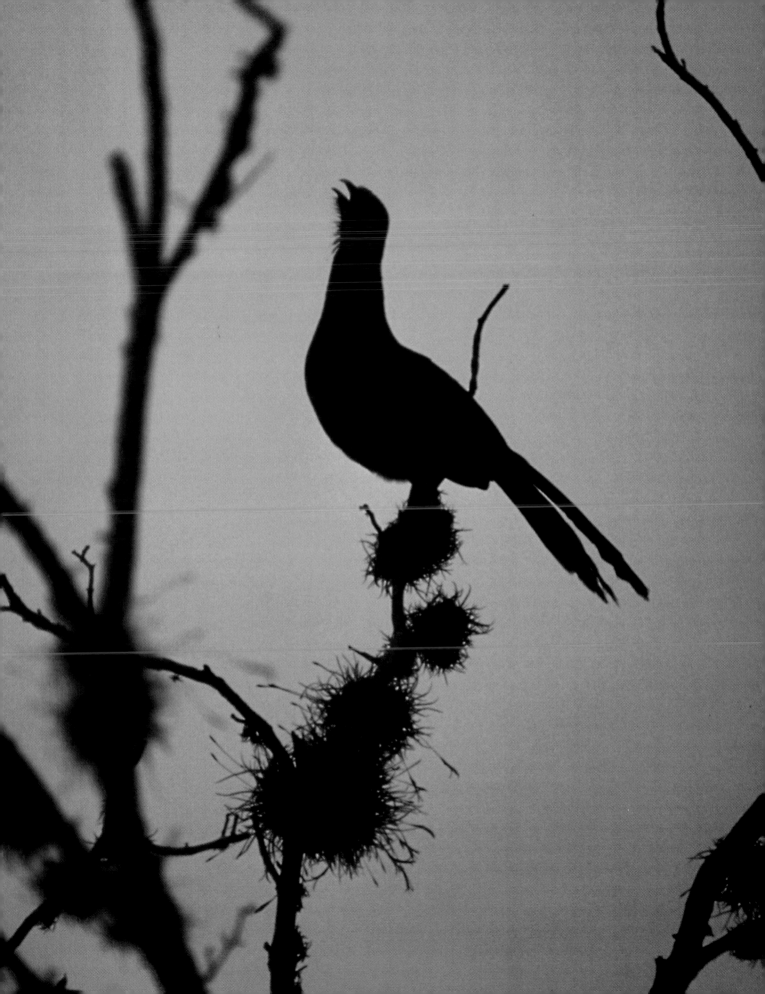

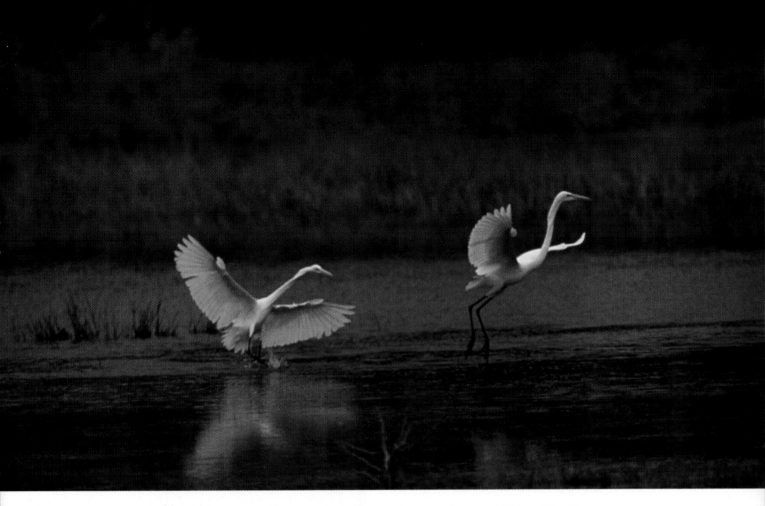

Great egrets take off from pond, Texas. Birds photographed taking off or landing add interest to a picture. Learn their behavioral characteristics to help you anticipate when they will leap into flight. Fujichrome 100 film, 1/500 second, 600mm f4 lens.

◁

Singing chachalaca silhouette. Exposed as metered with strong backlighting to create this interesting monochrome effect. The lines of the bird complement the vertical tree position.

FLYING DUCKS REFLECTED IN WATER,
GLACIER NATIONAL PARK, MT.
KODACHROME 64 FILM, 1/500 SECOND
300MM F2.8 LENS.

SANDHILL CRANES, BOSQUE DEL APACHE
NATIONAL WILDLIFE REFUGE, NM.
THOUSANDS OF THESE BIG, ACTIVE BIRDS
FILL THE WINTER SKY. 600MM F4 LENS,
1/500 SECOND.

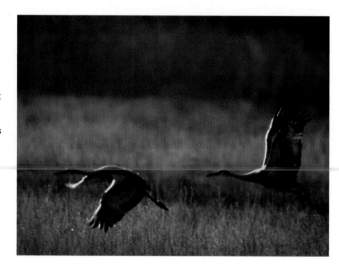

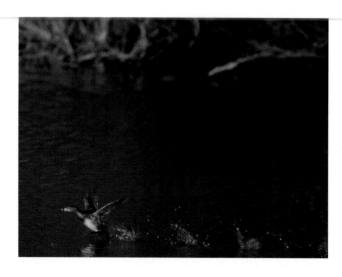

COOT TAKES OFF, PATTERING ACROSS THE
WATER WITH A TRAIL OF SPLASHES. THIS
SORT OF ACTION PHOTOGRAPH IS VERY
EASY TO TAKE: ANTICIPATE THE BIRD'S
TAKEOFF, SET UP, PRE-FOCUS THE CAMERA
AT AN AREA THAT YOU THINK THE BIRD
WILL FLY INTO, AND PRESS THE SHUTTER
AN INSTANT BEFORE THE BIRD ARRIVES AT
YOUR POINT OF FOCUS. FUJICHROME 100
FILM, 1/500 SECOND, 300MM F2.8 LENS.

Black skimmer, Ding Darling National Wildlife Refuge, FL. These birds fly in predictable, repeated patterns. I pre-focused the tripod-mounted camera on a nearby twig and then fired the shutter an instant before the bird passed the twig. "Anticipatory focusing" using the fastest possible shutter speed—1/1,000 second—is an easy way to photograph flying birds. Kodachrome film, 300mm f2.8 lens.

be that of severe underexposure with very little light reaching the film. This is fun to experiment with. You may want to add a stop or two of light in such situations, depending on whether you want a total silhouette or a more evenly exposed scene.

SCENIC LOCATION PHOTOGRAPHY

A bird adds interest and elegance to most landscape photographs. They bring that something extra to photographs of gardens, flowers, fields, and forests. Look for opportunities to photograph a bird in unique locations in all types of weather. Overcast days can give wonderful lighting effects, allowing a very limited range of contrast between the brightest and dimmest objects. Slide film reproduces more accurately if the contrast is limited. Colors are often softer and lovelier on misty days. Remember that you can take stunning bird photographs wherever you find birds and with virtually any kind of camera.

Prairies and Deserts

Look for the exciting and beautiful raptors: prairie falcons, Swainson's hawks, golden eagles, and others that frequent prairies and deserts. These birds are frequently found perching on power lines and fences. Look on the tops of bushes for the head of a hawk whose body may be hidden in foliage. Check around cliffs for evidence of roosts, watching for the telltale whitewash from frequent bird use. This may lead you to a nest. If you should discover a bird nest, do not go to it! A predator, such as a coyote, might follow your scent directly to it.

To photograph the nest and its occupants from a distance, use extreme telephoto lenses and two tripods—one to support the telephoto lens and one for the camera—for steady long-distance exposures. Consider stacking your teleconverters. Even if your teleconverters do not mechanically fit together, you can still fit them fairly close to each other by using an extension tube as a connector. This will allow you to take advantage of the magnification power and get a remarkably large image size. It may be sharper than you expect, especially if the telephoto lens is stopped down by two or three stops. When you photograph birds that are very distant from you on a sunny day, you should use an ultraviolet haze filter. This will eliminate any fogging or distorting effects that ultraviolet light causes.

Look for action shots of falcons and harriers "stooping" down or zooming low looking for prey. This is a time you should pan with the bird using a ball-head mount or an easily swiveled beanbag on a window mount.

Mountains

Blue grouse, ptarmigans, eagles, pheasants, snowy owls, and bald eagles flying through a snowstorm are some of the rewards for a photographer in cold country. Ptarmigans and grouse often allow very close approach, if done gently and carefully. The mountain passes at Yellowstone National Park are a good place to see blue grouse displaying during spring, summer, or fall. These birds, in breeding plumage, will often pose for long periods of time, allowing you to obtain a great depth of field and slow shutter speed. The scenic

▷

TENDER MOMENT BETWEEN BURROWING OWL AND OFFSPRING, LUBBOCK, TX. IN MOST PRAIRIE-DOG TOWNS, YOU CAN FIND THESE DELIGHTFUL, BOBBING LITTLE CHARACTERS THOUGHTFULLY PEERING AT YOU. BEANBAG STABILIZATION, AUTO MOUNT, 300MM F2.8 LENS WITH 2X TELECONVERTER.

mountain backgrounds and brilliant blue skies are a perfect backdrop for some spectacular photography.

However, high mountain/high altitude photography can be tricky. The sky oozes with blue at high altitudes. Most color films will show an excessive bluish cast in the clear, thin air, and a light warming filter, either light orange or pale reddish-amber, can help. Often, snowy, shaded areas fool the light meter, resulting in a photograph that is underexposed by a stop or two. In other words, it will try to turn a bright snowfield into a dull, hazy, uniform gray wasteland. You should slightly increase the exposure when photographing in these conditions. Use an ultraviolet filter to reduce the haze found at these elevations. Polarizing filters, which enhance colors, will make the sky seem brilliantly blue, and add a spectacular eye-catching effect to clouds and snow. Use of a polarizing filter can be overdone, however, and can make photographic images look artificial; they can turn a blue sky almost black at high altitudes, and this can either look strikingly interesting or quite unappealing. Therefore, use polarizing filters cautiously, if at all, turning the filter to just the right amount of sky and color enhancement, which you will see through your viewfinder. There are other lighting conditions involving snow reflections where less light may be needed, depending on your personal preference. Experiment and bracket. Fill-in flash is often helpful.

Protect your equipment in icy altitudes by following these tips. Try not to breathe on cold lens elements, as these can freeze. Keep your camera inside your coat as much as possible, as batteries and auto-winders are very cold sensitive. If cold film is wound, sparks can generate

◁

RISING FULL MOON WITH TURKEY VULTURE, BIG BEND NATIONAL PARK, TX. FULL MOON IS ILLUMINATED BY THE SUN, SO THE EXPOSURE FOLLOWED THE "SUNNY 16 RULE." BEANBAG STABILIZATION ON TOP OF CAR, 600MM F4 LENS.

and/or break the film, which becomes brittle. While photographing polar bears and snowy owls in Churchill, Manitoba, I saw another photographer's auto-winder completely shred an entire roll of exposed film during the rewinding process. When going to and from the indoors to the frozen outdoors, put your equipment in a sealed plastic bag to prevent condensation.

Seashore

Taking long exposure photographs of birds standing motionless in the surf or moving water can lead to beautiful effects, with the water turning to a pleasing smooth texture. For this type of photography, increase the exposure time, use a neutral-density filter, stop down to the smallest available lens opening, and perhaps add a polarizing filter, which can cause the loss of two or more stops of light and thus allow a longer exposure. Position yourself at the bird's level. When you photograph shorebirds, construct a photo blind by building sandcastles and lay a telephoto lens over a blanket. You can also use an automobile to cautiously and slowly approach shorebirds. Anticipate travel direction of feeding birds. Set up your equipment and wait for their arrival at intercepting points. Many shorebirds, such as plovers, run and stop; take photographs during one of their predictable pauses.

In places such as the Texas coast, rain forests, Olympic National Park in Washington, and Costa Rica, dim lighting conditions call for fast lenses, fast film, and perhaps flash. Flash, including projection flash units using Fresnel lens flash setups, are effective. Use fast film, such as Kodachrome 200, or even faster film. To get good photographs, it may be necessary to sacrifice the quality of the slides (e.g., increasing graininess) by using faster film.

Taking bird photographs from boats and ships can be challenging. In rough seas, use the fastest available shutter speed and fast film. Many of the birds you see

from offshore will be white, and you may need to consider a slight underexposure to keep the feathers from "burning out." Because of the reflections from the brilliantly lighted water, the camera's light meter may produce different effects, so experiment and do not be afraid to bracket. Try to get familiar with an effect that you find most pleasing. Warming and polarizing filters can cut the strong ultraviolet haze of the ocean, and polarizing filters greatly enhance cloud and water colors. The polarizing filter can increase exposure time and cause the loss of a couple of stops of light, but this may not be a problem on a brilliant sunshiny day where shutter speeds will be quite fast.

Use shoulder stocks or monopods used as "chest pods" when you take photos of birds from boats. Tripods usually do not work well on a boat. Slightly toward the rear of the boat from the center part, in the middle from right and left, is the most stable part of the boat—as low in the boat as possible. Avoid the top deck or extreme front of a boat, as wave motion will be magnified there. Stabilize yourself against the boat structure and do not rest the camera or lens against the railing. The horizon needs to be level, which is a real challenge on a rolling boat. If the water is rough and choppy, consider a gyroscopic stabilizer. This can be an expensive, but useful piece of equipment. You can purchase one that is pre-assembled or make your own from a gyroscope kit, which can be found at Edmund Scientific Company.

Different films seem to interpret the ocean differently. You may need fast film to allow fast shutter speeds if you are using a slow lens. Be sure to have plenty of fresh film loaded in case a once-in-a-lifetime photo opportunity should fly past.

Protect your equipment from the sea air and hot climate by following these tips: Use a filter to protect the front lens element from the unseen, but damaging salt spray. Change lenses very carefully and limit exposure to the elements. Store film in insulated chests with dry sources of refrigerant.

Protect yourself and your camera equipment from moisture and humidity with rain gear, boots, broad-brimmed hats, rain ponchos, Ziplock bags, large plastic trash bags, or silica gel canisters or bags. Place your camera and lenses in a sealable plastic bag with the silica canister or bag. You can regenerate silica products by heating them. This product is usually available at drug stores, but beware—there are horror stories about customs agents confusing them with illicit drugs. You may want to purchase the Ewa Marine Camera Housing, which is made for underwater use. This clear plastic device shelters the camera and lens, while allowing you to operate the camera's controls through gloves entering the enclosure. When changing from hot to cold environments, allow your equipment time to cool before removing from closed plastic bags.

▷

I PHOTOGRAPHED THIS GUILLEMOT FROM A BOAT OFF ALASKA. THE FAST 300MM F2.8 LENS AND GOOD STABILITY, FROM A MONOPOD SETUP THAT I HOOKED INTO MY BELT, ALLOWED A FAST SHUTTER SPEED, WHICH I NEEDED TO PHOTOGRAPH THE FLYING BIRD. THE BRIGHT ORANGE FEET CONTRAST NICELY WITH THE DEEP BLUE WATER.

EWA MARINE UNDERWATER CAMERA HOUSING FOR PHOTOGRAPHY IN THE RAIN, AT THE SURF, AND UNDERWATER.

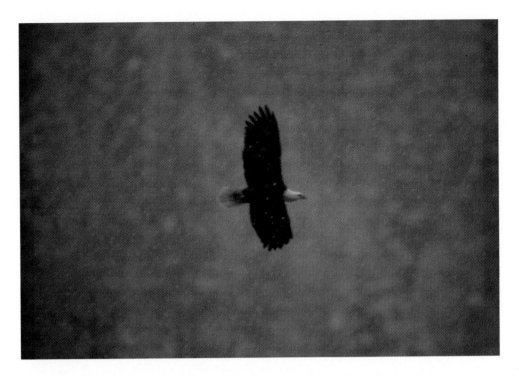

Bald eagle flies in a snowstorm. The quick, responsive mobility of this modified monopod allowed easy "tracking." Nikon 300mm f2.8 E.D. lens, 1/500 second, Kodachrome 64 film.

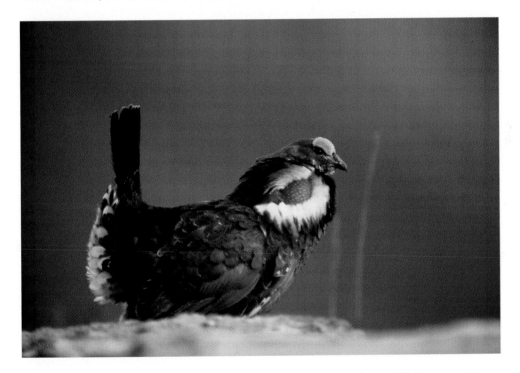

Blue grouse displaying in snow, Yellowstone National Park, WY. High in the mountain passes, these unwary birds, which allow very close approach, seem to be so territorial that they would go bear hunting with a switch.

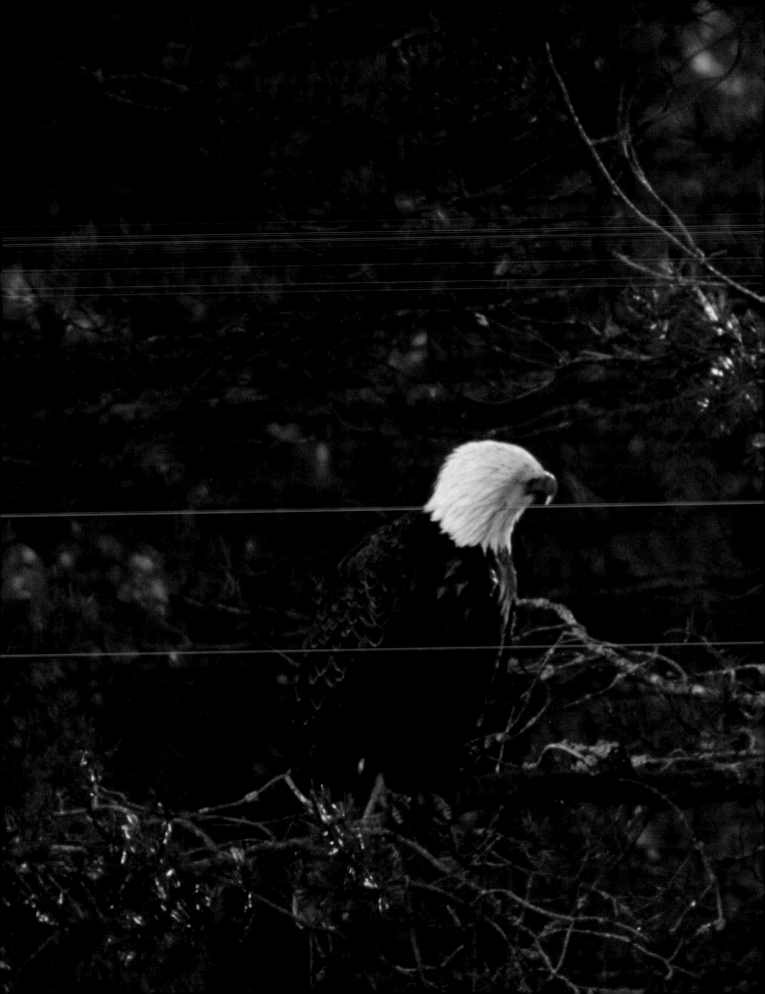

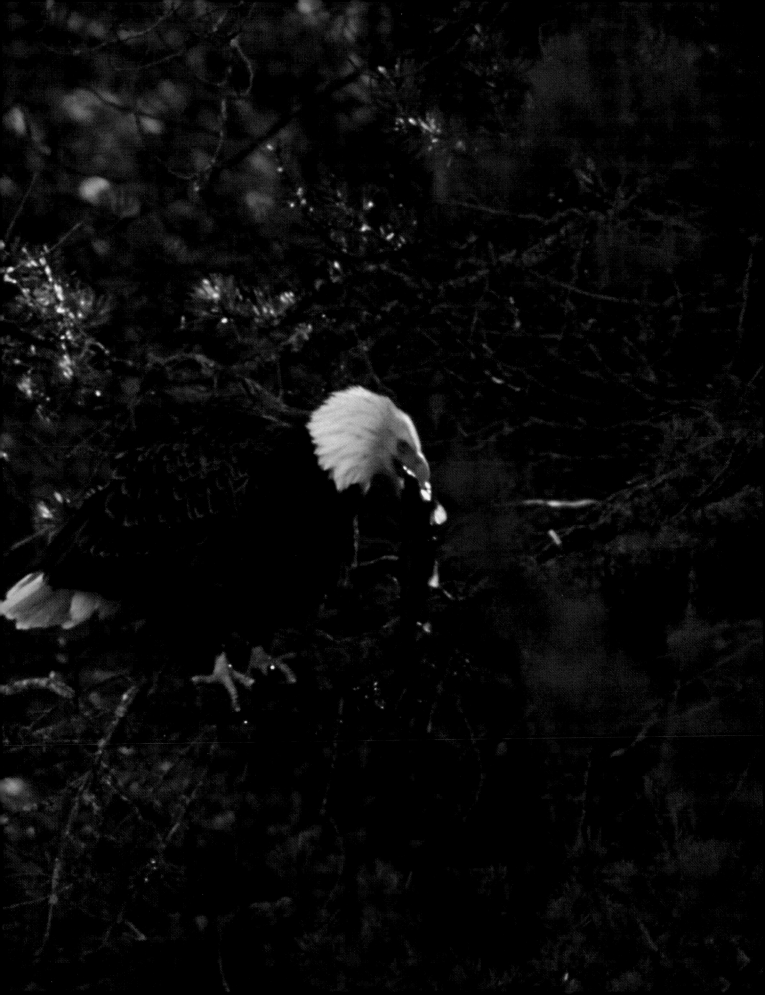

RING-NECKED PHEASANT IN SNOW, BOSQUE DEL APACHE NATIONAL WILDLIFE REFUGE, NM. FRESH BATTERIES FOR THE CAMERA ARE IMPORTANT IN COLD-WEATHER PHOTOGRAPHY. CARRY A SPARE SET! AUTO BLIND, 50–300MM ZOOM LENS, PHOTO BY BARBARA P. GROVE.

◁ ◁

TWO MATURE BALD EAGLES FEAST ON BANQUET OF SALMON, GLACIER NATIONAL PARK, MT. 600MM LENS.

Sun

Although photos of the sun can be very striking, remember that the telephoto lens is a magnifying glass that can focus the sun's rays, burning holes in camera shutters and destroying your vision. There are ways to take photos of birds in front of the sun without looking through the lens. First, focus on an object that is the same distance as the bird that you wish to photograph, but do this just outside of the range of the sun so that the sun does not appear in your photo while you are focusing. Then take your eye away from the viewfinder and quickly move the camera to the area of the bird by the sun, click the photograph, and then move the camera away. Combine this technique with either adding or subtracting light, to take advantage of the fact that the automatic meter of the camera, if the sun is part of the picture, will cause the image to be much darker and more underexposed and moody. Obtain a brighter image either by adding one or two stops of light with the exposure control attachment on your camera, opening the lens a stop or two, or by changing the shutter speed to allow more light to enter or vice versa.

Photographing the sun can cause star bursts, which you can see best when using wide-angle lenses with a small f-stop. The meter will probably cause the sky to be quite dark, and the darker the sky is the more pronounced the star-like image of the sun. Use a small lens opening with a wide-angle lens or bracket to see what your preference is.

Clouds

When you photograph beautiful cloud formations at sunset, look for birds flying into the "afterglow" that follows the actual setting of the sun, sometimes by several minutes. A previously somewhat dull sunset can explode into a firestorm of incandescent clouds glowing across the horizon, and you may be able to photograph a stunning panorama with your wide-angle lens. Such compositions are great calendar photographs.

Moon

An early morning or late evening full moon near the horizon adds striking drama to bird photographs. You can capture photos that range from wide-angle shots of large groups of flying and feeding birds, to extreme telephoto images of an almost frame-filling picture of the moon with birds flying or perching in front of it. You will notice that the moon appears much larger near the horizon at moonrise and moonset. The moon usually rises a half an hour later each day. The later in the day that the moon rises, the less sunlight will be available to illuminate the birds. The day *before* the scheduled full moon, as given in fishing almanacs and calendars, is a good time to photograph the moon at sunset, because there will be enough additional light to take a photo. Be up with your camera at dawn the day before the scheduled full moon and try to get photographs of the magic moment when the brightness of day and twilight are almost equal. To expose the full moon properly, try 1/60 second with ISO 64 film at f16, (the "Sunny Sixteen Rule"), and bracket to see what effect you prefer.

Rainbows

When the sun is out and it has been raining nearby, you can almost always find a rainbow. Look for birds around the rainbow for photographic zingers. Change your camera's position to make sure that the bird is situated in the position you would like in relation to the rainbow. Birds might be flying around the rainbow or perching at the end of the rainbow. The best lenses for photographing rainbows range from ultra-wide angle to ultra telephoto. Just a hint of polarization from a polarizing filter can cause a loss of a stop or two of light, but make a rainbow come alive. The full use of the polarizing filter can cause the rainbow to vanish. Expose as metered, then take a few shots that are underexposed by one-third to one stop for more rainbow color saturation. In addition to the polarizing filter, consider an enhancing filter.

WOODPECKER ON SAGUARO CACTUS, SUNRISE,
TUCSON, AZ. NOTICE SUNLIGHT REFLECTED FROM
CATCHLIGHT IN EYE. BACK- AND SIDE-LIGHTING BRING
OUT COLORS IN CACTUS SPINES AND FLOWERS IN A
PLEASANT "RIM-LIGHTING" EFFECT. 600MM F4 LENS,
1.4X TELECONVERTER.

▷

CLIFF SWALLOWS AT SUNSET,
LAKE TRAVIS, TX. ONE STOP
UNDEREXPOSURE EMPHASIZES COLORS IN
THE SKY. BOAT PHOTO, 24MM WIDE-ANGLE
LENS.

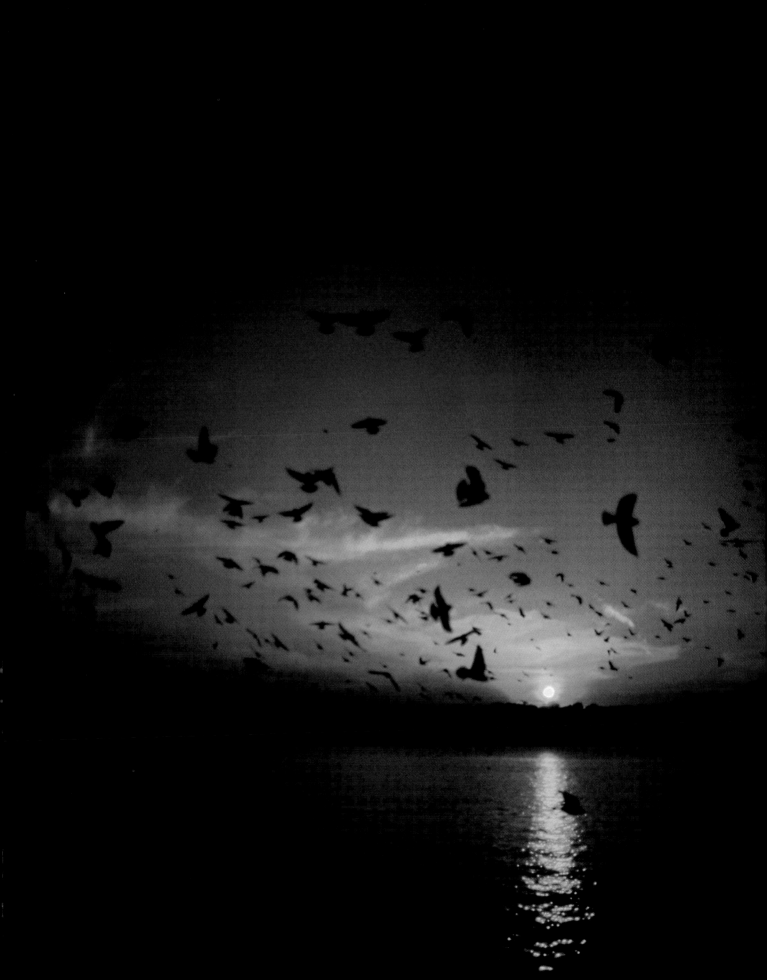

WADING BIRDS AT SUNRISE, DING DARLING WILDLIFE SANCTUARY, FL. I FOCUSED ON
AN AREA NEAR THE SUN, BUT DID NOT ACTUALLY LOOK AT THE SUN THROUGH THE
VIEWFINDER, AS THIS COULD CAUSE EYE DAMAGE. I THEN MOVED THE CAMERA TO A
"GUESTIMATED" POSITION AND TOOK THE SHOT. EXPOSED AS METERED BY THE CAMERA,
WHICH CAUGHT THE REFLECTIONS AS BURNISHED LIQUID GOLD. AN ADDITIONAL STOP
OR TWO OF LIGHT COULD BE ADDED TO BRIGHTEN THE SCENE.

BIRDS AT SUNRISE, BOSQUE DEL APACHE WILDLIFE REFUGE, NM.
SUNRISES AND SUNSETS SEEM TO HAVE BEEN CREATED JUST FOR ENJOYING
BIRD PHOTOGRAPHY. MARSH/WETLAND PHOTOGRAPHIC OPPORTUNITIES ARE
RICH HERE.

FULL MOON AT SUNRISE AND AWAKENING SNOW GEESE, BOSQUE DEL APACHE
NATIONAL WILDLIFE REFUGE, NM. IN THE MORNINGS AND EVENINGS,
THOUSANDS OF NOISY SANDHILL CRANES AND GEESE FLY JUST OVER YOUR
HEAD TO AND FROM THEIR FEEDING GROUNDS AT THIS FAMOUS WINTER
WILDLIFE SPECTACULAR. 50–300MM ZOOM LENS.

MALLARD DUCK, NIKON 50–300MM ZOOM LENS,
EKTACHROME 400 FILM. NOTICE THE RICH
REFLECTIVE COLORS AND RATHER LARGE GRAIN OF
THIS FAST FILM.

Improving and Presenting Your Photos

How to Improve a Photo

There are many ways to improve a "good" slide after you have taken it, but before you can improve your slides, you must make sure they are clean. Cans of compressed air, rubber bulb syringes to puff off dust, or special soft-bristled photo brushes from a camera store may do the job. Yucky, gooey stuff that has a way of getting onto our favorite slides is a different matter, and some professional labs use special slide-cleaning chemicals. You can use a dab of lighter fluid or naptha, which may work, but use it outside, don't breathe it, and wipe it off carefully with a soft, lint-free cloth. To remove ball-point pen marks on slides, apply isopropyl rubbing alcohol with a cotton-tipped applicator. DO NOT USE THESE CLEANING TECHNIQUES ON YOUR FAVORITE SLIDE UNTIL YOU HAVE EXPERIMENTED ON THROWAWAY SLIDES!

Professional labs, such as Holland Photographics in Austin, TX, make publication-quality duplicate slides, or "dupes," and use electronic/digital technology to enlarge, crop, or even adjust the color of your images. Manipulation of slides in professional photography laboratories using digital imagers is approaching a fine art. These imagers can remove blemishes, magnify, isolate, and creatively add and subtract from various images. Many such photographs appear on the covers of national publications. By the way, none of the photographs appearing in this book have been artificially altered.

Some pictures seem to "feel right" if they are reversed. This may have to do with the way the brain interprets sensations based on the direction the eye takes when the images enter the field of view. Whatever the reason, when you are projecting or viewing a slide, ask yourself if you think it would be more appealing if it were reversed. If so, you can easily remove a slide from its original mount and remount it in a plastic or cardboard mount in the "correct" orientation.

If you take a photograph that includes garbage, which went unnoticed during the excitement of clicking the shutter, simply block it out with silver photographic tape. You can apply this tape, which is available at photography stores, directly to the slide, allowing you to change the orientation of the slide from horizontal to vertical or vice versa. A wide-angle photograph cropped either horizontally or vertically gives an exaggerated panorama effect, much like photographs that expensive panorama lens and camera setups produce. You can also use this technique to change the apparent position of the bird within the viewfinder screen to get a more pleasing compositional style.

You can also create special effects such as "sandwiching." This technique allows you to place birds in front of interesting backgrounds. If you have a slide of, say, a bird flying against a gray, concrete-colored sky background, you can add it to another slide, perhaps of the moon or sun, and mount them together using "do-it-yourself" slide mounts, which are available from camera stores. You can project, print, or produce duplicate slides of this new image.

Slide Shows

Present slide shows that are fun to watch and leave your audience wanting more, rather than being glad that you are finished. Show the zingers! Keep the presentation brief and avoid over-narration. Forty-five minutes or less is long enough for most audiences, as they get jittery after a certain point regardless of how wonderful the slides may be. Usually leaving the slide on the screen for 10 to 15 seconds is long enough. Usually two, or fewer, 80-slide trays are enough for a presentation. Remember, the attention span of most audiences may be less than the hours you spent taking the photographs, since they were not there to see, smell, hear, and experience what you felt when you pushed the shutter. You can always extend the viewing time if the audience wishes.

Make sure the slides are scrupulously clean. Use a compressed air device or a special film brush to remove any dirt particles. Also check to make sure the projector optics have been cleaned. Carousels that hold 140 slides are far more likely to jam than those with a lower 80-slide capacity. The room needs to be dark enough to allow images to be bright on the screen. If your slide projector does not automatically darken after the last slide is projected, place a piece of rigid cardboard in the last slide slot, so the audience isn't blasted with bright light. The projection screen should be clean, and it is nice to have a projection table that is solid and high enough so that the projector is level with the screen. Change the projection bulb to a fresh

EGRET PHOTO WITH DISTRACTING WHITE GARBAGE.

I USED SILVER TAPE TO CROP THE WHITE GARBAGE OUT OF THIS
EGRET PHOTO. YOU CAN APPLY THE SILVER CROPPING TAPE
DIRECTLY TO THE SLIDE'S SURFACE.

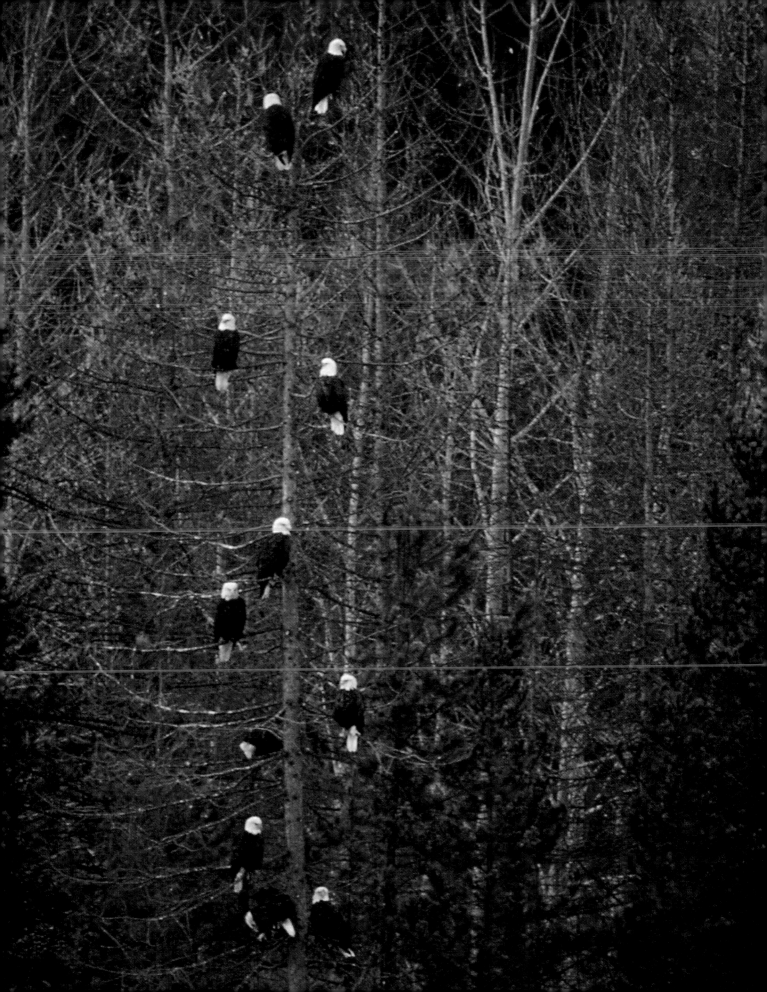

one before each show, as Murphy's Law may cause a bulb burnout during your show. Have a spare bulb and either a coin or a screwdriver to open the bulb receptacle on the projector. If you are invited to give a show elsewhere, some handy items to take along include a long extension cord, a projector table with telescoping legs, and a flashlight.

HOW TO PUBLISH YOUR PHOTOGRAPHS

First, you must find and meet the market needs. When you want to sell a photograph for publication, remember that one-time rights are usually purchased and the slide belongs to the photographer. Arguing or negotiating about the fee for use of a slide could lead to total rejection of a photograph, which otherwise might be published.

If an editor agrees, write a story about the subject at hand describing what you saw, how you felt, and others may see and share this with you. Don't be surprised if you find yourself the author of a magazine article, photo-illustrated by you.

Check the sharpness of your images before making prints or submitting photographs for publication. A slide projected on a screen may look "tack sharp," but appear quite "fuzzy" if viewed through a four- to eight-power hand loupe or special slide-viewing

◁

"EAGLE SPECTACULAR," GLACIER NATIONAL PARK. THIS PHOTOGRAPH HAS APPEARED ON TWO MAGAZINE COVERS. I USED TWO TRIPODS, ONE FOR THE LENS AND ONE FOR THE CAMERA AND STOPPED THE LENS DOWN BY ONE FOR SHARPER FOCUS. NIKON 600MM F4 LENS WITH 2X TELECONVERTER, KODACHROME 64 FILM.

magnifying lens, which most editors use. You can even use a two-inch eyepiece from a telescope as a loupe. These are available in varying powers of magnification and give a wide image, far wider than the usual photographer's loupe. Edmund Scientific Company sells wide-field photographers' loupes at reasonable prices. Never submit a blurred photograph for publication.

When you find a magazine or book that seems to cry out for your photographs, send a letter with an enclosed self-addressed stamped envelope and a message to this effect:

Please send photo guidelines for contributors. I am enclosing a self-addressed stamped envelope. Also, I would appreciate receiving a photo wants/needs list from you.

After you obtain a response about how and what to submit, label your slides with your name and address and copyright symbol, ©. Send a limited number of only your *best* images, perhaps no more than one or two 20-slide clear, plastic slide sheets, to a busy editor and a note to this effect:

I am submitting 40 photographs for one-time use in your magazine with my photo copyright intact and photo credit being given at your usual compensation. I enclosed a self-addressed stamped envelope for your convenience in returning these when you are through with them. I hope that you and your readers enjoy these.

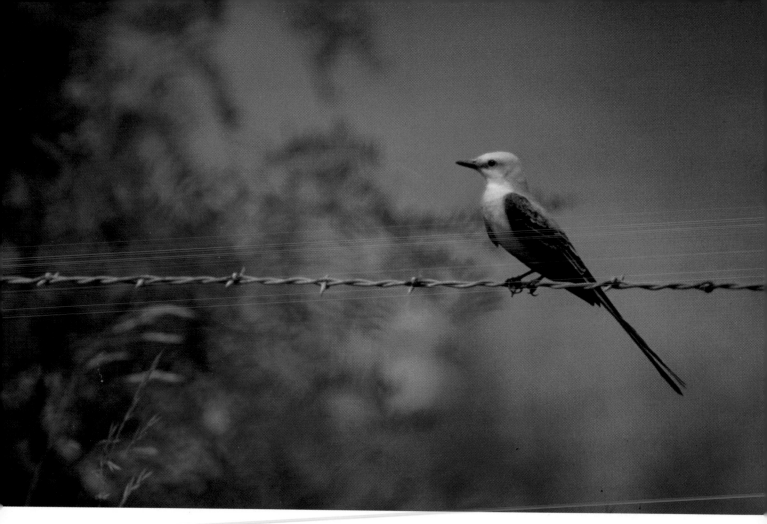

Scissortail flycatcher in front of golden wildflowers, Texas. This photograph appeared as a wraparound cover for Texas Parks and Wildlife magazine. Kodachrome 64 film, 600mm lens.

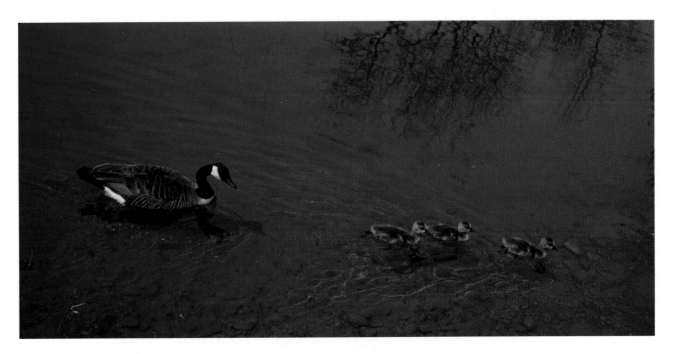

CANADA GEESE AND GOSLINGS PHOTOGRAPHED IN A CANADIAN CITY PARK IN
TORONTO. THESE TAME BIRDS ARE EASILY PHOTOGRAPHED IN THE PONDS AND
PARKS IN MOST LARGE CITIES AND OFTEN IN THE WATER COURSES IN MANY ZOOS.
SILVER TAPE WAS USED TO MASK AND CROP OUT DISTRACTING ELEMENTS AND TO
CREATE AN IMPRESSION OF A PANORAMIC PERSPECTIVE.

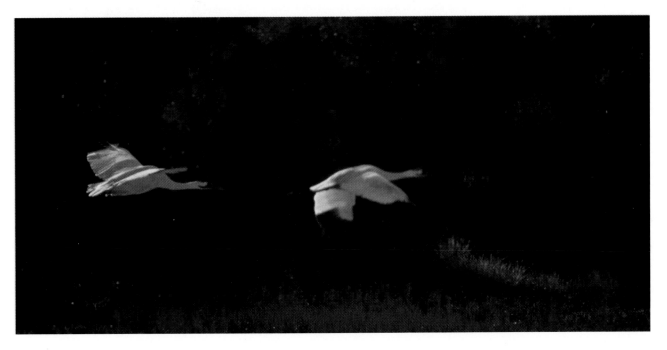

TWO FLYING WHOOPING CRANES, ARANSAS NWR, TEXAS COAST, PHOTOGRAPHED
FROM TOUR BOAT. 300MM F2.8 LENS, WIDE OPEN, 1/2000 OFA SECOND,
UNDEREXPOSED BY ONE STOP FROM CAMERA METERING. KODACHROME 64 FILM,
TRIPOD MOUNTING.

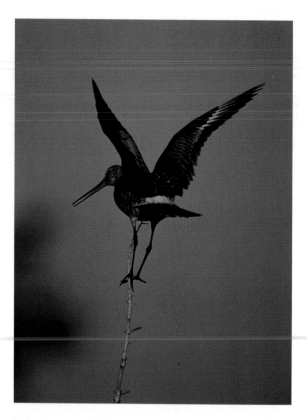

HUDSONIAN GODWIT DISPLAYING ON TOP OF TWIG IN
CHURCHILL, MANITOBA. THIS ARCTIC OUTPOST ON
THE HUDSON BAY HOSTS BREEDING BIRDS, WHICH
ALLOW CLOSE APPROACHES. PHOTOGRAPH APPEARED
ON THE COVER OF BIRDING MAGAZINE. KODACHROME
64 FILM, 600MM LENS.

Glossary

35mm camera system: The most widely used photographic system, uses a film size of approximately 35mm.

Advanced photo system (APS): A new, smaller photographic system that uses an image size considerably less than the 35mm format.

Aperture: An opening in the lens through which light passes on its way to expose the film, usually expressed as an f-number or f-stop.

Aperture priority setting: A device on some cameras that allows the photographer to pre-set the aperture (f-stop) so that the camera's built-in light meter can correctly adjust for the proper shutter speed for a correct exposure.

Auto-focus camera: A camera and lens system that automatically focuses an image. Great variability in cost, effectiveness, speed, and image selectivity.

Beanbag: A cloth bag filled with beans or similar small objects to form a very stable mount for camera and lens.

Blinds: Devices or objects that conceal a photographer so birds can be photographed in close-up situations without being disturbed.

Bracketing To take a series of photographs of the same subject, increasing and decreasing the recommended exposure to capture the most pleasing photograph. Recommended for unusual lighting situations.

Catchlight The light source (sun and/or flash unit) reflected in the bird's eye(s).

Close-up lens (diopters): Clear magnifying lens that attaches to the front of a lens and allows close-up focusing.

Dedicated flash unit: An artificial unit that interacts with a specific camera to automatically adjust intensity or duration of flash.

Depth of field: Part of the picture that is in focus from the closest point of sharp focus to the farthest point.

Depth-of-field preview control: A feature on many cameras that allows the photographer to stop down the lens to the pre-set f-stop so he/she can visualize the area in focus before taking the photo.

Digital camera: A photographic system that uses electronic technology instead of film to capture and process images.

Diopter: See Close-up lens.

Doubler: A two-power (2x) teleconverter, or supplemental lens attachment, that increases the power of a telephoto lens by a fraction of two.

Doughnuts: An optical distortion resembling a doughnut. This effect is often seen in photographs that are taken with a mirror lens, in which the internal mirror causes doughnut-shaped circles around bright objects.

Exposure: The amount of light that reaches photographic film in a given time interval.

Exposure compensation dial: A device on many cameras that allows the photographer to change the amount of light reaching the film by either increasing or decreasing the exposure.

Extension tubes: Glass-free attachments that fit between the camera body and lens and produce no image distortion, but cause some light loss. Used with telephoto lens to allow close focusing for close-up photos.

Fast lens: Lens with a large aperture, or opening, (small f-stop number) that admits lots of light and allows a fast shutter speed.

Fill flash: The use of a flash unit at less than the power needed to completely light up a photograph. This means a gentle touch of enough light to fill in the shadows and add life to the photo.

Film: A clear sheet coated with light-sensitive material that records light to make a photograph.

Film speed: Sensitivity of photographic film to light. Usually expressed as an ISO number, which replaced the ASA standard.

Filters: Transparent pieces of plastic or glass that fit on or in a lens to cause special effects, such as adding or enhancing color, polarization, or changing the relative amount of light admitted.

Fish-eye ultra-wide-angle lens: A big, bulging lens that has an enormous field of view and usually produces a pronounced image distortion, which is usually circular.

Fixed-focus lens: A lens that has only one focal length.

Flash synchronization: The coordination of an artificial flash unit firing and illuminating a photograph at the same time the camera's shutter is open to expose the photographic film.

Flash unit: A device that produces a very brief flash of artificial light to illuminate a subject in reduced lighting situations.

Focal length (FL): The distance from the film to a point inside the camera lens which correlates with the power of the lens.

Focusing screen: The part of the camera where the image is visualized by the photographer before the photograph is taken.

f-stop: A number that indicates the size of the lens opening or aperture, which indicates the amount of light admitted to illuminate the film. Expressed by an f-number as the relationship of the focal length of lens.

Grain: The relative size of light-sensitive chemicals, which usually include silver, that react to light to form an image. Small clumps are referred to as fine grain and are associated with sharp, clearly defined images.

Gray card: A card that reflects 18 percent of the light shining on it. A light meter reading taken from a gray card in the same light as the photographic subject gives the correct exposure.

Lens: A usually detachable glass or plastic device that processes light entering the camera. Available in many varieties of magnification, angle of view, weight, and cost.

Lens flare: An image distortion caused by contrast and color changes resulting from glare of sunlight hitting the lens surface.

Lens hood: Device that shields the front of the lens from direct sunlight, thus improving the photo by blocking lens flare.

Light meter: Device that measures and quantifies the intensity of light reaching a subject to allow the correct exposure.

Mirror lens: A lens of fixed focal length within which the path of light bounces back and forth between mirrors to produce a telephoto effect.

Monopod: A one-legged device that supports a camera and lens. Lighter and more portable, but not as inherently stable as a photographic tripod.

Motor drive: An electro-mechanical device in some cameras that rapidly advances film.

Normal lens: A lens focal length setting that resembles the perspective of the human eye, which, in a 35mm camera format, would be approximately 50mm focal length.

Point-and-shoot camera: Compact camera with one lens, often with automatic focus and exposure capabilities.

Polarizer: A type of filter that does not add color, but intensifies colors of feathers and foliage by removing reflections, intensifies colors of a rainbow if filter is rotated correctly to allow minimal polarization effect, and darkens the blue color of a sunlit sky, almost turning it dark blue-black.

Power wind: See Motor drive.

Predictive focus: Automatic-focusing mechanism that uses electronic technology to accurately focus on a moving subject before it enters the location where the photo will be taken.

Print film: Film that creates a negative image used to make prints.

Push processing: Alteration of development time to change the finished result of film as though the film had been taken at a different ISO setting, to, in effect, increase the light sensitivity, or speed, of the film.

Reciprocity color shift: The way in which various color films change their color response with long exposures in low light situations.

Reciprocity failure: The way in which various color films lose their sensitivity in low light situations.

Rectilinear ultra-wide-angle lens: A lens with an extremely wide angle of view, which produces less distortion of straight lines than a fish-eye ultra-wide-angle lens.

Rule of Thirds: A suggested principle of photographic composition, with the subject placed at one of the four points of intersection of horizontal and vertical lines, which divide the frame into thirds.

Shutter: That part of a camera which moves very rapidly to open and close, allowing light to reach the film.

Shutter priority: A feature on some cameras that allows the photographer to pre-set the shutter speed so that the camera's built-in light meter correctly adjusts to the proper f-stop for a correct exposure.

Single lens reflex camera (SLR): A camera system that uses only one lens to focus and expose a photographic film, which is made possible by a mirror device that rapidly flips at the instant of exposure to let light reach the film.

Slide film (transparency): The positive image recorded on film that can be used for slide projection as well as for making prints.

Slow lens: Lens with a relatively small aperture (lens opening), large f-stop number, and requires longer exposure times.

Smart flash units: Fairly expensive, fancy, sophisticated devices that interact with various electronic gadgets in the camera to add just the right amount of light to a photograph.

Spot meter: A light meter that measures the light reflected from a small portion of a subject, to allow that portion of the picture to be properly exposed.

Stop of light: Refers to the exposure-setting value, related to the length of exposure and brightness of light, the basis of the exposure dial.

Teleconverter (tele-extender, doubler, lens multiplier): Small, supplemental, light lens that fits between the camera and lens to increase magnification, usually ranging from 40 to 300 percent increases, but causes loss of image sharpness and light. A two-power (2x) teleconverter is a doubler.

Tele-extender: See Teleconverter.

Telephoto lens: A lens that causes a subject to seem closer than it really is.

Transparency: See Slide film.

Tripod: A three-legged device that supports the camera and lens to facilitate stable photographs.

Zoom lens: A lens with variable settings to change apparent subject size, ranging from wide angle to telephoto, depending on the design.

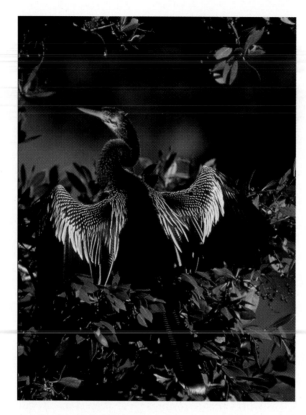

Anhinga drying wings in Ding Darling
National Wildlife Refuge after swimming
under water chasing fish. These birds may
stay motionless like this for many minutes.
300mm Nikon 50-300 zoom lens.

Further Reading

ATTRACTING BIRDS

How to Attract Birds. San Francisco: Chevron Chemical Company, 1983.

Kress, Stephen W. *The Bird Garden.* National Audubon Society. NY: DK Publishing, Inc., 1995.

McElroy, Thomas P., Jr. *The New Handbook of Attracting Birds.* NY: W.W. Norton & Company, 1960.

LOCATING AND IDENTIFYING BIRDS

Breedy, Edward C. and Stephen C. Granholm. *Discovering Sierra Birds.* Yosemite Natural History Association, National Park Service, U.S. Department of the Interior, 1985.

Clark, William S. and Brian R. Wheeler. *Hawks.* Peterson Field Guides. Boston: Houghton Mifflin Company, 1987.

Davis, Russell, *Birds in Southeastern Arizona.* Tuscon: Tuscon Audubon Society, 1984.

Dunne, Pete, David Sibley, and Clay Sutton. *Hawks in Flight.* Boston: Houghton Mifflin Company, 1988.

Ford, Paula. *Birder's Guide to Pennsylvania.* Houston: Gulf Publishing Company, 1995.

Kutac, Edward A. *Birder's Guide to Texas,* 2nd edition. Houston: Gulf Publishing Company, 1998.

Lane, James A. *A Birder's Guide to Southeastern Arizona.* Denver: L&P Press, 1984.

Robbins, Chandler S., Bertel Bruun, and Herbert S. Zim. *Birds of North America.* NY: Golden Press, 1983.

Terres, John K. *The Audubon Society Encyclopedia of North American Birds.* NY: Alfred A. Knopf, 1980.

The Audubon Society Master Guide to Birding, Gulls to Dippers. John Farrand, Jr., editor. NY: Alfred A. Knopf, 1983.

The Audubon Society Master Guide to Birding, Loons to Sandpipers. John Farrand, Jr., editor, NY: Alfred A. Knopf, 1983.

The Audubon Society Master Guide to Birding, Old Warblers to Sparrows. John Farrand, Jr., editor. NY: Alfred A. Knopf, 1983.

Vaughn, Ray. *Birder's Guide to Alabama & Mississippi.* Houston: Gulf Publishing Company, 1994.

Westrich, Lolo and Jim. *Birder's Guide to Northern California.* Houston: Gulf Publishing Company, 1991.

Scenic Locations

A Guide to Our Federal Lands. National Geographic Society, 1984.

America's Wildlife Hideaways. Washington, D.C., National Wildlife Federation, 1989.

America's Wonderlands, Our National Parks. National Geographic Society, 1984.

Bauer, Erwin and Peggy. *Photographing the West, A State-by-State Guide.* Arizona: Northland Press, 1980.

Harrison, George H. *Roger Tory Peterson's Dozen Birding Hot Spots.* NY: Simon & Schuster, 1976.

Mangelsen, Thomas. *Images of Nature.* P.O. Box 14604, 8206 "J" Street, Omaha, NE 68127.

National Wildlife Refuges (*list*). U.S. Fish and Wildlife Service, Department of the Interior.

Our Threatened Inheritance, Natural Treasures of the United States. National Geographic Society, 1984.

Scenic Wonders of America, An Illustrated Guide to Our Natural Splendors. Pleasantville, NY: The Reader's Digest Association, Inc., 1973.

Photographic Techniques

Bauer, Peggy and Erwin. *Wildlife Adventures with a Camera.* NY: Harry N. Abrams, Inc., 1984.

——————————. *Photographing Wild Texas.* Austin: University of Texas Press, 1985.

Breen, Kit Howard. *Photographing Waterfowl.* Stillwater: MN: Voyageur Press, Inc., 1989.

Capture the Beauty in Nature. The Kodak Library of Creative Photography, Salvat Editores, S.A.: Kodak Limited, Mitchell Beazley Publishers, 1983.

Caulfield, Pat. *Photographing Wildlife.* NY: Amphoto, 1988.

Fitzharris, Tim. *The Adventure of Nature Photography.* Edmonton: Hartig Publishers, 1983.

Freeman, Michael. *How to Take Great Nature & Wildlife Photos.* Tucson: HP Books, 1983.

Gerlach, John. *How to Shoot Perfect Natural Light Exposures on Color Transparency Film.* P.O. Box 259, Chatham, MI 49816, 1985. This booklet provides detailed information about exposure.

How to Improve Your Photography. Tucson: HP Books, 1981.

How to Make Better Color Photographs. Tucson: HP Books, 1981.

The Joy of Photography. Rochester, NY: Eastman Kodak Company, 1979.

McDonald, Joe. *A Practical Guide to Photographing American Wildlife.* Emmaus, PA.: Foxy-Owl Publications, 1985.

Patterson, Freeman. *Photography of Natural Things.* Toronto: Van Nostrand Reinhold, 1982.

Photographing Nature. NY: Time-Life Books, 1971.

Rue, Leonard Lee III. *How I Photograph Wildlife and Nature.* NY: W.W. Norton & Company, Inc., 1984.

Shaw, John. *The Nature Photographer's Complete Guide to Professional Field Techniques.* NY: Amphoto, 1984.

West, Larry and Julie Ridl. *How to Photograph Birds.* Harrisburg, PA: Stackpole Books, 1993.

Woottera, John and Jerry T. Smith. *Wildlife Images, A Complete Guide to Outdoor Photography.* L.A.: Petersen Publishing Company, 1981.

MARKETING PHOTOGRAPHY

1985 Photographer's Market. Robert D. Lutz, editor. Cincinnati: Writer's Digest Books, 1984.

Ahlers, Arvel W. *Where & How to Sell Your Photographs.* NY: American Photographic Book Publishing, 1979.

Engh, Rohn. *Sell & Re-sell Your Photos.* Cincinnati: Writer's Digest Books, 1984.

The Guilfoyle Report, AG Editions Inc., 142 Bank St., NY, NY 10014. This is a current, updated photo-needs market listing with an excellent series of articles of interest to photographers.

Thomas, Bill. *How You Can Make $50,000 a Year as a Nature Photojournalist.* Cincinnati: Writer's Digest Books, 1986.

PERIODICALS

American Birds, Audubon, Birding, Birdwatcher's Digest, International Wildlife, National Wildlife, Outdoor Photographer, Ranger Rick, The Living Bird, The Natural Image Newsletter, Western Photo Traveler, WildBird

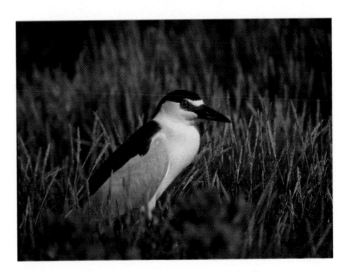

BLACK-CROWNED NIGHT HERON, TEXAS COAST ROOKERY ISLANDS. 600MM LENS FROM TOUR BOAT.

Videos

Companies

Audubon Society's Video Guide to Birds of North America, Vols. I-V. NY: Mastervision, 1988.

Ducks Unlimited's Video Guide to Waterfowl and Game Birds. NY: Mastervision, 1985.

Techniques of Birding with Arnold Small. Nature Videos, P.O. Box 312, South Laguna, CA 92677.

Watching Birds with Roger Tory Peterson. Metromedia Producers Corp. and Houghton Mifflin Co., 1981.

PHOTOGRAPHY EQUIPMENT

Beattie Systems, Inc.
2407 Guthrie Ave.
Cleveland, TN 37311

Bushhawk Products
Division of Ocean Industries
5312 Banks St.
San Diego, CA 92110

Four Seasons Nature Photography
P.O. Box 620132
Littleton, CO 80162

Leonard Rue Enterprises
138 Millbrook Rd.
Blairstown, NJ 07825

Photo Addition Enterprises
P.O. Box 1646
Champlain, NY 12919

Tekno Chicago
100 W. Erie St.
Chicago, IL 60610

Tiffen Manufacturing Corp.
90 Oser Ave.
Hauppauge, NY 11768

Wimberley Design
133 Bryarly Rd.
Winchester, VA 22603

LITTLE BLUE HERON, TEXAS COAST. 600MM F4 LENS, AS METERED, TRIPOD MOUNT, KODACHROME 64 FILM.

Birding Equipment

American Birding Association, Inc.
P.O. Box 6599
Colorado Springs, CO 80934-6599

Audubon Workshop
1501 Paddock Dr.
Northbrook, IL 60062

The Crow's Nest Book Shop
Cornell Laboratory of Ornithology
159 Sapsucker Woods Rd.
Ithaca, NY 14850

Johnny Stewart Company
P.O. Box 7594
Waco, TX 76714-7594

Wild Bird Supplies
Dept. WB
4815 Oak St.
Crystal Lake, IL 60012

Organizations

American Birding Association
P.O. Box 6599
Colorado Springs, CO 80934-6599
An active, national birding organization.

Cornell Laboratory of Ornithology
159 Sapsucker Woods Rd.
Ithaca, NY 14850
An excellent source for books, bird sounds, accessories, and sponsored tours.

National Audubon Society
Membership Data Center
P.O. Box 266
Boulder, CO 80322

Sierra Club
100 Bush St.
San Francisco, CA 94104
Features publications, programs, and promotes conservation in all areas of the U.S.

The Nature Conservancy
1815 North Lynn St.
Arlington, VA 22209
Purchases and administers strategic land for wildlife and publishes a beautiful magazine.

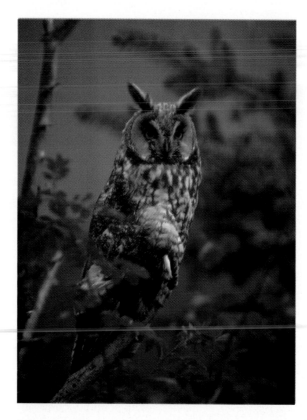

Long-eared owl, photographed at Calgary Zoo, Canada. 300mm f2.8 lens, wide-open, with monopod stabilization, Fujichrome 100 film, exposed as metered. The wide open, fast lens and fairly shallow depth of field threw the bars of the cage mostly out of focus.

Index

Installing
The Joy of Bird Photography
Screen Saver
Under Windows 95, Windows 98, and Windows NT

The CD-ROM that accompanies *The Joy of Bird Photography* includes screen-saver software that you can install under Windows 95, Windows 98, and Windows NT. To install the screen saver onto your PC, perform these steps:

• Insert *The Joy of Bird Photography* CD-ROM into your PC's CD-ROM drive.

• Within Windows, select the Start menu Run option. Windows, in turn, will display the Run dialog box.

• Within the Run dialog box Open field, type the command D:\SETUP, replacing the drive letter D with the drive letter that corresponds to your CD-ROM drive. For example, if your CD-ROM drive is drive E, you would type E:\SETUP. Press Enter to click your mouse on the OK button. Windows, in turn, will run the Setup program that will install the screen saver onto your PC's hard disk.

After you install *The Joy of Bird Photography* screen saver onto your PC, perform the following steps to select the software as your current screen saver:

• Within Windows, select the Start menu Settings menu and then choose Control Panel. Windows, in turn, will open the Control Panel window.

• Within the Control Panel, double click your mouse on the Display icon. Windows will display the Display Properties dialog box.

• Within the Display Properties dialog box, click your mouse on the Screen Saver tab. Windows, in turn, will display the Screen Saver sheet.

• Within the Screen Saver sheet, click your mouse on the Screen Saver pull-down list and select the BirdSaver option. Windows will display a bird photograph within the small monitor that appears within the Display Properties dialog box.

To preview the screen saver, click your mouse on the Preview button.

To speed up or slow down the speed at which the screen saver displays images, click your mouse on the Display Properties dialog box Settings button. Windows, in turn, will display the BirdSaver settings dialog box, within which you can use your mouse to slide the speed setting to the left or to the right to speed up or slow down the screen saver's photo display. Click your mouse on the OK button to close the BirdSaver settings dialog box.

Click your mouse on the OK button to close the Display Properties dialog box.

Troubleshooting *The Joy of Bird Photography* **Screen Saver:** If you encounter problems installing or running *The Joy of Bird Photography* screen saver, visit the Gulf Publishing Company Web site at www.gulfpub.com/books. Within Gulf's Web site, follow links to *The Joy of Bird Photography* page, where you will find a list of troubleshooting tips and possibly periodic updates to the screen-saver software, which you can download and install on your PC.